"When people think of museums, many imagine dusty repositories for the art and artifacts of bygone civilizations. Not so Robert Janes. To Janes, museums should represent the whole of time's arrow – past is prologue to the present which serves as harbinger to the future. Janes argues that museums can (re)organize, using what we know today to nudge humanity away from the black holes of despair toward the brightest stars in the constellation of future possibilities."

William Rees, *University of British Columbia*

"Janes is an unflinching truth teller who eschews pressures to make museums more like corporations and retains his brave, visionary, and practical view of museums. He explores how we can use these vital sites to grapple with the existential threats of the Anthropocene. *Museums and Societal Collapse* is challenging. But it also illuminates useful work in museums as a path forward."

Elena Gonzales, *Chicago History Museum*

"Why should museum practitioners care about societal collapse? And, why should readers aware of global survival-level crises like climate change care about museums? Humanity's rich cultural legacy is endangered by the converging predicaments of the 21st century, and it is largely up to museums to ensure that future generations have access to that legacy. Robert Janes lucidly and bravely explores how museums can aid cultural survival in a time of polycrisis."

Richard Heinberg, *Post Carbon Institute*

"All of Janes' books are milestones in thinking about the museum, its role, and its evolution. *Museums and Societal Collapse* addresses for the first time, abruptly, a topic related to the possible vanishing of our civilization. Global warming, resource depletion, increasing inequalities and conflicts provide the breeding ground for a radical world's metamorphosis. The role that museums can play in mitigating the effects of these transformations is at the heart of the author's concerns: a book that must be read."

François Mairesse, *Université Sorbonne nouvelle*

"Robert R. Janes has been challenging museums – and their workers – for decades to improve their internal cultures in order to better serve communities. *Museums and Societal Collapse* expands Janes's scope and challenge to what role museums must play in a world whose accelerating collapse may render museums obsolete. Museum workers who are ready to serve communities in regenerating civil society, and to move past hope to action, must read this book."

Robert J. Weisberg, *The Metropolitan Museum of Art, and creator of the* Museum Human *blog*

"'I feel obligated to write this book' writes Robert Janes – and it is one for which there is absolute need. Multiple crises are converging and just as museums have not faced up to 'climate grief', and 'societal breakdown', neither has the museum literature. Janes challenges the 'immorality of inaction' in museums, while weaving in personal experience and reflection. He challenges all of us in museums to examine our personal values and those of our institutions. This is a very necessary and urgent wake-up call by a globally respected museum leader and elder."

Bernadette Lynch, *Founder of the Solidarity in Action Network, museum practitioner and scholar*

MUSEUMS AND SOCIETAL COLLAPSE

Museums and Societal Collapse explores the implications of societal collapse from a multidisciplinary perspective and considers the potential museums have to contribute to the reimagining and transitioning of a new society with the threat of collapse.

Arguing that societal collapse is underway, but that total collapse is not inevitable, Janes maintains that museums are well-positioned to mitigate and adapt to the disruptions of societal collapse. As institutions of the commons, belonging to and affecting the public at large, he contends that museums are both responsible and capable of contributing to the durability and well-being of individuals, families, and communities, and enhancing societal resilience in the face of critical issues confronting our species. Within the pages of this groundbreaking book, Janes demonstrates how museums and their staff, as key civic resources with ethical responsibilities, can examine the meaning and value of their work, how that work is organized and managed, and to what end. This is a call to action, demonstrating how museums can move the conversation about collapse into society at large.

Museums and Societal Collapse will be essential reading for museum professionals working in museums and galleries, as well as for cultural and civil society organizations around the world. It will also be an essential reading for academics and students of Museum and Heritage Studies, Gallery Studies, Heritage Management, and Arts Management.

Robert R. Janes is an independent scholar/practitioner; editor-in-chief emeritus of the journal *Museum Management and Curatorship*; a visiting research fellow at the School of Museum Studies at the University of Leicester, UK, and the founder of the Coalition of Museums for Climate Justice. His museum publications have been translated into ten languages. He lives in Canmore, Alberta, Canada.

Also by Robert R. Janes

Looking Reality in the Eye
Museums and Social Responsibility
with Gerald T. Conaty

Museum Management and Marketing
with Richard Sandell

Museums in a Troubled World
Renewal, Irrelevance or Collapse?

Museums and the Paradox of Change
(Third Edition)

Museums without Borders
Selected Writings of Robert R. Janes

Museum Activism
with Richard Sandell

MUSEUMS AND SOCIETAL COLLAPSE

The Museum as Lifeboat

Robert R. Janes

LONDON AND NEW YORK

Designed cover image: Image by Robert R. Janes

First published 2024
by Routledge
4 Park Square, Milton Park, Abingdon, Oxon, OX14 4RN

and by Routledge
605 Third Avenue, New York, NY 10158

Routledge is an imprint of the Taylor & Francis Group, an informa business

© 2024 Robert R. Janes

Foreword © Ronald Wright 2024

The right of Robert R. Janes to be identified as author of this work has been asserted in accordance with sections 77 and 78 of the Copyright, Designs and Patents Act 1988.

All rights reserved. No part of this book may be reprinted or reproduced or utilised in any form or by any electronic, mechanical, or other means, now known or hereafter invented, including photocopying and recording, or in any information storage or retrieval system, without permission in writing from the publishers.

Trademark notice: Product or corporate names may be trademarks or registered trademarks, and are used only for identification and explanation without intent to infringe.

British Library Cataloguing-in-Publication Data
A catalogue record for this book is available from the British Library

ISBN: 978-1-032-38226-5 (hbk)
ISBN: 978-1-032-38224-1 (pbk)
ISBN: 978-1-003-34407-0 (ebk)

DOI: 10.4324/9781003344070

Typeset in Times New Roman
by Apex CoVantage, LLC

To Priscilla, Sula, Kiran, Cora, Otto, Peter B., Erica and Geoff, Lyn and Heather, Peter C. and Patti, Janet, Patty, and Barry – May you be well, happy, and peaceful.

CONTENTS

List of Figures	*xi*
Foreword	*xii*
Ronald Wright	
Acknowledgements	*xv*

 Introduction 1

1 Harbingers of collapse 9
Civilizational overshoot 10
Ecological overshoot 13
Climate trauma 15
Political incompetence and corporate deceit 18
Blundering hubris – ecomodernism 21
The madness of humanity 22

2 The anatomy of collapse 28
Global scenarios 29
The five stages of societal collapse 32
The truth hurts 35

3 The myth of sustainability 40
Curse of the baby boomers 41
Energy blindness 42
Clean technology? 43
Child servitude 45

The UN's unsustainable development goals 46
Comfort or contraction? 48
Beyond green 52

4 Why museums? 55
 Civil society and social capital 56
 Branding adaptation 58
 The ethical obligations of museums 59
 Fragmentation is good and bad 69
 A new narrative 74

5 The museum as lifeboat 77
 Adaptation or a litany of sorrows? 80
 The four questions 81
 Hopeless but not helpless 119

6 Afterthoughts 121
 Needed: new institutions 121
 Hospicing museums: an alternative 124
 The small picture 125
 The big picture 127
 Calling all museum people 129

7 Coda 131
 Indivisible benefits 132
 Who will steward the future? 133

References *138*
Index *155*

FIGURES

Cover: Abandoned truck in the Coastal Temperate Rainforest.

1.1 The urban heartland. Patrons enjoy restaurant dining below a massive bridge in Vancouver, British Columbia, Canada. 12

2.1 A community-supported agriculture (CSA) food box of fruits and vegetables. CSA is a system of growing and distributing organic produce that restores the direct link between farmers and their surrounding communities – eliminating the middleman. 33

2.2 A multi-generational family hiking high in the Canadian Rockies. Families will be the key as society adapts to an unknown future. 34

3.1 Solar panels on a residential dwelling. Renewable technologies are only a partial solution to society's burgeoning energy needs. 44

3.2 A mountain bike converted to a motor bike with a small gasoline engine – low budget and low carbon transportation. All of the society's transportation needs and desires require rethinking. 52

4.1 A buck mule deer ruminates as the More-Than-Human World rapidly deteriorates. 76

5.1 The author's naming ceremony where he received a traditional Blackfoot name in 1995. Kainai First Nation (Blood Tribe), Alberta, Canada. 109

5.2 The late Rosa Bernarde and the late Alice Bernarde smoke a moose hide at the K'á lot'ine Dene hunting camp in Canada's Northwest Territories. 114

6.1 Back to the land – this homestead begins with the construction of a tiny home. Note the membrane in preparation for a green or living roof. 128

7.1 Plaque on a forest trail in Haida Gwaii, Canada. This Indigenous perspective is a radical departure from conventional park signage. 137

FOREWORD

Museums are the keepers of deep time. Many hold evidence from former human worlds, fossils and artifacts that tell the story of our kind. Those dealing with natural history give the much deeper and broader narrative of most living things on Earth. Life has unfolded over more than three billion years, and our genus *Homo* arose about three million years ago: one-thousandth of the whole. Some museums dwell only on recent parts of our story, whether art, machinery, or local history. But what all museums have in common is the perspective they bring to the cutting edge of time, the ever-shifting present.

Robert Janes has had an outstanding career as museum director, museologist, archaeologist, and ethnographer. He is also a wise and eloquent writer on these subjects, with books and articles published worldwide in ten languages. His work has always been guided by a strong awareness of the cultural and ethical problems within the museum field, especially collections gathered through questionable means during the conquests and colonizations of the last 500 years. He is perhaps best known for his repatriation of Indigenous artifacts by Calgary's Glenbow Museum to the Blackfoot Confederacy in the 1990s – among the first and largest initiatives of this kind in North America.

As head of the Glenbow from 1989 to 2000, Robert Janes exemplified Neil Postman's dictum: "A good museum always will direct attention to what is difficult and even painful to contemplate." Under his leadership the Glenbow not only returned many holy objects to the Blackfoot people but also built a lasting partnership with the Blackfoot Confederacy in which exhibitions, cultural knowledge, and expertise were widely shared.

Repatriation is still a fraught issue for museums everywhere: witness the British Museum's Parthenon Marbles or the Peabody's finds from Machu Picchu.

I've known Robert (Bob) Janes for more than 50 years and worked with him on two occasions. In 1972, when we were both graduate students of archaeology at the University of Calgary, we took part in Professor Peter Shinnie's excavations at the ancient city of Meröe in Sudan. Bob showed a great capacity for hard work in harsh conditions, far from electricity and other comforts. As well as unearthing and studying artifacts, he developed an interest in the culture of the neighbouring villagers and desert nomads whose ways of life flowed from ancient traditions.

The thoroughness and creativity Bob brought to this work in Sudan blossomed in Canada's Northwest Territories (NWT), where he carried out digs and surveys along the Mackenzie Valley, heartland of the Dene Nation. To interpret finds and settlement patterns, Bob sought the help of the Dene themselves. Although undergoing a time of heavy Euro-Canadian impact – mining, oil and gas extraction, a proposed pipeline – many Dene kept to traditional ways and could understand and explain traces from the past that would otherwise have baffled outsiders. The Dene were generous with their knowledge, and Bob was able to deepen his understanding by accompanying hunting, trapping, and fishing families for whole seasons on the land. His wife Priscilla also took part in this work, adding insight on women's knowledge and perspectives within Dene culture. At that time, few archaeologists anywhere had considered such collaborations, let alone put them into practice.

Robert Janes was thus uniquely qualified to become the founding director of the new Yellowknife museum and archive being planned by the Northwest Territories government. He accepted this post at an early stage and had the building up and running by 1979, when it was named the Prince of Wales Northern Heritage Centre and opened by Prince (now King) Charles.

The second time Bob and I worked together was in 1982. I'd recently come back from the Peruvian Andes, where I'd been recording Quechua music and songs to help preserve them. Bob said, "We should do the same thing here in NWT." He then asked me to write a proposal, and had his staff set up the Dene Music Project, culminating with an invitation from Grand Chief Joe Migwi to record the New Year ceremony and Drum Dance at Behchoko (Fort Rae). Housed at the museum, the tapes are available to researchers, especially new generations of Dene musicians. A selection from the recordings has also been released on compact disc with help from the CBC.

Robert Janes's writings have reached a wide readership within the museum world and beyond it. He has the rare gift of being able to combine scholarly rigour with an outspoken and eloquent voice and to range with ease from hands-on practicalities to profound cultural, political, and moral problems. At the heart of all his work is a deep concern with the relationship of museums to society, to other societies of past and present, and to the natural world as a whole.

The human career can be summed up in three stages: three million years of hunting and gathering; 10,000 years of farming; and 200 years of runaway industrialization. Our numbers have grown in step with the hastening pace and impact

of technology: only a few million people in the world before the start of farming; one billion by the start of heavy industry in the 1820s; eight billion today. Everyone now over seventy has seen humankind triple in one lifetime. Anyone over fifty has seen wildlife populations crash by two-thirds. How can this end well? What world are we making, and why?

In *Museums and Societal Collapse*, Janes turns his gaze to these questions and our immediate future. "Our current systems," he argues, "be they political, financial, commercial or industrial, are now obsolete as a result of the damage they have inflicted on the world's ecosystems." Unless there is a radical pulling back from the brink – far swifter and deeper than anything yet attempted by the leadership of most countries and corporations – industrial civilization is likely to collapse in chaos, leaving a pillaged, poisoned world.

Museums, Robert Janes insists in this new book, can no longer be merely keepers of the past. They must step up and help society deal with the mounting crisis. Their knowledge of the human record can help us reshape beliefs that have become at best outworn or mistaken, and at worst suicidal: above all the myths of endless growth and material progress on an Earth already crumbling under the load of our demands.

<div style="text-align: right;">Ronald Wright</div>

Ronald Wright's ten books include *A Short History of Progress* and *Stolen Continents*. ronaldwright.com

ACKNOWLEDGEMENTS

I am deeply indebted to Ronald Wright, not only for his generous foreword but also for reviewing the manuscript and providing invaluable editorial guidance. His friendship and collegiality are gifts. I also want to thank a group of non-museum colleagues with whom I meet regularly to reflect and learn. Each of them is amazingly well-read and thoughtful, and together they have served as the best research team one could imagine. Thanks to Ruben Nelson, Robert Sandford, and Dale Stanway. I especially want to thank Bart Robinson for his ongoing support and guidance.

As a prelude to this book, I published an article in *Curator, The Museum Journal* and I wish to thank my colleagues Naomi Grattan, John Fraser, Emlyn Koster, Dominic O'Key, Michael Robinson, and Richard Sandell for their invaluable comments on various drafts of that article. I am also most grateful for the time and effort of those who provided endorsements for this book and I thank Elena Gonzales, Richard Heinberg, Bernadette Lynch, François Mairesse, William Rees, and Robert Weisberg.

I also thank my colleagues and friends who provided knowledge, experience, assistance, and moral support throughout the preparation of this book, including Gail Anderson, Lorraine Bell, Jessica Burylo, Jem Bendell, Américo Castilla, Kevin Coffee, Julie Decker, Victoria Dickenson, Beka Economopoulos, Haitham Eid, John Fraser, Charis Gullickson, Alexandra Hatcher, Robin Inglis, Sharilyn Ingram, Christine Iversen, Hilary Jennings, Emlyn Koster, Bridget McKenzie, Bernice Murphy, Lyndal Osborne, Lindsay Sharp, Martin Segger, Claude Schryer, Caitlin Southwick, Martina Tanga, Alison Tickell, and Ron Ulrich. I especially thank Bernadette Lynch for her steadfast interest and support of my work. I also wish to thank the Advisory Group for the Coalition of Museums for Climate Justice – Jennifer Carter, Vivian Gosselin, David Jensen, and Marie-Claude Mongeon – all steadfast advocates for a better world.

I thank Michael Ames, Bill Barkley, Gerald Conaty, Joanne DiCosimo, Elaine Gurian, Jose Kusugak, Allan Pard, Gerry Potts, Rene Rivard, Richard Sandell, Barbara Tyler, Stephen Weil, and Frank Weasel Head – museum elders, living and deceased, for the guidance and wisdom they have given me throughout the years. Their minds and spirits are ever-present.

I am grateful to my editor at Routledge, Heidi Lowther, for her ongoing support of my work and her ability to manage so cordially the endless details of publishing. I also thank Emmie Shand, Marc Stratton, Manas Roy, and Jasti Bhavya for their advice and assistance on editorial matters.

George Orwell (*Why I Write*, 1946) wrote that one would never undertake writing a book if one were not driven by some demon whom one can neither resist nor understand. I have encountered this demon but it has done little harm because of my spouse, Priscilla. She navigates all aspects of the writing process, from the vexing work of formatting references, to supplying photographs, to discussions about values, purpose, and intent. I am thankful for her unwavering counsel and assistance that have enabled me to continue to write and reflect, despite the occasional appearance of the demon.

INTRODUCTION

As the former CEO of one of Canada's ten largest museums (Glenbow Museum, Gallery, Library and Archives – 1989–2000), I oversaw a radical and painful organizational renewal in the early 1990s to confront a deep reduction in public funding – a recurring crisis in the museum world (Janes 2013). This work required an enormous investment of time, energy, and emotion in order to rethink the museum; it even resulted in a death threat from a staff member provoked by the organizational turmoil. No charges were laid, as I understood the distress that caused this incident. As the complexities of deep, organizational transformation increased in intensity and scope, a persistent question haunted me – "to what end?" I concluded that collections, exhibitions, education, and entertainment were no longer adequate reasons to justify a commitment to radical organizational change, with all of the unavoidable disruption, emotional pain, and monetary costs. I realized that these traditional museum activities were, in fact, not the end in themselves, but rather the means to the end. In short, what was the *end* and *why* were we doing what we were doing – a question that remains mostly unanswered by the world's museums? I refer the readers to the detailed account of how this story of change transpired (Janes 2013).

I have built, directed, managed, and changed museums and despite organizational failures, hazards, and the burden of stultifying museum traditions, I remain firmly convinced of the museum's value as a multifaceted force for good. I also believe that it is entirely possible for a competent museum to prepare itself and assist its community in addressing the real and potential consequences of societal collapse. Irrespective of my admittedly idealistic view of museums, I am less sanguine about the future of the world's 95,000 museums. Although they have many attributes with which to strengthen societal resilience and adaptation, these potential contributions are absent or constrained by unchallenged beliefs and practices.

More alarming is that far too many museums are unaware of their looming vulnerability in a time of increasing chaos and complexity.

The issues and challenges confronting museums have changed dramatically over the past 50 years, as they have for society as a whole (Janes 2016: 185–190). The erosion of public funding has been the overarching concern for Canadian museums since the1980s, for example, as it has been for many of the world's museums. This, in turn, has led to a preoccupation with earned revenues, visitor numbers, high-profile exhibitions, and burgeoning marketing departments, all with an emphasis on consumerism – be it restaurant meals, cruise ship packages, or exhibition bric-a-brac. I explored and lamented this unthoughtful and dangerous preoccupation with consumer culture, and its proliferation, in *Museums and a Troubled World* (Janes 2009a).

As a scholar/practitioner for much of my career, I have consistently questioned the conventional wisdom of mainstream museum practice (Janes 2016). I have made every effort to do this constructively, and with a degree of candour and self-reflection. Every discipline and profession needs internal critics – those with sufficient knowledge and grounding in the work to be able to assess and question the many assumptions, beliefs, and habitual practices that dog all of human activities. Marjorie Schwarzer, the American museum educator and author, noted that "Janes' stock-in-trade in his long and varied museum career has been upending the field's sacred cows and entrenched practices with that rare combination of persistence, rigor, courage and elegance" (in Janes 2016: back cover). Although "critic" and "activist" describe my perspective in this book, one of my colleagues prefers to see me as a "guide" for some of the difficult and intractable challenges of museum work (Darren Peacock, personal communication, 9 March 2015).

Moral considerations are also part of my museum work and my writing, although there has never been much interest in the museum community to shoulder such weighty matters – to say nothing of societal collapse. The threat of societal collapse is absent in the museum literature, despite my having introduced the topic in two books, as well in a recent journal article (Janes 2009a, 2022; Janes and Sandell 2019). Social ecology is an integral and moral dimension of the collapse and the crisis we face – that social and environmental issues are intertwined, and both must be considered simultaneously. Social ecology has never lost its meaning and is now more relevant than ever before. Our collective failure to honour this relationship lies at the core of our failure as a species. It befits all museums, irrespective of their disciplinary focus and loyalties, to bridge the divide between nature and culture in all that they do. The need for this holistic and systemic thinking is a recurring theme throughout this book.

Those readers who are familiar with my work will note themes, ideas, and references throughout this book that have appeared and reappeared throughout all of my work and writing – including social ecology, Indigenous voices, repatriation, decolonization, organizational design, work design, change management, the blight of corporatism, the tyranny of the marketplace, social responsibility, ethics,

and activism. These topics are both signposts and way stations in my effort to understand museums, a journey whose destination remains elusive. My writing is about lifelong learning and thus is cumulative and iterative (perhaps too repetitive for some readers) and includes the topics mentioned earlier and many more. These themes, concerns, and inquiries have come to resemble a pattern in my life and work – joined, interwoven, and ultimately seamless. This book is the culmination of my understanding of these interrelationships, grounded in an attempt to deepen my understanding of the museum profession and the role it might play in the cataclysm we now face. I am conscious of the many references to my previous work in this book and note that ethical publishing requires that I cite all those I have used.

Although I am no longer a museum practitioner, I have retained my commitment to scholarship and still firmly believe that the scholar/practitioner is essential to the strength and relevance of museum practice. Theory must be informed by the reality of the museum workplace and, in turn, method must be informed by the curiosity, discipline, and reflection that constitute scholarship. To allow the divide between these two mindsets to persist is to impair the very fibre of museums as knowledge-based institutions, yet these two solitudes persist.

Museums are now enmeshed in new technology and the digital world, driven by a constant obsession to enhance popularity and maintain the appearance of relevance. This is not new, as the notion of a panacea to solve deep and unacknowledged structural problems is a constant temptation and defect in museum governance and management. Digitization, virtual reality, and social media are the latest silver bullets on offer to heal the museum and establish its worth. Acknowledged or not, the pressures on all museums now reach far beyond money, popularity, and digital technology, however, to include the recognition of societal needs, issues, and conflicts – ranging from climate trauma, to social justice, and to the erosion of democracy. Furthermore, the threat of societal collapse is now acknowledged in mainstream society and can no longer be dismissed as a fringe fixation.

The purpose of this book is to introduce the museum community to the threat of societal collapse by initiating a frank and constructive conversation about the perils of such a future, as well as the roles and responsibilities of museums. There is a critical need to rethink museum visions, missions, and values in light of societal collapse. I will also examine the inherent strengths that empower museums to undertake this work, as well as the structural problems which hinder or prevent them from doing so. The ongoing COVID-19 pandemic offers an opportunity to embrace what we know and don't know, and to incorporate collapsology into contemporary museum thinking. Collapsology refers to civilizational collapse and is focused on contemporary, industrial, and globalized society (Servigne and Stevens 2020). In the absence of any conversation about societal collapse in the museum sector, it is imperative to catalyze both reflection and action. My approach is intended to be constructive, by acknowledging both the challenges and the opportunities. It has been said that if you want to learn something new, write a book.

John Michael Greer, historian and author, offers a fitting description of the human predicament, which frames this book:

Most ordinary people in the industrial world . . . are sleepwalking through one of history's great transitions. The issues that concern them are still defined entirely by the calculus of abundance. . . . It has not yet entered their darkest dreams that they need to worry about access to such basic necessities as food, clothing and shelter, the fate of local economies and communities shredded by decades of malign neglect, or the rise of serious threats to the survival of constitutional government and the rule of law.

(Greer 2011: 239)

Societal collapse may well be underway (Bendell 2018, 2019, 2020b; Ehrlich and Ehrlich 2013; Klein 2020; McKibben 2019; Nelson 2020; Orlov 2013; Rees and Nelson 2020; Safina 2021; Servigne and Stevens 2020; White 1967). The indicators include untenable economic inequality; the spread of authoritarian governments; the collapse of biodiversity; an economic system dependent on growth, consumption, and debt, and the failure of government institutions to respond to these crises. In addition, we must also contend with the manner in which "advanced" human societies respond to challenges – they respond to complexity by creating even more complexity (Tainter 1988: *passim*). This may work in the short term but eventually leads to both the worsening of the crises and the lessening of capacity to deal with the long-term consequences. For individuals, families, and communities, collapse refers to "the ending of our current means of sustenance, shelter, security, pleasure, identity and meaning" (Bendell and Carr 2019).

This book explores the meaning and implications of societal collapse for museums from a multidisciplinary perspective, including an examination of the potential of museums to contribute to the reimagining and transitioning of a new society in the face of collapse. Museums are well-positioned to mitigate and adapt to the disruptions of societal collapse as a result of various inherent strengths (Janes 2009a: 178–182; Sandell 2007; Stanish 2008; Watson 2007; Weil 1999). They are grounded in their communities and are expressions of locality; they bear witness by assembling evidence and knowledge and making things known; they are seed banks of sustainable living practices that have guided our species for millennia; and they are skilled at making learning accessible and engaging. Most importantly, museums can serve as a bridge between nature and culture, as well as between the sciences and the humanities.

These qualities are not fully operational at this time, however, hampered as they are by various internal challenges peculiar to museums, ranging from inadequate and outdated missions, to obsolete leadership models, to rigid organizational designs and work patterns. These and other structural deficiencies will be examined, with recommendations for alternate approaches to museum practice – unbound by tradition and unquestioned assumptions. As well as addressing the structural challenges

noted earlier, these alternate approaches to working differently also include reforming museum leadership and governance, nurturing personal agency, acknowledging that museums have ethical obligations, and challenging the persistent claim of institutional neutrality.

Total collapse is not inevitable. Museums and their staff, as key civic resources with ethical responsibilities, must now examine the meaning and value of their work, how that work is organized and managed, and to what end. As institutions of the commons, belonging to and affecting the public at large, museums are both responsible and capable of enhancing societal well-being and the durability of human and natural communities (Berry 2001: 134). I will refer to Nature in the broad sense as the More-Than-Human World, by which I mean the living beings and non-living things that make up the biosphere, including animals, plants, water, air, earth, and rocks. Museums are civic and intellectual resources that are accountable to both the human and non-human worlds, and this book is a call to action. It is also a call to grow up, show up, step up, and face up to a planetary mess that is devastatingly more challenging than what we are generally willing to concede or believe. Museums, in a metaphorical sense, can well serve as lifeboats for their communities as the threat of collapse deepens, and I acknowledge William Rees, the human ecologist, for inspiring me to think of museums in this way. More on what this means in Chapter 5.

Grappling with the implications of collapse means "enlarging the context of our work" and "increasing the number of considerations we allow to bear upon it" (Berry 2001: 84). Addressing the questions of *to what end and why* lies at the heart of this book, and this requires that museums enlarge the context of their work to include an acute sense of their civic responsibilities. As deeply trusted, social institutions in civil society, museums are essential in fostering public support for decisive action to address a litany of threats, ranging from climate chaos, to habitat destruction, to the loss of biodiversity, to decolonization. There are obvious and unseen opportunities that reveal the museum's unique role and potential in stewarding a more intelligent, altruistic, and conscious future for themselves and their communities. This book is concerned with stewarding the germ of that awareness in the museum community, however limited that consciousness may be at this time.

The ability of museums to link both nature and culture in their work, whether or not they are natural history, art, history, or science museums, is an unheralded and ignored gift for museums. Citizens are crying out for enlightened leadership from public institutions to address the issues that are relevant to their lives, to their civic responsibilities, and to their place in the biosphere – in a manner that overcomes political ideology, ineptness, and corporate malfeasance. Museums of all kinds are untapped and untested sources of ideas, knowledge, and memory and are uniquely placed to foster individual and community participation in the quest for greater awareness and intelligent adaptation to global crises. The problems we now face transcend all other considerations whether or not societal collapse has arrived or is unfolding.

I recall giving the 2014 Canadian Museums Association Fellows Lecture, wherein I received a standing ovation (Janes 2014b). This response came as a complete surprise, as I had suggested that the museum community was sleepwalking into the future. I posed several questions for consideration. First, why do we believe that museums may abstain from addressing societal needs and aspirations and be absolved of greater accountability, especially at this time of extraordinary societal upheaval? Second, what is your museum's higher calling – meaning the public value you wish to contribute to your community and the world? Third, when you think about your own museum, where does it sit on the continuum from internally focused to externally mindful? I concluded my presentation by urging that the meaning and purpose of museums were in need of urgent redefinition, based on deep listening to the issues and challenges that confront our world. My words could hardly be considered an outpouring of admiration for contemporary museum practice, as these questions were meant to provoke the prevailing complacency.

A senior art museum director (and also a board member of the Canadian Museums Association) arose to advise the assembly that I fretted too much and that all was "under control." As I stood at the podium, I realized that this self-affirming view of the museum sector's leadership was all too familiar. I hear this same refrain repeatedly from museum directors, CEOs, and museum managers worldwide – "Don't worry; we have it under control; everything is okay." This is not true and never has been. Although I deliver a much more ominous message in this book than I did in that keynote address, I am not interested in what readers remember about what they read here. Rather, I am interested in what they *think* about what they read in this book, and whether or not these thoughts will lead to a heightened sense of responsibility and action. There is a universe of difference between awareness, preparation, and action. This book is a call for both preparation and action, as awareness is only that.

In concluding this Introduction, I note that my use of the word "museum" is inclusive, and includes all types of museums, galleries, and heritage sites, as well as zoos and aquaria, where appropriate. This book is not a guidebook of solutions for any of these organizations. It is, however, a call for concern and reflection on what is possible which, in turn, may result in a commitment to action. The implications of climate change and its consequences have been known for well over a century, and yet the majority of the world's museums have failed to commit to addressing this issue. Collapse is an acutely more difficult and dangerous subject than the climate crisis, and there is no such book in the museum literature. This means that you, the readers, need not be constrained by the limitations of traditional museum thought and practice. You may ponder, speculate, rise to anger, and grieve, as well as seek peace and reconciliation with the challenges we face.

This book is holistic and multidisciplinary. I draw on museology, archaeology, anthropology, ethnography, ecology, climate science, management, and humanism, in addition to my 45 years of work experience in the museum field, to implore museums to take a stand on critical issues and make a difference in the well-being

of their communities. I have also made every attempt to ensure that this book is constructive in intent and in content. This book contains many pragmatic suggestions and opportunities, as it is insufficient to be a critic only. Yet the readers must bear with me when I can no longer contain my impatience or annoyance, and thus lapse into critiques that might well be considered inappropriate by those who are content with the *status quo* or who are disturbed by critical thinking. Various parts of this book were reviewed by colleagues to ensure that any tone deafness on my part was at least identified. I assume all responsibility for whatever insensitivity remains.

Last, this book is forthright and, I hope, empathetic, embodying an autoethnographic perspective. Autoethnography is a form of qualitative research in which an author uses self-reflection and writing to explore anecdotal and personal experience, and then connect this autobiographical story to wider cultural, political, social meanings, and understandings (Adams et al. 2015). In doing so, I must inevitably challenge the immorality of inaction as I have spent my career doing. I continue to do so in this book in an effort to reveal the untapped potential of museums as forces for good at this critical time. I use a qualitative research methodology based on a combination of primary and secondary research. The primary research includes my time living and working with the Dene and Inuit in northern Canada; my work with the Blackfoot Confederacy in Alberta, Canada; and my role as a co-owner of a permaculture farm, nursery, and orchard, as well as my 45 years' experience in the museum field as a director, chief curator, consultant, author, editor, archaeologist, board member, teacher, volunteer, philanthropist, and scholar/practitioner. I wish to normalize the conversation about collapse so that we may approach it with intelligence and compassion. Experience has taught me that certainty is the enemy of truth, so this book is necessarily fraught with uncertainty and vulnerability,

In thinking about the uncertain future of museums in a world beset by unprecedented challenges, it is clear that hope is an essential ingredient in any successful outcome for museums, and yet it is insufficient on its own. Holding on to hope can rob one of the present moment and divert attention from what needs to be done (Steinberg 2008: 136). My interest is in hope, intention, and action rather than in hoping that the challenges will resolve themselves (Janes 2014a: 408). This combination of hope and intention has been called active hope and it has been defined as a practice – it is something we do rather than have (Macy and Johnstone 2012: 3). In short, "we choose what we aim to bring about, act for, or express."

There is no question that we are living through the intensification of global climate trauma, casting the shadow of collapse. The underlying premise of this book is that each of us has something valuable to offer. There is no correct approach. We cannot stop global warning but we can confront the threat of collapse. We can come together and share our confusion, our uncertainty, and our sense of what we can do. I also know that I must share my grief, pain, and anger over what has come to be, and you will observe these sentiments throughout this book. There are many reasons to assume that we will do nothing to prepare for a frightening future,

accustomed as we are as a species to only respond when it is too late. I do not share this view, and I believe that much is possible if we acknowledge the reality we are living in and attempt to do the best we can. Can and will museums and museum workers operate with this deeper sense of purpose? To do so, we must acknowledge the enormity of the catastrophe we have created and assume responsibility for our actions.

1
HARBINGERS OF COLLAPSE

In my book, *Museums in a Troubled World* (Janes 2009a: 28–29), I drew on the work of Thomas Homer-Dixon (2006: 11–12), who identified various global pressures that he called the "five tectonic stresses that are accumulating deep underneath the surface of our societies." He organized them into five broad categories:

1. Population stress arising from differences in the population growth rates between rich and poor societies and from the spiraling growth of mega-cities in poor countries.
2. Energy stress, above all, from the increasing scarcity of conventional oil.
3. Environmental stress from worsening damage to our land, water, forests, and fisheries.
4. Climate stress from changes in the makeup of our atmosphere.
5. Economic stress resulting from instabilities in the global economic system and ever-widening income gaps between the rich and the poor.

These stressors have continued to evolve and expand in their complexity and their impact and are now confronting global society with a vengeance not imagined 17 years ago. At least not imagined by the policymakers and lawmakers who could have implemented remedial actions before they became the global polycrisis they now are. A global polycrisis "occurs when crises in multiple global systems become causally entangled in ways that significantly degrade humanity's prospects. These interacting crises produce harms greater than the sum of those the crises would produce in isolation" (Lawrence et al. 2022).

More recently, ten specific stressors, or "mega-risks," have been identified that amplify and compound the listing above. They are all interconnected and have been called, in a rather understated way, an existential emergency for humanity

DOI: 10.4324/9781003344070-2

(Cribb 2022). They include the Sixth Mass Extinction, resource scarcity, the threat of nuclear war, climate change (to 5° C), global poisoning, food system failure, pandemic diseases, uncontrollable technologies (including artificial intelligence), overpopulation and mega-city collapse, and false beliefs and delusions.

There are now so many scientific, political, economic, and spiritual publications, podcasts, websites, and videos devoted to these stressors that many books would be required for a comprehensive review. I have adopted a more synthetic approach in this chapter by subsuming many of these stressors under six categories. I will examine the key threats presaging collapse, with enough detail to confirm their meaning and consequences. I want to set the stage for the later discussion on opportunities for action.

Civilizational overshoot

Civilizational overshoot is rooted in modern techno-industrial (MTI) society, and when I use the word "civilization," I am referring to all of humanity. Our species has moved through a trajectory of small hunting and gathering cultures, to settled agricultural communities, to empires, and now to MTI and MTI empires (Nelson 2020). Although oversimplified, this evolutionary sequence is more than adequate for my purposes here. I must note, however, that this framework has recently been evaluated and challenged (Graeber and Wengrow 2021). Although a detailed examination is beyond the scope of this book, I want to acknowledge this new research on the history of humanity, as it is both profound and disturbing. Allow me to briefly digress. In a book nearly 700 pages long, Graeber and Wengrow investigate in great detail the prevailing assumption that the MTI culture constitutes the epitome of human development. They relentlessly demonstrate that there are other ways of knowing that so-called developed cultures in the Western world have systematically destroyed or ignored. They challenge our most fundamental assumptions about social evolution – from the development of agriculture and cities to the emergence of the state, political violence, and social inequality. Here is a glimpse of their refreshing critique:

> Anthropologists . . . tend to be well aware that even those who make their living hunting elephants or gathering lotus buds are just as sceptical, imaginative, thoughtful and capable of critical analysis as those who make their living by operating tractors, managing restaurants or chairing university departments.
> *(Graeber and Wengrow 2021: 96)*

As this book also has revolutionary implications for museums and how they present the story of humankind, it should be a mandatory reading for the entire museum community. Back to the task at hand.

Although it is impossible to separate civilizational overshoot from ecological overshoot (to be discussed shortly), it is the former that has given rise to the latter. Modernity is the godfather of the MTI culture, and it is necessary to highlight

some of the more grievous liabilities and costs of both modernity and its offspring, MTI (Andreotti 2020). These include the following:

- Unsustainable economic growth
- Overconsumption of everything
- Expropriation
- Waste accumulation and disposal
- Dispossession
- Genocide
- Destitution
- Violence and warfare

Although one is entitled to feel stunned at how all these stressors have now converged, this can be explained. The framework that nurtures and supports these pathologies consists of both the modern nation state (that protects capital and property over people) and the concept of universal reason – that is, we can control reality and any other ways of knowing are disallowed or discouraged (Andreotti 2020). Nature, within an MTI mindset, is a property to be managed and used – a belief underpinned by shareholder capitalism based on profit. MTI is grounded in this notion of human exceptionalism, whereby humankind has dominion over the earth, ethical and moral considerations are excluded, while boundless technological progress is assumed. We, as a species, fail to realize that "we live in a socially constructed reality consisting of myths, paradigms, ideologies and received wisdom" – some of which are good, while many others are destructive with no relationship to what is actually unfolding in the world (Rees 2020). This lack of collective consciousness may well be the most dangerous threat of all.

The result is a world ruled by maladaptive economic behaviour in support of the MTI society and its devotion to humanity's natural expansionist tendencies. This is the "progress trap" as described by Ronald Wright (2004: 5, 31–32, 40) in his seminal book *A Short History of Progress*. Human societies have repeated the same pattern of overconsumption, unchecked growth, and collapse ever since prehistoric times (e.g., overkilling big game worldwide). Wright notes that the scale and speed of this unintended "self-harm" grow in lock-step with evolving tools and technology. This is reinforced by growth-oriented, neoliberal economic theory that is completely devoid of any ecological considerations. This is only one aspect of neoliberalism that is maladaptive, as this ideology also includes obedience to the rule of the marketplace, cutting public funding for social services, deregulating laws that could diminish profits, privatizing public services, and replacing the concept of the public good and community with the tyranny of the marketplace (CorpWatch 2021). It is shocking to consider how unsuitable and dangerous this prevailing ideology is as the potential for societal collapse intensifies.

To put it bluntly, MTI society is self-delusional, relying as it does, of course, on the human brain (Rees 2020). We continue to think in a linear, simplistic, and

reductionist manner, failing to understand the complexity we have created and to acknowledge that no one is in control of any aspect of our world. With our simple-minded focus on single problems, we ignore systems and relationships and thus are oblivious to the principle that the component parts of a system can best be understood in the context of their relationships with each other and with other systems, rather than in isolation (Wikipedia 2022c). Which brings us back to our failure to acknowledge complexity which, in turn, has now ensured that "the MTI way of life has no long-term future" (Nelson 2020). In short, modernity must now be "hospiced" (Andreotti 2021; Nelson 2020). We must salvage what is useful, learn from our mistakes, and find our way out of modernity and beyond by using wisdom (nothing is left out), honouring integration (keep the whole together – systems thinking), and being reflexive by questioning our questioning (Andreotti 2020, 2021).

The world's museums have yet to seriously confront the climate crisis, much less the threat of social and ecological collapse, and they are effectively absent in the wide-ranging initiatives to confront these challenges. As noted in the Introduction, this is understandable, recognizing that museums are mainstream institutions and thus embody the general consciousness and values of the public at large. The public, in turn, is "culture-bound," meaning that both individual and societal perspectives are restricted in outlook by belonging to a particular culture. This may be understandable, but it is no longer acceptable, as museums must now look beyond their role as mirrors of society; break the mirror called MTI society with its particular values and aspirations; and create a new, truthful, and potent narrative for their communities. Confronting civilizational overshoot is the first chapter in this awakening. Left unacknowledged and uncontrolled, our unrestrained hubris could spell the demise of our species as the signs of disintegration are already appearing.

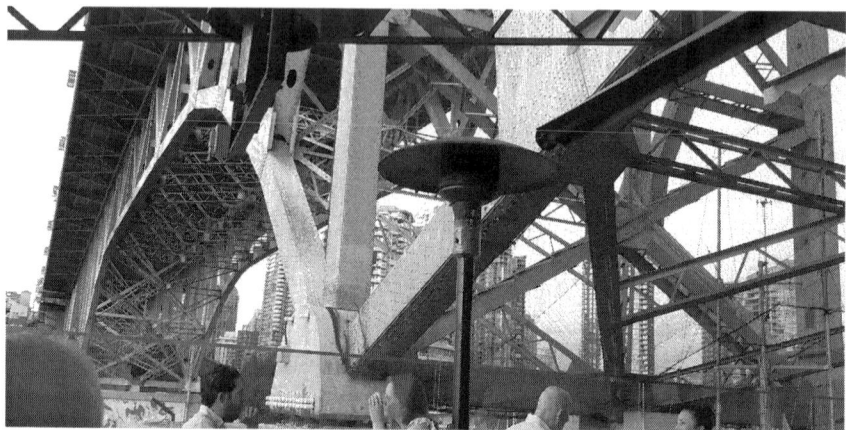

FIGURE 1.1 The urban heartland. Patrons enjoy restaurant dining below a massive bridge in Vancouver, British Columbia, Canada.

Source: Photograph courtesy of Priscilla B. Janes.

Ecological overshoot

Ecological overshoot is the unparalleled collateral damage resulting from civilizational overshoot. In short, humanity's demands on the natural ecosystems that support MTI society now exceed their regenerative capacity. Since the 1970s, humanity has been in ecological overshoot, with the annual demand on resources exceeding the Earth's biocapacity. Today, humanity uses the equivalent of 1.75 Earths to provide the resources we use and absorb the waste we produce. This means that it now takes the Earth one year and nine months to regenerate what we use in a year (Global Footprint Network 2022). Human beings expand to fill all habitats and use all of the resources, as do all species, and technology only makes this increasingly possible by redefining availability (Rees 2020).

This massive ecological overshoot is largely enabled by the increasing use of fossil fuels, driven by massive population growth and outlandish consumption. What follows are several indicators of the mounting catastrophe called ecological overshoot:

- The world is spending at least US$1.8 trillion every year on subsidies that destroy wildlife and increase global warming, prompting warnings that humanity is financing its own destruction. From tax breaks for beef production in the Amazon (destroying the forest for pastures) to financial support for unsustainable groundwater pumping in the Middle East, billions of dollars of public subsidies are destroying the environment (Greenfield 2022).
- The environmental crisis is rapidly accelerating, while society ignores or denies that a key driver is overpopulation. Reaching any sustainable future requires that we acknowledge and solve this issue. It is not "antihuman" to discuss this as it shows the deepest concern for future generations and the life they will lead. There are many humane and non-coercive strategies that the world can adopt to reduce the growing impact that population increase is creating (Kubanek 2022).
- There are two suicidal illusions. The first is economic – that technology and increased efficiency are enabling the human enterprise to "decouple" from nature. The second is political – that there is no conflict between the growth of the human economy and protection of the environment (Rees 2017). More on these illusions later – disguised as ecomodernism.
- High-income nations are responsible for 74% of the global excess material use, driven primarily by the United States (27%) and the European Union's 28 high-income countries (25%). China is responsible for 15% of global excess material use, and the rest of the Global South (the low-income and middle-income countries of Latin America and the Caribbean, Africa, the Middle East, and Asia) is responsible for only 8% (Hickel et al. 2022). These results demonstrate that high-income nations are the primary drivers of global ecological breakdown. They must urgently reduce their resource use to fair and sustainable levels by adopting transformative post-growth and de-growth approaches (Hickel et al. 2022: 342).

Richard Heinberg (2022c), a leading authority on sustainability and energy, reminds us just how staggering our consumption of natural resources is. He notes that each year we cut and use up to seven billion trees; we excavate 24 million metric tons of copper and nine billion short tons of coal and produce one billion tons of coffee. In order to mine resources and construct buildings and highways, we move up to 80 billion tons of soil and rock.

It is painfully clear that respect for natural systems must immediately become the foundation for economic policy (Rees 2020: 7). Political leaders, corporatists, economists, and civil society leaders (museums included) must now ask and answer a number of critical questions if we are to contend with ecological overshoot – questions that have yet to emerge in mainstream society. "The light bulb may appear over your head . . . but it may be a while before it actually goes on" (Conroy 1988: 70). We have no more time to wait for the light to go on, and the following questions articulated by Rees (2020: 7) will assist us, including the museum community, in becoming more informed and more accountable:

1. What weaknesses are inherent in existing environmental economics that facilitate ecosystem degradation and overshoot?
2. Can the damaged Planet sustainably support yet another two billion human beings plus a doubling of global warming and various forms of energy and material demands, as is expected by mid-century?
3. What eco-economic tools and policies might help maintain a satisfactory quality of life while implementing a planned contraction of Planet-depleting economic activities and populations?
4. What circumstances promote people's capacity for cooperation, community building and short-term sacrifice to achieve mutually beneficial future ends (e.g., survival)? This will be the subject of Chapters 5 and 6.
5. How can ecological economics identify efficient policies to regenerate key ecosystems and maintain essential life-support functions, including a predictably stable livable climate?

Judging by our current indifference to the well-being of the Planet, we apparently assume that our civilization will develop a viable combination of fossil fuels and renewable energy sources to maintain the collective addiction to perpetual growth and consumption. This, of course, is absurd as the renewable technologies (for batteries and solar panels alone) would require so much energy and materials that climate trauma would spin out of control, and the destruction of the natural would continue until all of the ecosystems finally perished (Rees 2020: 5). We cannot detach ourselves from the ecosphere nor can we bet the future on sustainable and renewable energy to meet our current needs and desires. Sustainability as currently understood is a myth, which will be examined in Chapter 3.

Climate trauma

I have chosen to abandon the words climate change, climate emergency, and climate crisis and, instead, refer to the present situation as climate trauma. Trauma is a more honest descriptor as deeply distressing experiences surround us daily and globally, be they wildfires, drought, extreme temperatures, food shortages, biodiversity loss, forest destruction, freshwater scarcity, air toxification, and ever-increasing climate refugees. The trauma list goes on and all of these crises bear some relationship to global warming. Although apparently not common knowledge, we have known about global warming for over 125 years – since 1896 to be precise. A Swedish scientist, Svante Arrhenius, first predicted that changes in atmospheric carbon dioxide levels could substantially alter the surface temperature through the greenhouse effect (Weart 2012). Bill McKibben (1989), author and environmentalist, provided an impassioned warning about global warming over three decades ago. We also know that corporations and individuals, notably in the oil and gas sector, opposed all proposed government regulation and began to spend many millions of dollars on lobbying, advertising, and "reports" that mimicked scientific publications – all in an effort to convince people that there was no problem at all. But the many scientific uncertainties, and the sheer complexity of climate, allowed limitless debate over what actions governments should take (Weart 2012), and there were none of any significance. Here we are today, victims of our own myopia, duplicity, and complacency.

My purpose here is to highlight some of the recent findings concerning climate trauma. The vast majority (97%) of actively publishing climate scientists agree that humans are causing the current global warming and climate change. Most of the leading science organizations around the world have issued public statements expressing this (National Aeronautical and Space Administration 2022). Scientists have found that nine of the 15 known tipping points that regulate the state of the Planet have been activated. A tipping point is when a temperature threshold is passed, leading to unstoppable change in a climate system, even if global warming stops. These tipping points include the collapse of the Greenland, west Antarctic, and two parts of the east Antarctic ice sheets, as well as the collapse of the Atlantic current (a large system of ocean currents that carry warm water from the tropics northwards into the North Atlantic), the Amazon rainforest dieback, and the loss of Arctic winter sea ice. There is now scientific support for declaring a state of planetary emergency and that extreme steps are needed to avert climate disaster (Tollefson 2022).

These tipping points can also trigger abrupt carbon release back into the atmosphere, such as the release of carbon dioxide and methane caused by the irreversible thawing of the Arctic permafrost. If damaging tipping cascades can occur and a global tipping point cannot be ruled out, this is an existential threat to civilization. The scientists noted that "[t]he evidence from tipping points alone suggests that we are in a state of planetary emergency: both the risk and urgency of the situation are

acute" (Pearce 2019). A 2023 United Nations (UN) report found that if we continue to push past these planetary boundaries, then total societal collapse is a possibility by 2050 (Whalley 2023).

The world has already been warmed by about 1.3°C, and studies suggest temperatures could cross 1.5°C within a decade. The UN Secretary General, Antonio Guterres, said that the report by the Intergovernmental Panel on Climate Change (IPCC) revealed "a litany of broken climate promises" by governments and corporations and accused them of stoking global warming by clinging to harmful fossil fuels. It is "a file of shame, cataloguing the empty pledges that put us firmly on track toward an unlivable world," he noted (United Nations 2022). Here are several examples to illustrate the breadth and depth of this shame:

1. Over the past five years prior to the Glasgow Climate Pact, 154 Parties have submitted new or updated 2030 mitigation goals in their nationally determined contributions and 76 have put forward longer-term pledges. Quantifications of the pledges before the 2021 UN Climate Change Conference suggest a less than 50% chance of keeping warming below 2° C (Meinshausen et al. 2022).
2. The following are the five key facts from the 2021 IPCC Report (Carbon Brief 2022):

 - Humans have already transformed more than 70% of the Earth's land area.
 - Food systems are responsible for 80% of deforestation, 29% of greenhouse gas emissions and are the single largest cause of biodiversity loss on land.
 - Protecting and restoring ecosystems could provide more than a third of the land-based climate action needed to meet global warming goals.
 - Land degradation threatens marginalized communities the most – but these groups have much to contribute to ecosystem restoration and protection.
 - The world faces a stark choice between protecting and restoring land and "business as usual."

3. Northwest and central India saw their highest average maximum temperature in April 2022, since record keeping began 122 years ago, according to the Indian Meteorological Department. At the same time, Pakistan reached 49°C, which is one of the hottest April temperatures ever recorded. "We are living in hell," said Nazeer Ahmed of Turbat, Pakistan (Rosane 2022). The town of Lytton, British Columbia, reached 49.9°C in June of 2021 (the highest temperature ever recorded in Canada) and then burned down.

The 2023 report by the IPCC estimates that global temperatures will reach 1.5°C above pre-industrial levels in the early 2030s, as society continues to burn oil, natural gas, and coal (Nature Briefing 2023). To stop warming from crossing this critical threshold, industrialized nations must cut greenhouse gas emissions in half by 2030 and achieve net zero by the early 2050s. If these two steps are taken, the world would have about a 50% chance of limiting warming to 1.5°C. The prospects

for doing are dismal, as existing and currently planned fossil fuel infrastructure – coal-fired power plants, oil wells, factories, cars, and trucks across the globe – will already produce enough carbon dioxide to warm the Planet by roughly 2°C this century (Plumer 2023).

These grim observations are now regrettably common, based as they are on scientific observations of events and processes. There are even more frightful scenarios stemming from the harm we are doing, such as the one predicated on the melting of the remaining Arctic sea ice and its ability to reflect incoming solar energy back to space. This would be equivalent to adding one trillion tons of CO_2 to the atmosphere, on top of the 2.4 trillion tons emitted since the Industrial Age, according to the researchers from Scripps Institution of Oceanography at the University of California (San Diego, USA). At current rates, this roughly equates to 25 years of global CO_2 emissions (Hester 2020).

It has been suggested that the global mean temperature could rise to 10°C in the coming decade or two. This would result in the mass extinction of many species, including many human beings (Hester 2020). In the final analysis, climate trauma, as immense as its consequences are, is not the cause – it is a symptom of the civilizational and ecological overshoots discussed earlier. Until we start to understand these interrelationships and assume a systemic perspective, we will remain surprised, frightened, and unprepared to act. Although too little and too late, even climate scientists are now confronting the charade propagated by politicians and corporatists, as summarized in this sobering admonition:

> The time has come to voice our fears and be honest with wider society. Current net zero policies will not keep warming to within 1.5°C because they were never intended to. They were and still are driven by a need to protect business as usual, not the climate. If we want to keep people safe then large and sustained cuts to carbon emissions need to happen now. That is the very simple acid test that must be applied to all climate policies. The time for wishful thinking is over.
>
> *(Dyke et al. 2021)*

For some in the scientific community, passive communication has also given way to a call for civil disobedience. Climate researchers are urging their colleagues to risk arrest and commit acts of civil disobedience in an effort to pressure governments to take quicker, more substantial action on the climate crisis, as well as to better convey how seriously the science community views the threats it poses to humanity and the Planet (Tigue 2022).

I leave the last word on the ultimate consequences of climate trauma to the American writer, Richard Powers, who wrote, "Life will cook; the seas will rise. The Planet's lungs will be ripped out. And the law will let this happen because harm was never imminent enough. *Imminent*, at the speed of people, is too late" (Powers 2018: 498).

Political incompetence and corporate deceit

Were it not enough to contend with civilizational overshoot, ecological overshoot, and the resultant climate trauma, we must also confront the political incompetence and corporate deceit that are preventing or obscuring mitigative, adaptive, and regenerative efforts to address the onset of collapse. Before assessing this lack of accountability, I want to emphasize that all of us living in developed countries are also responsible for the world we inhabit, and simply blaming politicians and corporatists is both cold comfort and insufficient. As both policymakers and lawmakers, however, elected officials are essential in mobilizing effective action, yet this responsibility continues to elude them or is ignored by politicians at all levels of government. This lack of accountability has become ruinous, as illustrated below.

Political ineptness is rampant at all levels of MTI society and is aptly demonstrated by the failure to achieve the environmental goals required to mitigate the climate crisis. Negotiators at COP27 (the 2022 UN Conference on Climate Change) failed again to agree to a deal that would limit global warming to 1.5°C. In short, the meeting produced no agreement to cut emissions and phase out fossil fuels – thus failing to agree to take action on the dominant cause of climate change (McGuire 2022). COP27 hosted more than 600 fossil fuel representatives and many others who were there to prevent rather than promote progress and action. The graveyard of broken promises continues with COP28 scheduled for 2023 in the United Arab Emirates – one of the world's ten largest oil producers. The lobbyists should have a field day.

In fact, the world's governments plan to produce 120% more coal, gas, and oil by 2030 than is allowable in order to meet the 2015 Paris Agreement climate target of 1.5°C of warming (McKibben 2019). The litany of incompetence and deceit grows daily, and it is impossible to separate government deceit from corporate duplicity. It is a matter of record that politicians now largely serve as handmaidens to private economic interests, to the extent that multinational corporations are now partners (with governments) in control of the public agenda throughout most of the world. The corporatists' agenda, with rare exceptions, is devoted to private gain at the expense of the collective good.

Corporate duplicity is alive and well – prospering, in fact. For example, fossil fuel financing from the world's 60 largest banks reached US$4.6 trillion in the six years since the adoption of the Paris Agreement, with US$742 billion in fossil fuel financing in 2021 alone. This report (Banking on Climate Chaos 2022) examines commercial and investment bank financing for the fossil fuel industry – aggregating their leading roles in lending and underwriting debt and equity issuances. It found that even in a year where net-zero commitments were all the rage, the financial sector continued its business-as-usual support of climate chaos. These findings "underscore the need for banks to immediately implement policies that end their financing for fossil fuel expansion and begin to zero out their support altogether" (Banking on Climate Chaos 2022). What are the odds of this happening?

Despite the national and international views of Canada as a nation that loves and respects its land, mountains, lakes, and rivers, Canada has the worst climate policy

and climate action record of the G20 countries (McCarthy 2022). Canada's Prime Minister Justin Trudeau now in his eighth year in office, has been a total failure in meeting Canada's international obligations to fight climate change (Mulcair 2022). The United States also continues its sleight of hand, with the revelation that the federal government forecasts that US$5 trillion will be spent over the next few decades to drill more than 700,000 fracked wells in the United States (Miller 2021). This amount of money is nearly ten times the record amount the US House of Representatives included in the recently passed Build Back Better Act to tackle the climate crisis. Really? This is fracked gas, a process that splits deposits of natural gas deep underground using high pressure chemicals. Recent research (Howarth 2019) has revealed that the process releases large quantities of methane and other harmful gases – yielding 20% more global warming per unit than coal. Without rigorous safety regulations, it poisons groundwater, pollutes surface water, impairs wild landscapes, and threatens wildlife.

Although seemingly unrelated, it is impossible to separate the growing income inequality with the deceit and ineptitude promulgated by governments and corporations with respect to climate trauma. While the richest 10% of adults in the world own 85% of global household wealth, the bottom half of the world's population collectively owns barely 1%. More strikingly, the average person in the top 10% owns nearly 3,000 times the wealth of the average person in the bottom 10% (Oxfam International 2022). The climate crisis and unprecedented wealth inequality are usually portrayed as separate issues, but this is fuzzy thinking. The wealthiest 1% of individuals worldwide have emitted 100 times as much CO_2 per year as the bottom 50%, while the richest 10% of individual emitters contributed to 45% of global emissions. The poorest 50% of the world's population accounted for 13% of world emissions (Campbell 2021).

Campbell further notes that annual per capita carbon emissions for the top 1% Canadians were about 35 times the world average, placing Canada fifth in the carbon emitter rankings. The number of Canadian billionaires has more than quadrupled in the past two decades, and their combined wealth has increased fivefold. Canada's billionaires now have as much wealth as the 12 million poorest Canadians. When will governments acknowledge the disastrous relationship between wealth, consumption, and planetary decline? It doesn't seem likely, fuzzy thinking aside, as maintaining the privileges and power of the *status quo* is the only game plan that MTI society knows, despite all of the harbingers of collapse. The following discussion reveals the fragility of the woefully mismanaged *status quo*.

William Rees, the human ecologist to whom I'm indebted for his courage and intelligence, provides a succinct summary of the incompetence plaguing our worldview:

> The world's great economic powers are currently trying to run the world using simple-minded economic models that contain no useful information about the unfathomable complexity and the non-linear and often irreversible behavioural properties of the ecosystems – or even the social systems – with which the

economy interacts in the real world. Our management/control system utterly fails the test of requisite variety. It is incompetent to fly the Planet.

(Rees 2021a)

It is the world's political and business elites who continue to fail the test of requisite variety by failing to acknowledge that diversity in viewpoints and perspectives is required for groups and organizations to address complex problems as they emerge. These elites also remain oblivious to the fact that addressing civilizational and ecological overshoot requires fiscal and regulatory mechanisms to ensure the redistribution of income, wealth, and opportunity among and within countries. This would both attack and erode the privilege of those with political and economic power, which is reprehensible to them, of course.

Richard Heinberg, senior fellow at the Post Carbon Institute, and a major voice in understanding our current world, also has much to say about the failure of global elites (Heinberg 2022a). He writes that in the 1970s, global political and corporate elites had all the information they needed to put the world on a path toward long-term stability, including "discouraging population growth, capping the scale of industrial production, reducing economic inequality, cleaning up past pollution, reducing current and future pollution, and leaving plenty of space for nature to regenerate."

The elites did not do these things for reasons of self-interest and society is now well on the path to instability and breakdown. Heinberg notes that "the actual core failure of elites – both liberal and conservative – goes unnamed and undiscussed . . . the core failure consisting of permitting society to proceed along a path of unchecked growth." Heinberg's wise advice is to not wait for the elites to get it right but to move on (Heinberg 2022a). He notes that "anything that further divides us makes it harder for humanity to do whatever is still possible. A better path would be building personal and community resilience ahead of what's coming. Ease the suffering. Save what can be saved."

I would add one more consideration to Heinberg's advice to "move on" and that is to take the government out of the hands of the moneyed elite. The role of big money in governments throughout the world has become more than toxic; it is now destroying the biosphere, not to mention democracy. Special interests, dominated by the corporate elite, be they big oil, pharmaceuticals, agribusiness, or the arms industry, conduct their business behind closed doors, aided and abetted by politicians and economists. Individually and collectively, the corporatists have far too much destructive influence on government. We only have to consider how the fossil fuel industry's dishonesty has stalled climate action for decades. Ending this lobbying and influence peddling would be a critical step in addressing political and corporate deceit, and thereby strengthen our ability to face up to disruption. James Hansen, the preeminent climate scientist, provides a blunt summary of the current political reality in America:

> The public understands that Washington has become a swamp of special interests. The public knows that, upon election, congress-people become elite,

concerned about maintaining that status, and willing to accept money from special interests. In short, our government is corrupt.

(Hansen et al. 2022)

The irony is now complete for those who measure their worth with money, yet deny the reality of global warming. Recent research has revealed that climate change could see 4% of global annual economic output lost by 2050 (Jones 2022). Other research estimates that the global economy lost between US$5 trillion and US$29 trillion from 1992 to 2013 (Callahan and Mankin 2022). Perhaps the best explanation for corporate deceit in the face of declining wealth is summed up by John Kenneth Galbraith (1994), economist and diplomat, who noted that, "Generally, people have been very resistant to attributing a causal role in history to stupidity."

Blundering hubris – ecomodernism

A recent addition to the list of collapse harbingers is ecomodernism, a destructive and misguided school of thought that is seemingly oblivious to what is transpiring in the world. It will also be examined in Chapter 3 on the Myth of Sustainability. Ecomodernism is an environmental philosophy which argues that humans can protect nature and improve their well-being (with a high standard of living) by developing technologies that decouple human development from environmental impacts (Wikipedia 2022a). Ecomodernism is centred on technology development, including microbial fertilizers, synthetic meat, desalinization, urbanization, and carbon capture and storage, as well as nuclear power plants and madcap schemes of geoengineering. In short, ecomodernism rejects the idea that high economic growth and environmental protection are at odds. It is based on the neoliberal belief in the supremacy of the so-called free market. In short, ecomodernism is hyper-capitalism dressed up in an imitation "green" suit and rooted in the belief that human ingenuity will always solve the problems caused by human ingenuity.

In light of all the evidence underlying ecological overshoot, it is inconceivable that society can continue to rely on dreams of technology to overcome the depletion and pollution of the Planet's natural resources. It would seem that the ecomodernists are ahistorical – demonstrating no knowledge of the damage our high standard of living, based on technology and consumption, has already inflicted on the biosphere. Many thinking people are beginning to discover that working harder and buying more stuff are not leading to what they had hoped for. Many of us have now entered that deeply perplexing realm of being in conflict with our own sense of values and principles, while we are losing our sense of stewardship (Janes 2016: 201). Part of this perplexity is the realization that nature does not belong to us – it is not "our" natural environment (Franklin 1999: 85). Nature is not infrastructure standing by to accommodate us. Rather, it is its own entity and people are but one

part of it, and it is high time that we learn to live with this essential truth. We need nature; nature does not need us.

We are faced with a poverty of thought and action in this regard, and professional economists are one of the greatest obstacles to achieving some degree of understanding and realism (Wilson 1998: 290). Mainstream economists and neoliberals ignore human behaviour and the environment in their analyses and pronouncements, and they pronounce daily, if not hourly, on every form of media. Most importantly, they do not use full-cost accounting, which means that they fail to recognize the depletion and contamination of natural resources as a cost. The general failure of this academic discipline to acknowledge the real world is not going unnoticed, with economics being called "a pseudoscience and a form of brain damage" (Henderson 1980: 22). William Rees, the human ecologist cited earlier for his penetrating analysis of the prevailing economic paradigm, provides a chilling summary of the ecomodernist deception:

> In short, the real commitment of the international community is to technological solutions that will sustain growth and not jeopardize the current social and economic system. Perversely, then, climate disaster policy is designed to serve the capitalist growth economy . . . so the latter becomes the solution to (not the cause of) the problem. Unfortunately, many environmental non-governmental organisations have bought into this illogical reasoning [believing] without justification, that the financialization of Nature will help prevent its destruction.
>
> *(Rees 2020: 6–7)*

The madness of humanity

Recognizing what we know about civilizational overshoot, ecological overshoot, climate trauma, political and corporate deceit, and ecomodernism, is this not madness? Madness that we in the Western world are failing to react with intelligence, courage, and dispatch to confront what is now being called an existential threat to our species, not to mention all we have created throughout prehistoric, oral, and written history? This madness is omnipresent in Western society and influences all aspects of our existence.

There is one dimension to this madness that overshadows all and it is best described by the late E.O. Wilson, the Pulitzer Prize-winning naturalist. In discussing the sixth mass extinction now underway on earth, he notes that "we will have done it all on our own, and conscious of what was happening" (Wilson 2006: 91). I will repeat this devastating observation that "we will have done it all on our own, and conscious of what was happening." As a species, we are capable of the foresight and knowledge required to envision and avoid collapse but have instead chosen to disregard our human capabilities.

Not only are we well on the way to destroying the More-Than-Human World, but we are also replicating the failures of our human ancestors, who through no forethought on their part have supplied us with lessons that remain unheeded. Two Canadian writers, Ronald Wright and Thomas Homer-Dixon, underscore the absurdity of what will be seen as perhaps the greatest fallacy of our time – the idea that we can get along without natural resources, an idea that is now apparently widespread in wealthy countries (Wright 2004: 81–106; Homer-Dixon 2001: 31, 241). We now have the benefit of archaeology and ecology, which neither the ancient Mayans nor the ancient Romans had, for example, to teach us how and why these societies wore out their welcome from Nature, and how ecological diversity is essential to the health of the biosphere (Heinberg 2011: 53). With a heightened historical consciousness, engendered and assisted by museums, society could take advantage of this knowledge and do much to avoid the mistakes that led to the catastrophic collapses of the past. Madness has gotten in the way.

Although it is painful to accept this madness as the defining feature of the prevailing worldview in developed countries, it is impossible to conclude otherwise. I will close this chapter with a closer look at this madness by examining some of its complexities and consequences. This is cold comfort, but it is also an opportunity to reflect on how we might escape from this stranglehold on our collective consciousness.

A moral hazard

The madness on the part of political and corporate elites, which we embrace, deny or reject, has created a moral hazard, which is defined as follows:

> The risk one party incurs when dependent on the moral behavior of others. The risk increases when there is no effective way to control that behavior. Moral hazard arises when two or more parties form an agreement or contractual relationship and the arrangement itself provides the incentive for misbehaviour by insuring one party against responsibility.
>
> *(Encyclopaedia Britannica 2022)*

The risk increases when there is no effective way to control that behaviour. One could argue that the dozens of UN COP climate conferences are glaring examples of a moral hazard, as one party, the fossil fuel industry, has never had any intention of doing what is needed to protect our climate and mitigate the damage (Zarnett 2022a). It is fair to say that this industry has entered into these various agreements and commitments in bad faith. We do not know all of the causes for this duplicity, but the accumulation of money and profit is obviously the root cause. Thus, financial power, influence, and greed are the key drivers of the prevailing madness, all of which are concentrated in the hands of a few.

Modernity again

A second key ingredient in the prevailing madness is modernity itself, discussed earlier as part of civilizational overshoot. I return to it here, as its worn-out and destructive ideology continues to thwart our ability to envision a new future. Along with unsustainable economic growth and unbridled consumption, modernity has also given us expropriation, dispossession, and genocide in the form of colonialism – policies and practices of acquiring political control over peoples and their lands – by occupying them with settlers and exploiting them economically. Modernity and colonialism are two sides of the same coin, whereby the nation state protects property and capital over people, as noted earlier. This is not to deny that ancient empires were often as cruel, exploitative, and ethnocentric as modern ones, as evidenced by slave raiding, elaborate torturing, and human sacrifices.

This view of the world is inherently mad, yet it persists to this day. Indigenous Peoples in the United States and Canada, for example, have been the unremitting casualties of settlers, armies, and successive governments, and the legacy of settler colonialism is still unfolding in North America, let alone the world (Janes 2021). Consider the prolonged societal indifference and government inaction to address the cumulative effects of this ongoing malfeasance, not to mention the contemporary disregard of Indigenous treaty and unceded rights, which is occurring throughout Canada (Smith 2020). The result is now a resolute and growing movement to address and redress the wrongdoings of the past in the name of truth and reconciliation, at the core of which lies decolonization. The madness that pilots climate denialism is the same madness that framed European imperialism and colonialism, as well as the US Indian Wars and the current marginalization of Indigenous Peoples in Canada, to mention only two examples. It appears to be a legacy we cannot renounce – a legacy of exceptionalism, entitlement, and ethnocentrism, which is most often accompanied by violence, physical or otherwise.

Fantasies and lies

The madness that pervades our waking lives in every type of media and marketing endeavour is dependent on numerous fantasies and lies (akin to propaganda). The most insidious fantasy is the belief, discussed repeatedly, that continuous economic growth is essential to our well-being. The second most dangerous dream is the brainchild of the first. This is the reverential obsession with the most sacred of all cows – the Gross Domestic Product (GDP) which is the monetary measure of the market value of all the goods and services. The GDP continues to be firmly embraced by the political and corporate elites, who are unable to understand or concede that the past is no longer the guide to the future. The lethal absurdity of this belief is a matter of record, and Richard Heinberg portends the GDP's deadly legacy:

> As long as we continue to pursue growth, we are on track to attempt more doublings of resource extraction and waste dumping. But, at some point, we will

come up short. When that final doubling fails, a host of expectations will be dashed. Investment funds will go broke, debt defaults will skyrocket, businesses will declare bankruptcy, jobs will disappear, and politicians will grow hoarse blaming one another for failure to keep the economy expanding. In the worst-case scenario, billions of people could starve and nations could go to war over whatever resources are left.

(Heinberg 2022f)

We also must contend with a constellation of lies and propaganda, in addition to the fantasy world. The most important of these lies is ecomodernism, which was assessed earlier, but nonetheless merits one more comment. Ecomodernists are telling us that we can separate our needs and aspirations from the natural world while increasing our prosperity. This may be the worst lie. A second deception, following directly from the first, is more personal. We are told that we are good people and we can have, and deserve, whatever we want whenever we want. Commercial advertising is, in effect, the propaganda machine of capitalism and we need to be good consumers. In the words of Brad Zarnett, a climate trauma activist:

So hold your head high as you drive your Chevy Suburban to your newly built 6000 square foot retirement summer home. Your plan to fly guests in for weekend visits to play on your new pair of jet skis, while you watch your sustainable (ESG) stock portfolio rise, is the culmination of a life of hard work. You're a hero of global prosperity!

(Zarnett 2022b)

A third lie directly related to the one above was discussed earlier under ecomodernism, and so I will make only a brief mention of it again here. It merits repeating as it is immensely popular with its message that nothing really needs to change. That is, we can simply develop renewable energy sources, eat manufactured meat, drive electric vehicles, capture carbon, and bury it. No mention of the energy and the materials required to do this; no mention that the Planet is no longer capable of providing these resources. Madness.

I will conclude this discussion with a brief look at what amounts to propaganda that shapes our consciousness as a society. Along with the fantasies and lies discussed earlier, it is part of the inertia that is hindering or preventing effective climate action. This lie is at the core of our madness and has rightfully been called the Big Lie (Zarnett 2022c). In short, all of the harm we have done – civilizational overshoot, ecological overshoot, climate trauma, and ecomodernism – "are all the cost of doing business." Furthermore, "capitalism may not be perfect, but it is the best we have." The height of our madness is embedded in this fiction – that we can manage our way to a secure and stable future using the same system that created all the problems in the first place.

Our elected leaders and the world's corporate oligarchs continue to deny the obvious truth – capitalism is the toxin that is collapsing the biosphere. The legacy

of the capitalist system is indeed grim – our civilization, through its uncontrolled consumption of fossil fuels, has destroyed robust natural ecosystems and replaced them with artificial and fragile ones. I must also acknowledge that Marxist/Leninist/Maoist nations were, and are, equally as hard on their environments, for they share the modernist belief in unending material progress and growth underwritten by science.

With the truth and consequences of global warming firmly grounded in science and reality, how is it that these lies continue to dominate mainstream thinking? Addressing this question requires examining the psychology of our species, something I am not qualified to do. I would, however, like to note some salient characteristics of our flawed humanity that might shed some light on the origins and durability of our madness.

How Homo sapiens *think*

As *Homo sapiens* (humans), we have two immense challenges to contend with in the contemporary world. The first is human exceptionalism, including the beliefs that humans are different from all other organisms, that all human behaviour is controlled by culture and free will, and that all problems can be solved by human ingenuity and technology (Oxford Reference 2022). Human exceptionalism is further beset by the idea that humans are separate from nature and that we have transcended it in some way through spirituality, technology, or consciousness. The second liability is anthropocentrism or the belief that human beings are the central or most important entity in the universe.

The tough truth is that *Homo sapiens* is a biological species like all others and is subject to the same natural laws and limitations (Rees 2020: 7). There are some additional traits that further complicate our ability to see and accept the truth of our predicament, including the fact that *Homo sapiens* are not primarily a rational species, and that emotion and instinct play a remarkably large role in directing human affairs (Rees 2020: 6). There are yet additional limitations to our cognitive skills, including natural optimism and an innate tendency to favour the here and now, as well as close relatives and friends over distant places, future possibilities, and strangers (Rees 2020: 6).

The favouring of relatives and friends over strangers is particularly pernicious as climate trauma unfolds, as both human exceptionalism and anthropocentrism are also burdened by boundaries. These boundaries give rise to what is called "othering," meaning to view or treat a person or group of people as intrinsically different from, and alien to, one's self. In short, "they are not us." This form of exclusion is not necessarily intentional, malicious, or racist, and it likely eludes the consciousness of *Homo sapiens* in general. For those in the midst of climate trauma, however, it is another transgression committed by privileged individuals and governments who consistently disregard the litany of global climate catastrophes unfolding among powerless and marginalized peoples in both hemispheres. The Western world continues unabated in its pursuit of consumptive privilege and

placebo happiness (i.e., I will go to Mexico for a week of leisure – it's cheap; or maybe an ocean cruise at a budget price), while those immersed in the climate trauma attempt to survive. Here is a case in point – one more illustration of our madness.

As the Venezuelan state descended into a political and economic crisis, corrupt military and political leaders are controlling and profiting from a flood of illegal mining in a 43,000 square miles (nearly 111,000 square kilometres) region south of the Orinoco River (Yale School of the Environment 2021). Working at an estimated 900 sites, illegal gold, diamond, and rare-earth miners are destroying extensive areas of the Amazon rainforest and largely unspoiled rivers in parks and protected areas. The miners also are invading the territory and threatening the culture of roughly 170,000 Indigenous Peoples. This is the epitome of "othering." It is common knowledge that the Amazon rainforest plays a crucial role in regulating the world's oxygen and carbon cycles. It produces roughly 6% of the world's oxygen and is a carbon sink, in that it readily absorbs large amounts of carbon dioxide from the atmosphere. For those of us in the privileged world, this unfolding tragedy is out of sight and hence out of mind, aided and abetted by our collective "othering." This may be understandable, but it is no longer acceptable. "We are all related" in the Indigenous Lakota worldview (Brown 1989: xiii), meaning that climate action now equals climate justice.

Two final comments on the madness that has gripped us. The first is to offer a more generous, albeit pessimistic, view of impending collapse:

> It's quite simple: None of us is willing to make the sacrifices necessary to avert collapse. We have shown that to be true in our elections and our buying decisions as much as through the corporate behaviours we tolerate. We're not "to blame" for that. This is our well-intentioned nature, and the expression of that nature is now colliding with the longer-term interests of our Planet and all its residents. This does not make us evil; it makes us human.
>
> *(Pollard 2022a)*

My last comment is to note that our madness was recently celebrated in a Hollywood film featuring numerous high-profile actors. *Don't Look Up* is said to be the most accurate depiction of "society's terrifying non-response to climate breakdown" (Kalmus 2021). It is perversely ironic that our madness is now packaged as satirical entertainment – our natural optimism at work again. As mentioned earlier, our collective failure to act has been so heavily dissected that a much-needed synthesis of our predicament is most welcome. For this, I acknowledge E.O. Wilson (2016), the holistic thinker, for his incisive brevity. He writes, "The real problem of humanity is the following: we have Palaeolithic emotions; medieval institutions; and god-like technology." What has this madness wrought, enmeshed as it is in these perverse and intractable contradictions? The next chapter provides a road map, where you may choose your destination until the options are exhausted.

2
THE ANATOMY OF COLLAPSE

I introduced *collapsology* in the Introduction and I return to it here for a more detailed examination. To reiterate, collapsology refers to civilizational collapse and is focused on contemporary, industrial, and globalized society (Servigne and Stevens 2020). Not surprisingly, there is no consensus in the literature on what the future holds – be it decline, collapse, or apocalypse. It is important to note that none of these outcomes necessarily follow in succession. One observer, for example, argues "that our entire civilization is in decline. Not quite a total apocalypse but a slow, grinding descent into less prosperity, lower quality of life, and diminished prospects for a better world" (Potter 2022). Potter, a professor of public policy, further notes:

> [D]ecline is not the apocalypse. And decline is not extinction. It's just decline. It doesn't mean nobody can be happy. It doesn't mean there's not going to be anything worth doing. It doesn't mean there's not any moral progress. It's the world getting more difficult for everybody, coarser, rougher and things sort of generally wearing down.
>
> *(Potter 2022)*

My perspective, based on both contemporary circumstances and scientific projections, makes me considerably more anxious and alarmed. Our way of life is certainly in decline, but the evidence to date indicates that this decline is on an accelerating trajectory that far exceeds a "general wearing down." As a result, I have elected to use "collapse" for the purposes of this book. My outlook, however, is not yet as dire as that of Chris Hedges, the Pulitzer Prize-winning journalist, who wrote:

DOI: 10.4324/9781003344070-3

There are three mathematical models for the future: a massive die-off of perhaps 70 percent of the human population and then an uneasy stabilization; extinction of humans and most other species; an immediate and radical reconfiguration of human society to protect the biosphere. This third scenario is dependent on an immediate halt to the production and consumption of fossil fuels, converting to a plant-based diet to end the animal agriculture industry – almost as large a contributor to greenhouse gasses as the fossil fuel industry – greening the deserts and restoring rainforests.

(Hedges 2022)

Surprisingly, the possibility of collapse is not a new topic in the museum field (Janes 2009a, 2016; Janes and Sandell 2019; Koster 2011, 2020a, 2020b). I will review some of my earlier observations as they are useful in highlighting the accelerating lethal trends that now confront us. I speculated in my earlier work about the ideas of irrelevance and collapse but restricted my comments to museums only, based on their growing dependence on marketplace values and revenues (Janes 2009a: 176–177). Admittedly, the idea of museum and/or societal collapse a dozen years ago required a leap of imagination. Among the litany of other stressors beyond museums, I examined the destruction of our closest living kin, the other primates – apes, lemurs, and monkeys. At that time, 114 of the 394 primate species were classified and threatened with extinction. I then turned my attention to the ongoing destruction of biodiversity (Janes 2009a: 42–44). I urged readers to confront this truly staggering loss, as only 5% of all animals in the world are now wild and free-living. Farmed animals and human beings now constitute 95% of all land vertebrates (Safina 2021).

In a subsequent book (Janes 2013: 371–374), I ventured beyond the More-Than-Human World and examined four possible scenarios for the future of our civilization based on the work of Bridget McKenzie (2012), a UK curator, consultant, and activist. I am indebted to McKenzie for identifying and describing these four scenarios, which are summarized next and which continue to be a valuable framework. Because we are unable to reverse the trajectory we have set for ourselves, with all of its dire consequences, it is helpful to have close look at what the future might hold. There are options and choices to be made.

Global scenarios

The Red Global Scenario – Status Quo

In this scenario, there were serious efforts to address the environmental and resource crises globally, but this work was dominated by technology and the marketplace, without sufficient attention paid to regulating the ensuing damage to the biosphere, and coupled with insufficient efforts to restore ecosystems. Inequality and conflict over resources persisted. The *Red Scenario* was fully revealed in the previous chapter on the harbingers of collapse.

The Silver Global Scenario – techno-utopia

In the second decade of the twenty-first century, there was a redoubled effort, supported by corporations and governments, to replace fossil fuels with alternative energy sources and to engineer new sources of food and water. The effects of climate change increased, however, and the oceans continued to acidify and the deserts continued to expand. The reduction in greenhouse gas emissions enabled some cities to persevere and bring back climate stability. There were some remarkable technological advances, but they were insufficient. The *Silver Scenario* is Ecomodernism.

The Green Global Scenario – ecotopia

In the second decade of the twenty-first century, the inherent value of the biosphere was finally recognized and efforts to restore and "rewild" the forests and oceans intensified. Urban gardens became commonplace. All of these efforts failed to prevent the tipping points of climate change feedback, however. It was hoped that wilderness could be restored in some regions to allow for biodiversity to recover. Humans and nature are both thriving in some areas, but not worldwide.

The Black Global Scenario – accept decline

Efforts to address the environmental and resource crises were ineffective and too late, lacking courage, determination, and purpose. The consequences were varied, with some communities accepting the decline, some choosing crime and conflict, and still other communities becoming nomadic. McKenzie noted that "[o]thers might form protective spiritual clans that 'live for now' while aspiring to morality" (McKenzie 2012).

Because all of these scenarios are plausible, aligning with one or another is a matter of personal values and beliefs that reflect one's life experiences and anxieties. Grandparents will undoubtedly feel greater distress, for example, when considering the implications of the *Red and Black Global Scenarios* for their grandchildren. The *Red Global Scenario*, or *status quo*, is an apt description of what is unfolding now and does not have to fail if we attend to what we have learned. The temporary abundance of fossil fuels, dysfunctional politicians, and deceitful corporatists are providing a false sense of normalcy, however, and are thereby sabotaging concerted action. The *Red Global Scenario* is also not new, and we have the catastrophic events of the distant past to ponder, such as the fall of the Classic Mayan civilization and the demise of ancient Rome. The stories of these collapsed societies are popular analogues for the present, and their meaning and implications for contemporary challenges have been examined by various writers (Homer-Dixon 2006; Wright 2004), as noted previously.

The second scenario, *techno-utopia*, is what corporatists and governments would like us to believe, and many intelligent and responsible people have adopted this belief, including the Ecomodernists discussed earlier. It is difficult to be a contrarian in light of all the technological benefits that underpin contemporary life, even while global governments and corporations continue to erase the future with their simple-minded belief that technology will fix everything. At the very least, societal leaders in all sectors should be exercising the precautionary principle – if an action or policy may potentially cause harm to the public or to the environment (in the absence of scientific consensus that the action or policy is harmful), the burden of proof that it is *not* harmful falls on those taking the action (Pinto-Bazurco 2020).

The hubris and ignorance underlying the "technological fix" are the result of both willful ignorance and the plutocracy's self-interest. We are now controlled, along with our governments, by people with great wealth and income. This belief in technology is also driven by neoclassical economics and the fixation on economic growth as the dominant benchmark of societal well-being. Recall Henderson's earlier observation that economics is "a pseudoscience and a form of brain damage." More bluntly in the words of economist, Kenneth Boulding, "anyone who believes exponential growth can go on forever in a finite world is either a madman or an economist" (Posen 2015).

Techno-utopia is too little and too late, a common theme throughout history where privatized interests are in control – why change if you are reaping the benefits? Although the *techno-utopia* is theoretically possible, it will fail because it is predicated on the denial of the unfolding damage to the biosphere's complex systems – the atmosphere, the hydrosphere, the cryosphere, the biosphere, the humanosphere, and the lithosphere (Koster 2020a). Although museums have a vital role to play in examining the meaning and value of technological solutions to the current crisis, there is no doubt that technology remains a naïve and partial solution.

This leaves *ecotopia* as a third possibility and it will not unfold as described without the unequivocal collaboration of the public and private sectors, including museums. An unprecedented sensitivity to the integrity of the biosphere will be required, as well as a commitment to individual and community self-reliance and sacrifice not seen since World War II. All of this is possible and is, in fact, underway in a variety of local, regional, and national initiatives that remain largely unacknowledged by governments, be they Transition Towns, or urban gardens, or land-based cooperatives. The combination of ecological overshoot, climate trauma, and political ineptitude, however, will likely make *ecotopia* impossible.

In the remainder of this chapter, I will examine what McKenzie calls *The Black Global Scenario* and which I call collapse. I will conclude with a discussion of some observations, warnings, and wisdom to be gleaned from this summary examination of collapse. It is incumbent upon us to understand what is possible and what is perilous.

The five stages of societal collapse

Although the same pattern of complexity, speculation, and unpredictability is true of societal collapse as it is for ecological collapse, the work of Dimitry Orlov (2013) provides an invaluable examination of how collapse might unfold for human society. To reiterate, for individuals, families, and communities, collapse refers to "the ending of our current means of sustenance, shelter, security, pleasure, identity and meaning" (Bendell and Carr 2019). Few would dispute that collapse is a socially awkward subject (Orlov 2013: 1–2) – the difficulty being that pondering collapse is seen to be "overly negative, disturbing, distressing, depressing, defeatist." Orlov addresses these concerns by examining several pre- and post-collapse societies with insight and humour. The result is Orlov's taxonomy of collapse that synthesizes a great deal of complexity (Orlov 2013: 14–16):

Stage 1: Financial collapse – Trust in "business as usual" and the past is no longer the guide to the future. Financial institutions become insolvent; savings are erased, and access to capital is lost. Orlov (2013: 62) notes that "life without global, or even national, finance is possible. In many ways it is even desirable." He foresees a successful human culture universal:

> A family is three generations at a minimum, living together, pooling resources, and allocating them in the best interests of the whole. A community is a band of such families capable of self-governance. The traditional form of self-governance . . . is a council of elders.
>
> *(Orlov 2013: 42)*

Stage 2: Commercial collapse – Despite society's utter dependence on commerce, the faith in the market is gone. Money is devalued, commodities are hoarded, imports collapse, retail chains break down, and widespread shortages of the necessities for survival become the norm. Orlov (2013: 101) notes that there is an alternative to this: "The normal human relationship pyramid, based on personal, tribal and familial relationships and dominated by gifts, barter and tribute, can provide a solid base for a local economy."

George Monbiot (2022), the writer and activist, provides a glimpse of the fragility of the global food supply. Four corporations now control 90% of the global grain trade. The same corporations also own seed, chemicals, processing, packing, distribution, and retail. Although our food is becoming more diverse locally, only four crops (wheat, rice, maize, and soy) now account for almost 60% of the crops grown and this production is concentrated in several nations. More alarming is the fact that the food system is tightly tied to the financial sector, increasing the risk of cascading failure, a concept which will be discussed shortly. Monbiot (2022) notes that we urgently need to diversify the global food supply, including the types of crops and farming techniques, in order to eliminate the brittle domination of corporations and financial speculators.

FIGURE 2.1 A community-supported agriculture (CSA) food box of fruits and vegetables. CSA is a system of growing and distributing organic produce that restores the direct link between farmers and their surrounding communities – eliminating the middleman.

Source: Photograph by Robert R. Janes.

It is surprising and heartening to note that peasants are the main or sole food providers for more than 70% of the world's population, and that peasants produce this food with less (often much less) than 25% of the resources – including land, water, and fossil fuels (ETC Group 2017: 6). In contrast, the industrial food chain uses 70% of the agricultural land, 70% of the freshwater use, causes 70% of the biodiversity loss on land, and 73% of the deforestation in the tropics, while only feeding 30% of the world mostly in the Global North. If that is not sufficiently alarming, industrial agriculture is also a major source of greenhouse gas emissions (ETC Group 2017: 6, 17). The contrast between the reality of modern industrial farming and the enduring knowledge of ancestral agricultural practices could not be starker.

Stage 3: Political collapse – There is no longer any faith in government, including its ability to care for society, to level wealth inequality, and to mitigate the widespread loss of goods and services needed for survival. The political establishment at all levels loses legitimacy and relevance. The vanishing of the industrial age, however, and with it the nation states that maintain it, will make room for

smaller and more local political entities – a rebirth of states small enough to renew themselves democratically (Orlov 2013: 157). The seeds of political collapse have been sown as aptly summarized in this observation by Peter Janes, a regenerative farmer:

> A prosperous and growing economy will only destroy our global life supports faster and more efficiently than a steady state or recession economy. Logically, every politician who promises economic growth is promising to keep you more comfortable now while also promising to simultaneously and rapidly destroy your future.
>
> *(Janes, P.B. 2022)*

Stage 4: Social collapse – Social institutions, be they charities and other non-profits, run out of resources or fail internally, and with this goes the belief that the "your people will take care of you" (Orlov 2013: 15, 202, 197). To remain healthy as social animals, however, "we need to be part of a small, close-knit group". In short, "society exists, until it does not." Self-organization will be key (a couple, family, or families), and it will be vital for people to find a safe *way* to be with others, rather than a safe *place* to be.

FIGURE 2.2 A multi-generational family hiking high in the Canadian Rockies. Families will be the key as society adapts to an unknown future.

Source: Photograph courtesy of Priscilla B. Janes.

Stage 5: Cultural collapse – This is the grimmest of the scenarios, summed up in the dictum, "May you die today, so that I can die tomorrow" (Orlov 2013: 15). Faith in the goodness of humanity is lost, and along with it peoples' capacity for kindness, generosity, honesty, compassion, and charity. Families disband and compete as individuals for meagre resources. Orlov (2013: 244) concludes "that family is society, while larger groups are illusory . . . there is no individual and there is no state; there is only the family . . . or there is nothing at all."

The truth hurts

As hypothetical or realistic as these scenarios may be, they are all instructive in revealing some fundamental truths that are now shaping the future and will continue to do so. Although these truths stand in stark contrast to our current way of life and all of its inherent assumptions, they can no longer be ignored. They contain seeds of wisdom and motivation that could assist in creating a new approach to the future, grounded in knowledge, experience, compassion, and common sense. Several of the more notable observations and warnings are examined later.

Our current systems, be they political, financial, commercial, or industrial, are now obsolete as a result of the damage they have inflicted on the world's ecosystems. There is great urgency in developing new life-support systems that steward and protect the More-Than-Human World. In essence, our current way of life, with all of its privileges and complexities, is *hostile* to life on this Planet (Haque 2022a). We continue to act as though nature exists to serve the interests of human beings and that we, as humans, have dominion over the plants and animals. All aspects of our lives are embedded in nature, and to think that we can somehow separate ourselves, or opt out, is simply not possible without dire consequences. It is also essential to recognize that nature does not belong to us – it is not "our" natural environment (Franklin 1999: 85).

The systemic changes discussed earlier are not only scientific, political, economic, and cultural, but also moral in nature. The debate about when or how collapse unfolds matters little, as long as we continue to ignore the *immorality of inaction*. We must determine what kinds of actions are appropriate and commit to them, and the opportunities and responsibilities to do so will be addressed later in this book. Every day we lose irreplaceable time as politicians and corporatists debate their half measures and indulge in their deceitful procrastination. Assuming personal and organizational agency to challenge inaction is the only antidote to the fiction we are currently living. The procrastination and indecision are widespread and also includes the scientific community. Jem Bendell, founder of the Deep Adaptation Forum (DAF), notes:

There are two problematic stories coming from some scientists: the first is to engage in endless scientific discussion before preparing for such an eventuality;

the second is to take this scientific uncertainty as an excuse for not acting, or simply ignore the question.

(Bendell 2020c)

Bendell wonders why it is that many climate scientists assume that the burden of proof in relation to anticipated collapse is on those who warn and ask us to prepare, rather than with those individuals who do not want to discuss it. We are left with two obvious responsibilities as a result – we must learn how to live with the relentless news of the crises we face and we must determine how we intend to respond to calamitous risks and events. I'll conclude with a more sobering scientific perspective, grounded in reality and courage:

> The IPCC has yet to give focused attention to catastrophic climate change. Fourteen special reports have been published. None covered extreme or catastrophic climate change. A special report on "tipping points" was proposed for the seventh IPCC assessment cycle, and we suggest this could be broadened to consider all key aspects of catastrophic climate change.
>
> (Kemp et al. 2022: 7)

Further, "there is ample evidence that climate change could become catastrophic. We could enter such "endgames" at even modest levels of warming" (Kemp et al. 2022: 8). Clearly, an understanding of the extreme risks is essential to all manner of decision-making in preparing for collapse. This book is intended to provide some urgent realism concerning the risks for the museum sector.

Synchronous failure

We must also acknowledge that we have now entered the realm of synchronous failure, as described by Thomas Homer-Dixon (2006: 16, 29–21). Synchronous failure occurs when multiple, interconnected stressors amplify over time before triggering self-reinforcing feedback loops which result in them all failing at the same time. The resulting crises then overwhelm the technological, social, and ecological systems, as summarized in the five stages of collapse discussed earlier. As noted earlier, Homer-Dixon calls this a polycrisis. Furthermore, our highly compartmentalized and specialized world is incapable of managing the ensuing complexity and the ensuing polycrisis.

Homer-Dixon (2006: 281–282) suggests that "we must bring experts together across disciplinary boundaries . . . and realize that there's no magic bullet: there's no single technical solution, institutional response, or policy that will neatly resolve all our challenges." In short, we need to start using our imaginations to think about the unthinkable. Recent research suggests that global warming could increase to 7°C by the end of the century if carbon emissions continue unabated,

two degrees higher than the most recent modelling. This means that the earth is far more sensitive to atmospheric carbon than previously believed. This also "suggests that the climate models we've been using are not too alarmist; they are consistently too *conservative*, and we have only recently understood how bad the situation really is" (Ahmed 2019).

There is cause for active hope, however, embedded in the concept of "catagenesis" or renewal through breakdown and the birth of something new. Most of us, at some point in our personal or professional lives, have suffered a crisis – loss of a job or the death of a loved one, for example. In response, we examined our assumptions, gathered our resources, and started again, often in new and better ways. This is catagenesis – the everyday reinvention of our lives. This concept, developed by Homer-Dixon (2006: 22–23), is augmented by the "Seneca Effect," named after Lucius Annaeus Seneca, a Roman philosopher, who wrote that "increases are of sluggish growth, but the way to ruin is rapid." Ugo Bardi (2017, 2020), a professor of physical chemistry, expanded this observation by developing an explanatory framework.

Bardi's examination of the collapse and growth of human civilizations revealed that after collapse a "Seneca Rebound" often takes place in which new societies grow at a rate faster than the preceding growth rates (Ahmed 2019). This is because collapse eliminates outmoded and obsolete structures, paving the way for new structures to emerge which often thrive from the remnants of the old. This is akin to catagenesis or a breakdown into simpler forms with the opportunities to generate new ideas that could transform our civilization. Recalling E.O. Wilson's earlier observation about our Paleolithic emotions and our medieval institutions, it is indeed possible to transform "medieval" institutions like museums into something more responsive to the threat of collapse.

Bunker mentality

The threat of collapse has also invited a stark trend that is difficult to identify with, unless you are one of those who share its motivation and are materially able to participate. I include this at the end of this chapter because the phenomenon has arisen in direct response to the global scenarios and the stages of collapse discussed earlier. I am referring to the proliferation of doomsday bunkers for the moneyed elite (Robinson and Borden 2020). In 2008, for example, an entrepreneur bought a Cold War missile silo in the state of Kansas (USA) and converted it into a US$20 million fortified shelter complete with a grocery store, a general store, gardens, and a dog park. While units in the development are mostly sold, several are currently available for prices ranging from US$500,000 to US$2.4 million. The clientele for this real estate could be described as an affluent variety of the preppers – those people who believe a catastrophic disaster or emergency is likely to occur in the future and make active preparations for it by stockpiling food, ammunition, and other supplies.

The vacant missile silo has 15 floors divided into 12 single-family homes as well as common areas and space for operations. At the risk of belaboring the details, I note that the purchase of each unit includes mandatory survival training, a five-year food supply per person, and Internet access. In addition, there is an armory equipped with guns and ammunition, including an indoor shooting range for practice so that homeowners can defend themselves against intruders. There are also hydroponic food systems, medical facilities, a gym, and a swimming pool with a water slide. If the apocalypse, nuclear warfare, or a viral epidemic come to pass, private special weapons and tactics (SWAT) teams will pick up homeowners within a 400-mile radius of the bunker. I cannot help but wonder what is planned at the end of the five-year food supply and who will provide Internet services in this doomsday scenario?

The doomsday option is a fitting conclusion to the anatomy of collapse, as it brings us full circle to the beginning of this chapter. Whether you consult scientists, social philosophers, or mainstream pundits, there is no consensus on what the future holds – be it renewal, decline, collapse, or apocalypse. But if the five stages of collapse unfold, you will be insulated from the chaos in your bunker complete with your family and friends. But to what end? Thinking constructively, perhaps these bunker communities could become the human nucleus of a brave new world. It is hard to imagine, however, living in a world confined by concrete and furnished with LED windows that show a live video of the prairie outside. The will to live is exceedingly strong in our species, but is it not better served by efforts to do what is possible now to minimize the consequences of civilizational and ecological overshoot?

If, instead, there is a slow, grinding descent into less prosperity and a wretched quality of life, the doomsday bunker option allows one to escape, or at least minimize the ensuing privation and hardship in isolation with family and friends – presumably to emerge when the worst is over. To privatize one's interests to this extent, however, is to perpetuate the values and beliefs of the MTI society that created the need for these bunkers in the first place – entitlement, consumption, and separation. This is coupled with an apparent belief that it is possible to transcend ecology, economics, and morality to escape from the world we have created. We are left not only with the embodiment of irony here but also with what can only be described as the limitations of our cognitive abilities as a species.

I recall the earlier observation of John Kenneth Galbraith about the causal role of stupidity in history, and it appears that this condition is widespread among the moneyed elite. Stupidity or not, bunkers are not useful in enhancing community well-being. Nor can they conceivably avoid the consequences of the many liabilities we have created, including the sixth mass extinction, resource scarcity, a nuclear conflict, global heating, global poisoning, pandemics, the population crisis, food insecurity, threats from runaway technology (artificial intelligence), and the spread of misinformation.

To conclude this chapter, I look to Joseph Conrad, the nineteenth-century Polish writer who reflected deeply on the perils of modern civilization, including imperialism, colonialism, and the tyranny of groupthink. He noted:

> Few men realize that their life, the very essence of their character, their capabilities and their audacities, are only the expression of their belief in the safety of their surroundings. The courage, the composure, the confidence, the emotions and principles; every great and every insignificant thought belongs not to the individual but to the crowd: to the crowd that believes blindly in the irresistible force of its institutions and of its morals, in the power of its police and of its opinion.
> *(Conrad 1960: 251)*

Conrad provides a cautionary tale that is prophetic for contemporary times.

3
THE MYTH OF SUSTAINABILITY

It is with genuine difficulty that I write this chapter, recognizing that there are so many people who are committed to sustainability as the overarching solution to planetary chaos. Sustainability's adherents are intelligent, caring, and committed human beings, and I count many of them as my close colleagues, friends, and family. But the "emperor of sustainability has no clothes" (to borrow a time-honoured parable), and the sooner we acknowledge this the more time and opportunity we will have to act with understanding and urgency. In short, sustainability and sustainable development, as currently defined, are falsehoods.

Sustainability means "meeting our own needs without compromising the ability of future generations to meet their own needs" (Brundtland 1987: 16). Equally as important, sustainability also means avoiding the depletion of natural resources in order to maintain an ecological balance. The concept of sustainable development, still highly celebrated despite its oxymoronic meaning, extends beyond the natural world to include economic growth, environmental protection, and social equality. Sustainability is a vast and complex topic with devout disciples and fierce critics, some of whom were introduced in the discussion on the harbingers of collapse.

I belong to the critics' camp and will argue that the widely used concept of sustainability is an unachievable myth as currently promoted. In brief, efforts to address environmental sustainability have centred on green growth, which is described as a win–win proposition – continuing economic growth while simultaneously meeting environmental outcomes and goals (Petersen et al. 2019). The promise of green growth relies on decoupling environmental harm from economic growth and, as such, denies the fundamental relationship between economic growth and greenhouse gas emissions.

Green growth denies this relationship and therefore fails to see that continuous economic growth (coupled with a burgeoning global population) is the root cause

DOI: 10.4324/9781003344070-4

of the climate crisis and the other planetary woes described earlier, including the possibility of societal collapse. Sustainability and ecomodernism have much in common, although the latter is more extreme in believing that humans can protect nature and improve their well-being (with a high standard of living) by developing technologies that decouple human development from environmental impacts. Although sustainability champions have yet to embrace this radical notion, the uncritical adoption of sustainability is a major obstacle in addressing the consequences of the world we have created.

Despite many warnings, sustainability adherents have largely failed to acknowledge the root cause of the climate crisis. The goal of ever-increasing economic growth and accumulation drives production, consumption, and the associated harm to the environment. Sustainability is predicated on an array of green technologies and behaviours all of which require burgeoning resource extraction and significant economic growth. We are already consuming the equivalent resources of 1.75 Planets, as noted earlier. To assume that we can continue to do so as the world's population grows is delusional (Rees and Nelson 2020). Resource consumption and sustainability are also plagued by Jevon's Paradox (Wikipedia 2022b). This occurs when technological progress increases the efficiency with which a resource is used – reducing the amount necessary for any one use. However, the falling cost of use increases its demand, thereby negating the efficiency gains. We erroneously assume that efficiency gains will lower resource consumption, whereas increased efficiency results in increased resource use and the destructive impact of the technosphere on the biosphere.

Curse of the baby boomers

I want to revisit a topic I wrote about nearly 20 years ago that received only marginal attention in the sustainability discourse – the role and responsibilities of the baby boomers (born between 1946 and 1964) in the planetary crisis (Janes and Conaty 2005: 6–7). This discussion could have fit neatly in the previous section on *Homo sapien* madness, but I include it here as this generation manifests a philosophy of life that has both greatly deepened the sustainability crisis and wishes to ameliorate it. In short, the baby boomer generation (my generation) in the developed world is the most responsible for the unrestrained consumption of natural resources, as well as for being the most profligate consumers (Gibney 2017). Baby boomers in developed countries have a bigger climate footprint than other age groups, with older adults in 32 countries increasing their climate emissions. For example, seniors in Japan accounted for over half of the emissions in that country (Melore 2022).

In labelling the baby boomer generation as narcissistic, it is important to note that narcissism is not only the overvaluing of self and one's abilities but also the undervaluing of others and their contributions. This is a normal trait of childhood and is mostly outgrown with age, although critics argue that the boomer generation

is characterized by a very high cognitive capacity coupled with persistent selfishness (Wilber 2001: 17–32). In short, this narcissistic individualism can culminate in an inability to take other people, places, and things into account, and the emotional narcissism of the baby boomer generation is a significant factor to consider in our current polycrisis (Janes and Conaty 2005: 6–7). It is not this generation's creative intelligence that is at issue but rather its tendency toward extreme individualism.

This hyperindividualism, in conjunction with culture as consumption and tyranny of the marketplace, is a significant factor in the relentless erosion of meaning in everyday life, including our alienation from the natural world. Baby boomers have maintained this particular frame of reference, along with the values of MTI society – all of which now fuel the harbingers of collapse. Although sustainability has emerged as the pragmatic *mea culpa* for the baby boomer legacy, the research to date clearly demonstrates that the silver bullet of sustainability as currently conceived is not achievable. I will spend the remainder of this chapter examining why. The literature on sustainability, its strengths and failures, is so voluminous that I will limit my commentary to a sample of the more startling and critical assessments.

Energy blindness

The sustainability movement is founded on one crippling deficiency – energy blindness. I am indebted to Nate Hagens, Co-Founder and Director of the Institute for the Study of Energy and Our Future, for his penetrating analysis of the greatest flaw in modern economic theory (Hagens 2022). That is, we do not pay for the creation of, or the pollution from, the most valuable contribution to our economies – fossil fuels. Each barrel of oil is equivalent to four to five years of one person's labour. No one thinks about this when they fill up their gas tank or fly in a plane. Nor do we necessarily know that a barrel of oil also produces up to 6,000 products, including asphalt, all types of plastics, medicine, drugs, fertilizer, insulation, and condoms, to name only several (Hagens 2022).

The average American consumes the energy equivalent of 72 barrels of oil per year. We live in a sea of energy use that we are not even aware of and the oil bank account is diminishing (Hagens 2022). We are burning and releasing ancient carbon ten million times faster than it was sequestered in the earth, and this enormous consumption is directly related to the destruction of the biosphere. Hagen attributes energy blindness to ecological blindness – blindness to the primordial and profound relationship between our species and the natural world we depend upon. This blindness is endemic among those who oversee the political and financial systems, as well as institutions of higher learning.

This relationship also appears to have escaped the sustainability proponents, as replacing our current energy needs with renewable technology (also called clean or green technology throughout this book) is not possible, as renewable energy technologies only produce electricity, and electricity is only 19% of the energy we use globally (Hagens 2022). We need natural gas for heat, gasoline, aviation

fuel, petrochemicals, and so on. In addition, the production of clean technologies will require the same fossil fuels that created the problem in the first place, not to mention all of the raw materials that will be required for manufacturing. What follows are some astonishing examples of this profound disconnect in the sustainability mindset.

Clean technology?

In a recent paper, Seibert and Rees (2021) examined the proposed renewable energy transition and focused on the widely overlooked limitations of the renewable energy technologies commonly proposed as solutions to our energy needs. This examination shows that clean technology cannot deliver the same quantity and quality of energy as fossil fuels; that the espoused technologies are not renewable; and that their production, from mining to installation, is fossil fuel-intensive. I have chosen to examine electricity for the purpose of this discussion, recognizing our unconscious dependence on it for most of what we do. I find it much more difficult to imagine life without electricity than I do a life deprived of fossil fuels. This, despite the fact noted earlier, that only about 19% of the global energy consumption is in the form of electricity, with the other 81% in the form of fossil fuels.

Solar panels

In condensing a great deal of scientific and technological information into a graphic and disturbing message, I am grateful for the work of Seibert and Rees (2021: 4–8), noting that their focus is on the United States – the largest source of greenhouse gas emissions in the world. Transitioning the US electrical supply away from fossil fuels by 2050 would require a grid construction rate 14 times that of the rate over the past half century. The actual installed costs for a global solar program would have totalled roughly $252 trillion (about 13 times the US GDP) a decade ago and considerably more today. What's more, to achieve 90% "decarbonization" and electrification, the United States would have to quadruple its last annual construction of wind turbines every year for the next 15 years, and triple its last annual construction of solar panels every year for the next 15 years.

The future of renewable becomes more agonizing when one considers that there are only four sources of industrial energy – natural gas, petroleum, electricity, and coal (Seibert and Rees 2021: 4–5). Seibert and Rees note that if industrial manufacturing (responsible for generating the innumerable components of renewable technologies) is to continue without fossil fuels, renewable-based technologies must be developed that would supply seamless replacements for sources of energy at acceptable economic and ecological costs. This replacement has not yet occurred. The litany of challenges is long, as the production of solar panels uses toxic substances, large quantities of energy and water, and produces toxic by-products such as silicon tetrachloride and dangerous particulates (Seibert and Rees 2021: 6).

FIGURE 3.1 Solar panels on a residential dwelling. Renewable technologies are only a partial solution to society's burgeoning energy needs.

Source: Photograph by the author.

To worsen the profile of solar panels, they have a lifespan of only 20 to 30 years, making a massive waste management problem. By the end of 2016, there were roughly 250,000 tons of solar panel e-waste globally (Seibert and Rees 2021: 7). Recycling is not the antidote to this short life cycle, as it requires copious amounts of energy and water and exposes workers to toxic materials that have to be disposed of. Currently, there are only a handful of recycling facilities around the world. According to the International Renewable Energy Agency, solar panel waste could amount to six million tons annually by 2050, and the cumulative waste by then could reach 78 million tons. By 2050, dead solar panels could account for 10% of all e-waste (Seibert and Rees 2021: 7).

Batteries

The other most popular panacea to sustain our energy blindness is the electric vehicle, all of which depend upon batteries to function, as do solar panels when the sun is absent. An entire year of production from the world's largest lithium-ion battery manufacturing facility – Tesla's US$5 billion Gigafactory in Nevada (USA) – could store only three minutes' worth of annual US electricity demand (Seibert and

Rees 2021: 7). Storing only 24 hours' worth of US electricity generation in lithium batteries would cost US$11.9 trillion, take up 345 square miles (555 kilometres), and weigh 74 million tons (67,131,000 metric tons) at enormous ecological cost. A sustainable future based on batteries also means mining gigatons of rare-earth mineral ores. For every kilogram (2.2 pounds) of battery, 50–100 kilograms (110–220 pounds) of ore needs to be mined, transported, and processed. In short, all of this only increases our reliance on non-renewable resources – not only fossil fuels but also on the enormous exploitation of more metals and minerals, with all of its consequences for the health of the geosphere (the solid parts of the earth) and the atmosphere (Seibert and Rees 2021: 9).

One need only observe what is unfolding in Peru to understand the unsustainability of battery production (Pearce 2022). Growing demand for lithium for electric vehicle batteries has led to a surge in mining projects in Chile, Bolivia, and Argentina, where companies gather the metal by pumping lithium-rich brine from underground and evaporating it in the sun. For every ton of lithium carbonate produced, miners use up about a half a million gallons of water. As mining lowers the water table, disaster looms for some of the world's rarest and most precious ecosystems, including wetlands, grazing pastures, and lakes high in the Andean mountains, as well as precious water for Indigenous communities.

Child servitude

Environmental issues aside, there is a sordid revelation permeating the push for renewables – a topic that receives little or no attention in proportion to its human consequences. In short, social injustice abounds in the production of current renewable technologies, as much of the mining and refining of the material required for renewable technologies takes place in developing countries (Seibert and Rees 2021: 10). It contributes to environmental destruction, air pollution, water contamination, and risk of cancer and birth defects. Low-paid labour is often the norm, as is gender inequality and the subjugation and exploitation of ethnic minorities and refugees fleeing a litany of threats and hardships.

What should be of particular concern to the privileged world is that this mining often relies on the exploitation of children, and more than one million children are now engaged in child labour in mines and quarries (International Labour Organization 2019: 2). Child labour is found in cobalt and coltan mines – minerals used in portable electronic devices (smartphones) and rechargeable batteries, including the batteries of electric cars. More than half of the world's supply of cobalt comes from the Democratic Republic of the Congo, where children, some as young as seven years of age, work in life-threatening conditions. The risks imposed on these children range from poisonous gases, to tunnel collapse, to neurological damage, to extortion, to sexual abuse by adults, and to death by the lack of medical treatment – to name only several of the health consequences catalogued by the International Labour Organization (2019: 3). Cobalt from these mines has been traced to lithium

batteries sold by major multinational companies, making this a problem of global dimensions. This is a sobering reality to consider when the next flashy upgrade to your handheld device floods the market.

To conclude this discussion of the so-called clean energy, the International Energy Agency (2021: 192) has considered a succinct summary of the risks:

- Significant greenhouse gas emissions arising from energy-intensive mining and processing activities.
- Environmental impacts, including biodiversity loss and social disruption due to land use change, water depletion and pollution, waste-related contamination, and air pollution.
- Social impacts stemming from corruption and misuse of government resources, fatalities and injuries to workers and members of the public, human rights abuses, including child labour and unequal impacts on women and girls.

All things considered, the clean technology panacea must be recognized as a well-intentioned effort to salvage the *status quo*, but the road to hell is paved with good intentions, as the saying goes. The pursuit of renewable technologies in the name of sustainability will heap terminal abuse on the Planet, based as it is on unrestrained consumption devoid of any effort to question MTI civilization. I reiterate that the goal of ever-increasing growth and accumulation drives production, consumption, extraction, and all of the associated harm to the environment. Sustainability is predicated on an array of green technologies and behaviours, all of which require burgeoning resource extraction and significant economic growth. Sustainability as currently defined denies this relationship and fails to see that continuous economic growth, with its extractive industries, is the root cause of the climate crisis, the loss of biodiversity, the destruction of forests, and the acidification of the oceans. Clean technology promises to change everything while keeping everything the same. This is indefensible, impossible, and dishonest.

The UN's unsustainable development goals

Denying the relationship among growth, consumption, and environmental harm is regrettable, as it has sabotaged the UN's praiseworthy efforts to address the well-being of the world's marginalized peoples. In 2017, the UN's Open Working Group on Sustainable Development Goals suggested the following 17 Sustainable Development Goals (SDGs) (United Nations 2015, 2020): (1) No Poverty; (2) Zero Hunger; (3) Good Health and Well-being; (4) Quality Education; (5) Gender Equality; (6) Clean Water and Sanitation; (7) Affordable and Clean Energy; (8) Decent Work and Economic Growth; (9) Resilient Industry, Infrastructure, and Innovation; (10) Reduced Inequality; (11) Sustainable Human Settlements; (12) Responsible Production and Consumption; (13) Urgent Climate Action; (14) Use of Marine Ecosystems Sustainably; (15) Use of Terrestrial Ecosystems Sustainably; (16) Promote Peace, Justice, and Strong Institutions; and (17) Forge Partnerships for the SDGs.

The SDGs are a vital concern as they have now been introduced to the global museum community, with the request that museums adopt them as strategic priorities and assist with their realization. Toward that end, the International Council of Museums established a Working Group on Sustainability (WGS) in 2018 to promote the SDGs and to "recognise that all museums have a role to play in shaping and creating a sustainable future through their various programmes, partnerships and operations" (International Council of Museums 2019). The WGS also urges "museums to respond through rethinking and recasting their values, missions, and strategies and to become familiar with, and assist in all ways possible, the goals and targets of the UN SDGs."

The WGS's progress in achieving these aims is not public knowledge within the museum community, although the SDGs have been embraced by an unknown number of museums and associations. As noted earlier, the climate crisis has yet to command the concerted attention of most museums, and expecting the global museum community to attend to the 17 imperatives of global well-being is unlikely. Although the inherent decency and necessity of the SDG's global agenda are indisputable, its realization is beset with the same absence of reason that underlies the myth of sustainability. I resigned as a member of the WGS a year and half after my appointment, having concluded that the SDGs were a well-intentioned illusion that were drawing attention away from all of the harbingers of collapse discussed in Chapter 1. There are numerous reasons to doubt the soundness of the SDGs, and I offer a summary of three salient reasons why.

First, and most importantly, the SDGs for development and poverty reduction rely on the model of technological-industrial growth with its ever-increasing levels of extraction, production, and consumption. Goal 8 calls for 7% annual GDP growth in the least-developed countries and continued global economic growth equivalent to 3% per year (Hickel 2015). In terms of all we know about ecological and civilizational overshoot, this is not possible. Second, it is clear that economic growth does not reduce poverty. While global GDP has grown by 271% since 1990, the number of people living on less than $5/day has *increased* by more than 370 million (Hickel 2015). Hickel notes that the elimination of poverty using the SDG strategy will require growing the global economy by 175 times its current size and take 207 years. Such immense growth is clearly impossible. Last, underscoring the fallibility of all the SDGs is the simple fact that wealth inequality is ignored (Hickel 2015). If economic growth cannot solve global poverty, then the only alternative is to reduce the enormous inequality that marks our society, where the richest 1% own half of the world's total private wealth. As the Planet continues to warm, it is patently obvious that economic growth must give way to equitable wealth distribution and the equitable sharing of global resources if poverty is to be eliminated.

The three reasons summarized earlier further magnify the myth of sustainability, and yet demonstrate how it has pervaded thinking at the highest level of global public policy. In contrast, the scholarly and scientific communities are pushing back against its false promises. In a letter dated 23 May 2022 and published in the

Independent newspaper, 100 scholars from 17 countries called for abandoning the concept of sustainable development as a result of 30 years of proven failure. I have excerpted part of this letter that is particularly condemning:

> The United Nations has reported non-existent progress to meet the Sustainable Development Goals (SDGs) on reducing poverty and environmental destruction. As members of universities and research institutes from around the world, we know that UN Secretary-General António Guterres was right to state that humanity is moving backwards in relation to the majority of the SDGs. As he emphasised, even *before impacts of the pandemic* response, the "number of people suffering from food insecurity was on the rise, the natural environment continued to deteriorate at an alarming rate, and dramatic levels of inequality persisted in all regions.
>
> Failure to meet the SDGs is an indication of a systemic problem. If the way modern societies operate cause the problems that the SDGs seek to address, can we be surprised that those same systems are incapable of fixing them? It is becoming clear that the assumptions that underpin the SDGs are invalid, including continual economic expansion.
>
> *(Initiative for Leadership and Sustainability 2022)*

Comfort or contraction?

As bleak as this assessment of sustainability is, there are alternatives for realistically addressing the limits to economic growth and accepting the true meaning of sustainability for the polycrisis we face. Although these solutions and alternatives will not be easy or acceptable to many people, and will be poor consolation to others, living within our means is certainly possible. An historical example, within the living time horizon of baby boomers and their parents, is revealing. Because the climate crisis has been likened to World War II, it is instructive to consider what was happening in England in 1944. Rick Atkinson, a military historian, writes:

> Privation lay on the land like another odor. British men could buy a new shirt every twenty months. Housewives twisted pipe cleaners into hair clips. Iron railings and grillwork had long been scrapped for the war effort; even cemeteries stood unfenced. Few shoppers could find a fountain pen or a wedding ring, or bedsheets, vegetable peelers, shoelaces.
>
> *(Atkinson 2013: 1–2)*

Rationing had started in 1940 and did not end completely until 1954. Atkinson (2013: 2) describes the privation in more detail, noting that "the monthly cheese allowance stood at two ounces per citizen. Many children had never seen a lemon; vitamin C came from turnip water." The Ministry of Food promoted "austerity bread" with a whisper of sawdust and "victory coffee" brewed from acorns.

Along with the climate trauma, the COVID-19 pandemic continues to unfold as I write, with new variants appearing regularly. Although it cannot be compared to the death and destruction of World War II (an estimated total of 70–85 million dead), the pandemic is nonetheless an experience in global trauma that merits attention. The pandemic is not over, and it will not likely end for years (Nikiforuk 2022). The disease is clearly not mild, depending on the person, and just one infection can destabilize your immune system and age it. The virus is now evolving at a rate faster than vaccine development and the effectiveness of current vaccines are now waning. In response, public health officials around the world have largely abandoned any coherent response, including masking, testing, tracing, and even basic data collection (Nikiforuk 2022).

There is no certainty about what the current pandemic portends for our biological, cultural, and economic futures. We may well be in a time of extraordinary danger (Janes 2020: 591–593), recognizing all of the other perils discussed earlier. It is salutary to reflect on the COVID-19 pandemic, however, and learn what we can as a preview and dress rehearsal for the evolving climate trauma and the threat of collapse. There are lessons here about discomfort, contraction, and privation, as well as compassion, discovery, and love.

The pandemic has provided an unprecedented opportunity to reflect, reconsider, and reset our lives as we explore two fundamental questions which underpin the meaning of sustainability: "What meaning do we want to give to our lives at this time, and how should we live?" This is the existential crisis emerging from global warming that now permeates even the popular press and is perhaps the greatest spiritual challenge of our time (Scherer 2019). The pandemic has called attention to, if not cleared away, some significant cultural debris that distracts, misleads, or prevents us from addressing these questions (Janes 2020: 592). Such debris includes:

1. Extravagant and wasteful ocean cruises;
2. Unnecessary retail shopping;
3. The assumption that "I can do whatever I want whenever I want";
4. Hyper-capitalism, marketplace dominance, and unrestrained consumption; and
5. The economic hype of globalization.

Even as the pandemic revealed the emptiness of consumer culture, numerous encouraging developments also emerged:

1. Governments acted, albeit not always decisively, when forced to do so.
2. Individuals, families, communities, museum workers, and non-profit organizations drew on deep reservoirs of creativity and ingenuity to adapt, as well as demonstrated remarkable empathy and support for the frontline workers and victims of the pandemic.
3. A new level of organizational consciousness and responsibility emerged in public and private sectors, including the viability of working from home using

digital technology. The value of meetings and conferences that require travel was finally questioned in sectors ranging from museums to the justice system.
4. Citizens reverted to skills and knowledge that were once the mainstay of personal competence and self-sufficiency, such as slow cooking, sewing, gardening, canning, preserving, and home repair.
5. Involuntary or not, a heightened consciousness of collective, rather than individual, well-being emerged, although it may be short-lived.

During the initial spread of the COVID-19 pandemic, we collectively experienced little or no air travel, empty streets, closed shopping malls, working at home, limited entertainment options, and videoconferencing as a mainstay of personal, professional, and business communication. We must ponder what these abrupt changes and the loss of assumed privileges mean in our lives – likely far less than we are accustomed to believing. Now, nearly 80 years since World War II, the world must once again contemplate the need for austerity. The reality of climate trauma and collapse will affect hundreds of millions of privileged people in developed countries who have never known suffering and privation. Business as usual, along with the prevailing sense of entitlement must stop, if we are to dramatically reduce our greenhouse gas emissions.

Perhaps we can change how we live and discard the values and assumptions underlying our consumptive Western way of life. The ongoing pandemic was, and remains, a laboratory and trial run to test the meaning of contraction and reduction under socio-economic circumstances that so far have allowed experimentation with relative comfort and choice, but not for much longer I fear. Regrettably, these opportunities are now being rapidly lost, as the citizens of wealthy countries resume their long-standing habits of comfort, distraction, and conformity. The total demand for air travel in April of 2022 (measured in revenue passenger kilometres) was up 78.7% compared to April of 2021. "With the lifting of many border restrictions, we are seeing the long-expected surge in bookings as people seek to make up for two years of lost travel opportunities" (IATA 2022). The opportunities to rethink our appetite for whatever the marketplace has on offer, and reconsider the planetary consequences of trivial air travel, are rapidly disappearing. The airline industry is of no assistance, as revealed in a research paper that concluded, "the aviation industry's response to the climate challenge is a triumph of industrial interests over reality" (Kallbekken and Victor 2022: 674).

Another indicator of our collective denial is the resurgence of cruising. Cruise ships are notorious for harming communities globally through air and water pollution, tax avoidance, and overtourism. Cruise ships are also powered primarily by heavy fuel oil, the dirtiest fossil fuel available which pollutes three times as much as aircraft (Coulter 2021) – consuming 30 to 50 gallons (114 to 189 litres) of fossil fuels per single mile (1.6 kilometres) Yet, pent-up demand has led to a huge surge in bookings in 2022 and 2023 by people who had their trips cancelled or delayed because of the COVID-19 pandemic, as well as new bookings. For

example, Oceania's world cruise for 2023 sold out within one day of the sale being open to the public in January 2021.

It is unfortunate that the lessons and experiences learned in the pandemic are vanishing, as thrift and hardship will inevitably become necessities in managing societal collapse if we are to achieve even a rudimentary level of sustainability. To date, the world's climate policies are bound up in the very same thinking that created the problems in the first place – now taking the form of incentives, rebates, carbon capture and storage, and carbon pricing in deference to fossil fuel corporations – all based on neoliberal cant (Klein 2020: 171). None of these market-based approaches will reduce household consumption, trivial jet travel, ocean cruising, and business investments in ecological destruction. We now have the opportunity to plan and experience what contraction, adaptation, and transition mean and feel like, and learn invaluable lessons in the process. *Homo sapiens* madness remains at play with its rampant denialism, but museums need not be held captive in this mindset. In fact, it has been suggested that museums can provide an inventory of how societies have achieved rapid transitions in the past by codifying the ingredients and design criteria for successful future rapid transitions. Simms, a political economist and environmentalist, notes:

> Museums matter because they challenge our lack of belief in the possibility of change. In fact, they graphically demonstrate its inevitability. Museums give the lie to the myth of permanence. They are filled with objects and documents that show how change happens, including the possibility of rapid transitions, whether in response to cultural, political, or environmental factors, or war, technology, or demography.
>
> *(Simms 2019)*

Simms's solution is a Museum of Rapid Transition to help us understand the dynamics of change and the stories of how we have made a home in the world. Simms is neither a museologist nor a practitioner, but he clearly understands that museums are not neutral observers of their societies but rather active agents within them. Museums of Rapid Transition, should there ever be any, could play a key role in crafting a new societal narrative.

In addition to overcoming our collective denialism, there is another ingredient in preparing ourselves to accept that sustainability's clean technology is not the promised panacea. Richard Heinberg (2022b) once again offers his wisdom and broadens the context in which we must now understand our roles and responsibilities in the absence of a silver bullet. He notes that we must adapt our values, laws, and core institutions to the increasing scarcity we face as a species. As core institutions, I emphatically include museums. Heinberg writes:

> The only path forward that doesn't end in universal tragedy is a politics of shared sacrifice. If we are living now in a time of converging limits, and are

FIGURE 3.2 A mountain bike converted to a motor bike with a small gasoline engine – low budget and low carbon transportation. All of the society's transportation needs and desires require rethinking.

Source: Photograph by the author.

facing the end of cheap fuel and consumerism, then we need to negotiate these new conditions openly and experience the joy of solving problems by pitching in and working collaboratively . . . but if everyone tries to cling to their current advantages while offloading sacrifice onto others, there'll be hell to pay.

(Heinberg 2022b)

Beyond green

Broadening the context of our thinking to include shared sacrifice reveals that the Western world's concept of sustainability through "clean" technology is essentially a framework for supporting privileged lives in wealthy countries, unencumbered by change and sacrifice. Differing, and far more severe circumstances globally, require a higher level of awareness. Vaclav Smil, an interdisciplinary scholar of energy, environment, and public policy, poses two difficult and overlooked questions:

"What miraculous options will be available to African nations now relying on fossil fuels to supply 90% of their primary energy in order to drive down

dependence to 20% within a decade?" Or "How will China and India (both countries are still expanding coal extraction and coal-fired generation) suddenly become coal-free?"

(Smil 2022)

Broad-brush bans on fossil fuels help no one in lower-income countries. Norway, for example, is one of the world's largest exporters of natural gas and yet is seeking to ban the financing of all fossil fuel projects in low- and middle-income countries entirely. Vijaya Ramachandran (2022), the director for energy and development at the Breakthrough Institute in Berkeley (California, USA), notes that "[t]his puritanical, one-size-fits-all approach is bad for the climate and overwhelmingly leaves women breathing in dangerous smoke from dirty cooking fuels." Ramachandran urges the West to recognize these complexities and understand that safe cooking fuel is both a public health issue and a sustainability issue.

In short, it is simply impossible to eliminate fossil fuel use in a few decades, recognizing the sheer scale, cost, and technical inertia of carbon-dependent activities – not to mention the many other systemic problems bound up with fossil fuel use, such as the public health issue mentioned earlier (Smil 2022). The heart of the matter is to curtail our cultural patterns of consumptive capitalism and economies based on growth, grounded in our ever-increasing energy use. This is a matter of social justice, considering for example, that three billion people use less energy on an annual per capita basis than a standard American refrigerator (Thunberg 2022).

Sustainability as currently defined will not achieve fairness or constraint. Doing with less of the material world is the only alternative for the Western world and it will come at the cost of highly rationed fossil fuels, sacrifice, and hardship as the transition to a new narrative unfolds. Specifically, this will require major changes in consumer lifestyles involving a 40% reduction globally in energy/material consumption per person and an 80% reduction per capita in high-income countries (Rees 2021b). Rees also calls out the taboo subject of population control and notes that a global population strategy is urgently needed to enable a smooth and socially just descent to the one billion to two billion people who could live comfortably indefinitely without destroying the ecosphere.

We will be strengthened in this enterprise of restraint by broadening our understanding of sustainability, beyond "green" comfort and convenience, to include a new sensibility – social sustainability. At the heart of social sustainability is the recognition of interdependence, and the lack of interdependent relationships among most museums and their communities is an increasing liability, as it is for society at large (Janes 2016: 181–182). Neoliberal thinking has done great damage to our sense of community and collective well-being, replacing it with a shallow and self-absorbed individualism. There are now myriad opportunities for museums to respond to the issues and aspirations of their communities, and embed themselves as advocates, collaborators, partners, and problem solvers. Achieving this

heightened sense of interdependence is a brave new world for museums and it must become a strategic priority as collapse presents itself.

There is also another side to social sustainability that is more complex and involves the "perceptions of the broader community about the institution, and how strongly that community supports the organization, in good times and bad" (Friedman 2007: 8). How will these community perceptions play out as economic growth declines and everyday assumptions about the good life begin to evaporate? Will museums be recognized as sources of adaptive knowledge and skills, with the capacity to assist with defining and assisting with this transition? Do museums care enough about their communities to ponder these questions in collaboration with them? Will museums listen and take to heart the needs and aspirations of their communities? Will they share in the civic leadership that their communities require? These are the questions that must now dominate staff meetings, board meetings, strategic planning sessions, workshops, and conferences.

It is more useful to think of sustainability as navigating between the extremes of catastrophism and the techno-utopia of green technology. Sustainability for our civilization is no longer about buying more energy-efficient stuff, such as electric vehicles, or rationalizing one's consumption by buying carbon offsets. Sustainability for museums is no longer about social media, popularity, new buildings, growing audiences, and earned revenues. Sustainability must now embrace intangible matters that are not openly discussed and that fail to make the news, such as critical thought, compassion, sacrifice, contraction, grieving, and generosity. We will need these intangibles as we face the future together.

4
WHY MUSEUMS?

The global museum community is the largest, self-organized franchise in the world, and museums constitute an informal network of public storefronts, unlike any other organizations. As noted earlier, museums are also civil society spaces where the threat of collapse, and all its attendant issues, can be aired, discussed, and acted upon. Museums are uniquely qualified to do so because of their singular combination of historical consciousness, sense of place, long-term stewardship, knowledge base, public accessibility, and unprecedented public trust. No social institutions have a deeper sense of time than museums, and by their very nature they are predisposed to exercise their larger view of time as stewards of the biosphere. Although still plagued by elitist behaviour and denialism, museums are public places where people can meet, work, and learn from each other. Museums can move the conversation about collapse beyond the academy and the fringe into society at large (Janes 2022).

Acknowledged or not, the world and its peoples are now part of the greatest transition in human history, as a result of the disruption of natural systems (Greer 2011: 239; Kunstler 2005) and the ensuing socio-environmental consequences now unfolding across the world. MTI society has commodified everything and shattered our sense of community and interdependence. Our collective separation from the More-Than-Human World is also now complete (Wilson 1998, 2006). Museums are grounded in community; they bear witness by making things known, and they are a bridge between nature and culture, and science and the humanities. They are key resources in starting the conversation around a new story for our species – moving from the myth of continuous economic growth and human exceptionalism to the durability and well-being of communities and the natural world (Korten 2014; Macy and Johnstone 2012).

Civil society and social capital

Recognizing the nearly complete absence of museums in the public discourse on pressing societal issues, it is necessary to establish more decisively why they have a role to play in contemporary affairs, above and beyond their preoccupation with collections, education, and entertainment. Although there is little discussion or literature about museums as organizations of civil society, this status is at once both a defining attribute of museums and a licence to serve society unhindered by the dictates of marketplace ideology and profit-making. I have written extensively about museums as stewards of civil society and the following discussion draws on one article in particular (Janes 2007).

The concept of civil society is by no means new. Its definition is attributed to the nineteenth-century German philosopher G.W.F. Hegel, best known for his idealist philosophical system in which dialectical logic sees contradictions as fruitful collisions of ideas from which a higher truth may be reached by way of synthesis (Bullock and Trombley 1999: 126, 222, 387). Simply put, "civil society" is the sphere of society lying between the private sphere of the family and the official sphere of the state and refers to the array of voluntary and civic associations, such as trade unions, religious organizations, cultural and educational bodies, that are to be found in modern, liberal societies. In practice, the boundaries between state, civil society, family, and market are often complex, blurred, and negotiated. Civil society commonly embraces a diversity of spaces, actors, and institutional forms, varying in their degree of formality, autonomy, and power.

Of particular importance in considering museums as agents of civil society is the concept of social capital, since it is civil society organizations that generate the networks, norms, trust, and shared values – the "social capital" – that is transferred into the social sphere and not only helps to hold society together but is also instrumental in facilitating an understanding of the interconnectedness of society and the interests within it. Social capital is born of long-term associations that are not explicitly self-interested or coerced, and it typically diminishes if it is not regularly renewed or replaced (Bullock and Trombley 1999: 798). In short, civil society enables individuals to participate in a variety of ways in the life of society without any direction by the state.

In a country like Canada, where most professional museums are owned and operated by some level of government, the role of museums in civil society remains undiscovered and unexplored (Janes 1997: 232, 254–258). Whether a museum is government-owned or not (the latter being more characteristic of US museums), the concept of civil society provides a valuable context in which to clarify some persistent complexities that obscure a clearer understanding of the meaning and value of museums. This is particularly important for museums at this time of world crisis, since the concept of civil society serves to explain how an increasingly economic view of museums is destructive and continually undermines the unique contributions that museums are capable of making. An economic view of democratic

society sees only individuals and government (Dahrendorf 1990: 24–32). This perspective, grounded in marketplace ideology, creates the space for autonomous activity, but then corrupts civil society by turning everything into commodities. This is best summed up by the eminent sociologist, Sir Ralf Dahrendorf:

> If we allow an economic view of society to prevail, then the institutions that provide a buffer between the state and the individual will be left unprotected, leading to their disruption. In the end, universities will be places not of teaching and research, but appendixes of economic growth; the arts will be mediums not of human expression and enjoyment but of commerce, entertainment, or advertising.
>
> *(Dahrendorf 1990: 26)*

Dahrendorf's observations were prescient; the future has arrived. The pressures to buy, sell, and entertain are front and centre, and the ensuing unbridled consumption has brought the Planet to the brink of collapse. Whether the offerings consist of plastic replicas of Egyptian funerary objects or the mummified remains of our Neolithic ancestors, far too many museums have joined the perpetual round of entertainment, complete with the inevitable sameness inherent in contemporary consumerism. Seeing people only as audiences is understandable and necessary to a certain extent, but it is only short term and it is only bottom-line-driven. Museums, as constructions of civil society are exceedingly more valuable than this, as they are an essential counterbalance to the rhetoric of the free market.

As such, museums have a much more enduring role to play in society by clearly demonstrating that no one group or ideology possesses the sole truth about how society should conduct itself. A competent museum is testimony to the fact that a healthy society is a multitude of competing interests, aspirations, plans, and proposals that cannot be ignored in favour of economic utility. Recognizing this creative chaos is the only guarantee of an open society (Dahrendorf 1990: 24), and museums are the obvious caretakers and facilitators of these complexities and competing values.

The value of social capital assumes more meaning for museums with the work of Robert D. Putnam (2000) in his well-known study of the decline of civil society in the United States. He identified two types of social capital – bonding and bridging – with bonding social capital referring to social networks between homogeneous groups of people (similar age, race, religion, etc.). Bridging social capital consists of social networks among heterogeneous groups who are dissimilar and diverse. Both of these types of social capital are essential to civil society, with the bridging variant being critically important in multi-ethnic societies if they are to achieve some degree of stability and cohesion. Although largely absent from the roster of civil society organizations, museums have engaged in the creation of bonding social capital for a significant portion of their history.

As for bridging social capital among heterogeneous groups, time will tell although the collective track record of museums to date is dismal or non-existent.

One need only recall the growing unrest over the lack of access, diversity, equity, and inclusion in North American museums, and the fact that much of the museum reaction has been performative – good words but with little or no structural reform to effect authentic organizational change (Tortelero 2022). There is no doubt that museums are deeply entrenched in the broader histories of colonialism, globalization, and capitalism and are closely bound up with the forces that have led to the marginalization and oppression of Indigenous Peoples (Museums 2020).

Despite these shortcomings, there is no doubt that museums are privileged to operate in civil society. This privilege is a pathway to museum relevance and meaning, notably at a time when governments and corporations have limited their actions to the realm of self-interest, while global civilization confronts disruption and collapse. Building and sustaining social capital will be a critical ingredient in adapting to an unknown future, including creating new social networks; meeting new people; finding colleagues, friends, and allies. This is the meaning of community and its value will have no substitute in an uncertain world.

Branding adaptation

With few exceptions, most museums do not brand values – they brand "stuff," and the language used is all about customer service, efficiency, entertainment, value for money, and so on (Janes and Conaty 2005: 1–17). Success is measured by increasing attendance, growing collections, and expanding facilities. Adherence to this model of "more is better" is now fatal, as the fallacy of unending growth has been revealed.

It is both puzzling and exasperating that the museum's kinship with civil society has not been recognized as a marketing and branding opportunity, bringing the credibility and integrity that would stem from such a connection. This linkage will be instrumental in empowering those far-sighted museums that choose to carve out their role and responsibilities in defiance of disruption and collapse. There is still time to plan and adopt this new way of communicating the societal value of museums as instruments of civil society. In so doing, it is essential to move beyond the two predominant types of brands – corporate and product – and focus on the branding of values – the category that is most appropriate for museums. A values brand, according to Scott (2000: 36), "has an enduring core purpose, which creates a long-term bond with those sectors of the market sharing the same values." It would seem that most museums are unaware of these distinctions as museum branding and marketing strategies persist in treating visitors and users as consumers and customers (Kotler and Kotler 2000: 273).

Museums continue to use the language of the marketplace in addressing their purported needs and aspirations, even while under siege for elitism, racism, colonization, falling attendance, and precarious relevance. Museums continue to brand "stuff," not values as noted earlier, and the language used is all about consumption and customer service. The uncritical use of these private sector techniques has not gone unnoticed, however. There is now a growing interest in moving beyond the

language of the marketplace to create civic brands around ideas that are less tangible, and intended to build emotional identification and take credit for the public value (the social capital) that non-profit organizations create (Demos 2023; Ferguson and Janes 2022; Institute for Media, Policy and Civil Society 2004). Herein lies a realistic approach for nurturing a civil identity for museums – an essential first step in preparing for disruption and breakdown.

There are several requirements for doing so, which are summarized here (Institute for Media, Policy and Civil Society 2004: 1–10). Because the brand is central to the values and mission of a museum, the marketing department cannot be given the task of defining the brand. It cannot be manufactured by clever people brainstorming but must be based on the answers to several key questions, including why does your museum exist, what changes are you trying to effect, what solutions will you generate, and what are your non-negotiable values (collaborative, inclusive, diverse, empowering, and so forth)? Addressing these salient questions requires broad, deep, and lengthy conversations among staff, boards, collaborators, and citizens. The forces of the marketplace have prevented most museums from moving beyond conventional branding to engage in this questioning, but it is never too late to rethink.

To begin, museums could introduce the topic of societal collapse to select groups or individuals in their communities and explore its meaning and consequences with those who are ready and willing to engage in this difficult topic. One outcome could be learning how the museum could advise and assist in exploring what both inner and outer adaptation mean for individuals and communities (Deep Adaptation Forum 2022). I will examine this in detail later in the book but for now I note that inner adaptation means "exploring the emotional, psychological, and spiritual implications of living in a time when societal disruption/collapse is likely, inevitable, or already happening." Outer adaptation means "working on practical measures to support well-being, ahead of and during collapse" (e.g., regenerative living, community building, and policy activism).

Having introduced this most urgent and threatening of issues, the next step would be to develop a constellation of activities that both create and uphold the brand. In short, branding is a powerful technique for allowing museums to move beyond the reigning model of economic utility and to create an alternative language to that of the private sector – a language more appropriate for museums as instruments of civil society and one that is absolutely essential in bringing to bear the value of museums in reducing the consequences of disruption and collapse. Although government and business have chosen to ignore the peril that surrounds us, civil society organizations need not and should not.

The ethical obligations of museums

If civil society is the social context to realize the potential of museums, defining this potential is contingent upon embracing a wide and deep vision of the museum as a force for good. I have chosen to anchor this vision in a framework of ethical obligations, for which museums are aptly suited to both adopt and pursue

(Janes 2013: 351–360). In considering the role of museums as active agents of cultural change and forces for good, I have three expectations of them as public institutions (Janes 2013: 375): (1) to be open to influence and impact from outside the museum, (2) to be responsive to citizens' interests and concerns, and (3) to be fully transparent in fulfilling the first two expectations. Fulfilling these expectations will require that museums expand their understanding of their mandate and purpose at this time in history.

Such rethinking and reinvention are already underway in other sectors of society and I am indebted to the economist Jeffrey Sachs (yes, an economist) for his assessment of the environmental degradation, rapid population growth, and extreme poverty that threaten global peace and prosperity. Sachs (2008) argues forcefully that these so-called soft issues will become the hard issues of geopolitics in the coming years – which they indeed already are. He writes that dealing with these issues will require the energies and talents of all parts of society, and he notes that the public sector, the private sector, and the non-profit sector (including foundations and academia) have always played interlocking roles in global problem solving, although the success of this collaboration is certainly debatable. He specifies the core responsibilities of each sector, with the proviso that only clearly stated and shared goals can orient the multitude of individual actions that are necessary to confront these challenges (Sachs 2008: 291–293).

Mobilizing science, entrepreneurship and applying solutions are the key components of Sachs's blueprint for change and museums, although unmentioned by him, are certainly capable of all three. Building on Sachs's description of the non-profit sector's key roles in global problem solving, I propose that museums have six ethical responsibilities in a troubled world. In using the word "ethical," I am referring to such things as justice, right conduct, and duty. I agree with Janet Marstine's observation (2011: 8) that "the new museum ethics stresses the agency to do good with museum resources."

Public advocacy

As commonly understood among museum practitioners, advocacy means lobbying governments for greater recognition of museums and more public funding. It means letting legislators, policymakers, and other stakeholders know what museums are, what they do in their communities, and why they are valuable. Museum workers advocating for support, however, is not the meaning of public advocacy as an ethical responsibility. As an ethical responsibility, public advocacy is concerned with broader societal issues and concerns where the museum can add perspective, expertise, and value. It means moving beyond the many internal agendas devoted to the museum's well-being and using the museum's resources to enhance individual and community well-being in collaboration with like-minded organizations. In so doing, it is inevitable that a museum will broaden its constituency and strengthen its role as a recognized community organization.

The major obstacle to any sort of advocacy is the conventional museum commitment to neutrality (Janes 2009a: 59–61, 2016: 164; Museums Are Not Neutral 2021). There is a widely held belief among museum-governing authorities and staff that they must protect their neutrality (with the exception of their expert pronouncements on quality and excellence), lest they fall prey to bias, trendiness, and special interest groups. The meaning of neutrality has changed over the past decade, however, as museums have increased their reliance on corporate, foundation, and private funding, and more and more business people are appointed to governing boards. The unspoken argument is that museums cannot risk doing anything that might alienate a private sector sponsor, real or potential. The simple truth, apparently unrecognized by the proponents of museum neutrality, is that corporations and the business community are themselves special interest groups, grounded in ideology and neoliberal beliefs, including free-market capitalism, deregulation, and reduction in government spending.

Museum staff and boards also argue that it is foolhardy and dangerous to take a stand, or advocate for a particular perspective or issue, because the world is too complicated and truth and opinions are ephemeral in the postmodern world. There is no doubt that moving beyond neutrality requires judgement and risk-taking, with the potential for both collective good and abuse. Experience, intelligence, and prudence are essential in assessing each situation, comparing various courses of action, and then choosing the one that best fits the purpose and circumstances. This process would be aided considerably by an advocacy policy, which I will examine in Chapter 5.

It is important to note that a museum need not sacrifice its traditional activities to advocate publicly, and there are various examples that confirm this. The Science Museum of Minnesota, for example, has made a bold commitment to advocate for climate action, as embodied in this official statement (Science Museum of Minnesota 2022):

From awareness to action

Help move the climate conversation beyond awareness to action.

It's time to talk about the reality of climate change. Individual actions are essential, but ultimately change needs to take place on a larger scale as well.

Learn about the science behind our changing climate, how to support bold actions informed by science, and how to advocate for climate justice with friends, family, and elected officials.

Get inspired to protect our home Planet by seeing it from new perspectives and being reminded of all the Earth provides for us.

Add your voice to demand Action for Earth with the Science Museum of Minnesota.

It is important to note that the Museum's commitment to its collections remains intact – providing artifacts, documentation, archival information, and expertise for exhibitions and programs, while ensuring the collections' physical integrity and maintaining the intellectual content. Providing access to the collections for museum staff, outside researchers, and the public also remains as a core commitment, alongside the climate advocacy. Advocacy and traditional practices are not antithetical, despite conventional wisdom to the contrary.

Problem solving

Problem solving as an ethical responsibility is closely related to public advocacy, as one may serve the other. These can be seamless or, depending on the project, be separate in thought and execution – in part because problem solving may not require advocacy. Or, the advocacy may not require problem solving – just bringing attention to a particular issue. Again, the focus of problem solving as an ethical responsibility is on societal issues, concerns, and aspirations where the museum can provide advice, assistance, and expertise. Because problem solving in a public context is not commonly done in museums, some discussion is in order. With the pervasive nature of socio-environmental issues, problem solving is unlimited in scope and can thus mirror the museum's particular resources and expertise.

Problem solving requires a greater degree of engagement than advocacy, as it will require both the examination of what needs to be done and the marshalling of support in order to follow through. This takes collaboration, as it is unlikely that a museum is sufficient in expertise and resources to act alone. Clearly stated goals will have to be developed in collaboration with the appropriate community, whoever that may be, and the initial work can take the form of a pilot project where the new thinking and initiatives can be a proving ground. Museums have a distinct advantage in adopting this experimental approach because they are relatively free and creative work environments and far less constrained than many public and private institutions. Museums do not represent commercial interests with widget quotas and, with the exception of national museums, are not agents of national policy. Nonetheless, most museums still have much to do to test their autonomy with staff and governing authorities, in order to determine their appetite for taking action while contending with their own liabilities and limitations.

Recipients of the Activist Museum Award provide excellent case studies of museum workers and museums as both advocates and problem solvers, and clearly demonstrate that there is no formulaic approach to doing so (Activist Museum Award 2021–2022). This award was established to encourage, inspire, and support activist museum work throughout the UK museum community and the world. Museum activism refers to museum practice that is shaped out of ethically informed values and is intended to bring about political, social, and environmental change. Several winners of the Activist Museum Award include:

1. **Jean Campbell**, an arts educator, has over 12 years of experience in facilitating training workshops for museum professionals who work directly with colonial histories and their objects. The award will enable her to develop a series of podcasts and zines which will explore and critically review the design, delivery, and experiences of Trans-Atlantic slavery for staff training.
2. **Museum as Muck** is an activist network that has started a dialogue around class in the UK museum sector and the need for museum workforces and audiences to be inclusive and diverse. The Museum supports museums across the United Kingdom to improve their recruitment and retention of working-class talent and foster progressive working practices that will lead to social change within the sector. The award was used to develop workshops and interventions with people who understand the barriers to a diverse museum workforce.
3. **Museum of Transology**. Community collecting as a democratic form of peaceful direct action is one of the most powerful tools museum activists can use to disrupt colonial narratives. This award will enable the Museum to share its resources, methodology, and experience beyond the trans community. This will not only showcase the trans community's generosity of spirit and willingness to collaborate, but also demonstrate how museums can – and must – harness their social agency to combat historic misrepresentation of marginalized groups.

It is clear that the museum landscape is changing as demonstrated by these non-traditional initiatives that not only advocate but also offer solutions to solve problems.

Collaborating on the funding of solutions

Collaborating on the funding of solutions is perhaps one of the most potentially contentious responsibilities for museums, given the financial pressures they contend with daily. How could one conceive of parting with scarce funds, even for a related interest? This is where courage and imagination are required, as collaborating on the funding of solutions can take various forms. Depending on the issue or concern, there could be a direct connection between public advocacy, problem solving, and funding, with one leading sequentially to the other. Or the museum's financial support might be in kind – through collection loans, staff expertise, or exhibition production, for example. In deciding to share a museum's funding with outside agencies, it is important to note that there are a great many non-profit organizations, working in all sectors of the society, that have far more meagre finances than most museums.

Although collaborations among museums and non-museum organizations are uncommon, there are exemplary ones underway (Szántó and Schell 2022). As part of the Frankenthaler Foundation's prioritizing climate action in the United States, they launched an initiative to assist American museums in reducing their climate impact. In collaboration with the Asia Society, the Hirschhorn Museum,

the National Gallery of Art, the Phillips Collection, the Environmental Defense Fund, and the John F. Kennedy Center for the Performing Arts (all in the United States), the Frankenthaler Climate Awards were established. I quote:

> At a time when so many aspects of institutional behavior are under scrutiny, from collecting policies to hiring practices, still far too few galleries and museums showcase work done by artists dedicated to shaping public perceptions about how to save our Planet from the ravages of climate change. There is no time to lose.
>
> *(Szántó and Schell 2022)*

This multisectoral alliance of philanthropists, museums, galleries, an environmental non-governmental organization (NGO), and the performing arts might well be unprecedented and clearly models an approach to charting the future that is indispensable in addressing the current chaos and complexities. Assembling a critical mass of resources, knowledge, and prestige is within the reach of any museum and is only limited by the availability of courage, humility, and the willingness to act.

Insisting on the accountability of government and the private sector

For several decades or more, the focus has been on improving the accountability of museums. Governments, foundations, the private sector, and museum workers themselves concluded that museums needed to be more open, more fiscally responsible, and more accountable to the visitor. Performance indicators and quantitative measures were also introduced (albeit unsystematically and with no consensus in the museum sector), and there was a move to reduce the authority of the so-called self-interested, professional groups – notably curators. This, in turn, led to the unconfirmed "death of the curator" – a rumour, which is still alive and well, but essentially untrue. It is now generally believed that museums spend more time on their visitors than on their collections, although there is little evidence to support this claim.

Much good has been accomplished as a result of this insistence on greater museum accountability and this is a matter of record. In light of what has been accomplished, and recognizing the litany of dire societal issues, it is now essential to reverse the accountability imperative, wherein museums exercise their right as social institutions to insist on the accountability of governments at all levels, as well as the private sector. It is clear that governments and the private sector require inordinately more accountability, as both persist with decisions, actions, and inactions that are destroying the well-being of individuals, communities, and the biosphere.

The most obvious risk in insisting on accountability is "biting the hand that feeds" – that governments and businesses are key funders of museums. In 2012, for example, the Canadian government enacted legislation that brought more scrutiny

to foreign funding for charities, including how charities used the money for political purposes. The government targeted environmental organizations with this legislation because many of them were actively opposed to major resource extraction projects that the federal government was promoting (Blumberg 2012). Similar consequences could befall activist museums, but this remote possibility is not a sufficient justification for inaction. Some courageous risk-taking is in order.

At the same time, I recognize that there are countries throughout the world where insisting upon the accountability of government could risk one's life. Any challenges to the system originating in the museum sector in these countries will have to be more subtle than what is being recommended here. Admittedly, insisting on government and private sector accountability as an ethical responsibility borders on the theoretical, but there are notable examples underway. The "We Are Still In" movement is a joint declaration of support for climate action, signed by more than 3,900 CEOs, mayors, governors, tribal leaders, college presidents, faith leaders, healthcare executives, and cultural organizations (We Are Still In 2022). The organizations they represent constitute the largest and most diverse coalition of individuals and organizations ever established in pursuit of climate action in the United States.

The "We Are Still In" Declaration was launched on 5 June 2017 in response to the United States' signalled withdrawal from the Conference of the Parties or Paris Agreement (COP21), and is a joint statement of support for the Paris Agreement. Signatories are committed to:

- Recognizing the economic and public health benefits of climate action;
- Pursuing ambitious climate goals, regardless of federal leadership;
- Working collaboratively, with signatories and other partners, to take forceful action; and
- Maintaining American leadership through engagement with the international community.

Of particular interest is that 87 of the signatories are cultural organizations, including museums such as the Californian Academy of Sciences and the Field Museum, as well as state museum associations and the American Alliance of Museums. Museums are clearly ready, willing, and able to push back against government irresponsibility and incompetence if they choose to do so.

A second example demonstrates a particularly courageous challenge to the *status quo*, undertaken by the Natural History Museum (NHM – established in 2014), a travelling, pop-up museum that highlights the sociopolitical forces that shape nature (Natural History Museum 2022). Working with artists, activists, First Nations, scientists, and museum professionals, the NHM organizes exhibitions that interpret environmental history – connecting local threats and movements to protect the environment, public health, and local cultures to the history of museums and the legacy of colonialism, as well as to ongoing concerns about cultural and environmental heritage. Their intention is "to unleash the power of museums,

motivating them to act not as shrines to a civilization in decline, but as agents of change" (Natural History Museum 2022).

This the NHM did with a vengeance in 2015 when they launched a petition to remove David Koch from the Board of the American Museum of Natural History in New York (Lyons and Economopoulos 2015). A billionaire philanthropist and climate-change denier, Koch's businesses are major contributors to greenhouse gas emissions, as well as funding groups that foster climate denial. The NHM's message was clear and simple – "There's no place for David Koch, or anyone behind funding the denial of man-made climate change, on the boards of these trusted institutions" (Lyons and Economopoulos 2015). In the wake of public pressure, Koch resigned from the board of the American Museum of Natural History early in 2016 after having served for 23 years. If mainstream museums are not willing or able to demand accountability from their governing authorities, it is now clear that this new breed of activist museum organizations has the vision and means of doing so.

Beka Economopoulos, co-founder and executive director of the NHM, noted that they have grown too frustrated with mainstream museums to imagine that they can change them, at least not with the time and labour-intensive collaborations that come and go without any deeper institutional transformation. Instead, she writes that, "we're leaning into joyful autonomy, rebranding NHM as a 'museum for the movement,' and writing our own rules for what a museum is and does in our era of crisis" (Beka Economopoulos, personal communication, 10 March 2023).

Fostering scientific, humanities, and social science research

Research has long been a core function of competent museums, although its importance has declined over the past several decades worldwide. It has suffered from decreasing public funding for museums and the need to allocate limited resources to enhance fund raising and increase earned revenues. Most museum research is devoted to the collections, however, and its societal relevance may not be readily apparent to the non-expert. My concern with scientific and humanities research as an ethical responsibility is directed to increasing our knowledge and understanding of pressing social and environmental issues – not only by championing practical approaches which use the collections but also by engaging in problem solving. This will not only serve the cause of science in the public interest but also raise the profile and value of museum-based research. I will provide two brief examples as illustrations.

The first is the Canadian Museum of Nature, which joined the Global Coalition for Biodiversity in 2021. It was one of the first North American institutions to support this international campaign to raise awareness about the need to protect biodiversity and to share its importance to the health of the Planet (Canadian Museum of Nature 2021). This global coalition was launched by the European Commission in

2020 and now includes more than 250 museums, botanical gardens, zoos, aquaria, parks, universities, and research centres from around the world. This collaboration comes at a critical time as the world's biodiversity suffers a dramatic decline as a result of human activities. Knowledge, understanding, and awareness of the natural sciences are imperative to finding and implementing sustainable solutions to the climate trauma, habitat loss, and the spread of invasive species. Museum collections provide the physical evidence that documents biological and geological change over time and describe trends to help predict future impacts on biodiversity, all of which are essential to finding solutions.

The second example of museum research in the service of society is also Canadian and is a collaboration between the Royal Saskatchewan Museum, Heritage Saskatchewan, and the University of Regina (Heritage Saskatchewan 2022) – led by the Museum's Curator of Human Ecology, Dr. Glenn Sutter. This project, The Saskatchewan Food, Culture and Heritage Survey, is examining how people produce, access, and consume food, including the relationship between food, Saskatchewan cultures (Indigenous and non-Indigenous), and local environments. The findings from this study will provide important information with which to share knowledge about local food security challenges and opportunities in the province. The ultimate aim is to inform advocacy work and government policy development. At a time when global food systems are severely disturbed by climate trauma, poverty, conflicts, and wars, this is a noteworthy and prescient initiative that clearly demonstrates the valuable role a museum can play.

Although humanities and social science research in museums is seemingly less developed and visible than the physical and life sciences discussed earlier, this research is also underway. A prominent leader is the Research Centre for Museums and Galleries (RCMG) at the School of Museum Studies at the University of Leicester, UK (co-directed by Suzanne Macleod and Richard Sandell). The RCMG is concerned with nurturing critical thinking and developing new approaches that equip museums to take up socially purposeful roles (Research Centre for Museums and Galleries 2022). The RCMG's current projects are many and varied, including reframing difference and disability, human rights and LGBTQ+, building healthier, well-connected communities, and socially purposeful organizations, to name several. The latter project is of particular interest to me, as the RCMG has generated new insights, concepts, methodologies, and practices that have enabled museums to refocus their aims and ambitions in relation to social needs, concerns, and challenges. This is precisely the essential organizational shift facing the global museum community.

The RCMG demonstrates both the value and necessity of collaboration between museum academics and practitioners and sets the standard for enhancing the method and theory of progressive museum practice. They are unconstrained in their research by entrenched professional and academic boundaries, a radical departure from current museum practice and museological training. Collaboration

is the foundation of the RCMG's work and they bring together organizations and expertise within and beyond the cultural field, including researchers, practitioners, policymakers, artists, and activists. Together, they "give value to forms of expertise derived from lived experience alongside curatorial and academic specializations" (Research Centre for Museums and Galleries 2022). One cannot overestimate how exceptional and valuable this perspective is at a time of increasing complexity, chaos, and insularity. As disruption increases, we will adapt to the extent that we can share diverse perspectives and knowledge with a common purpose. The RCMG is clearly ahead of the curve and stands in stark contrast to the perplexing insularity of many museum studies programs.

To reiterate, humanities and social science research in museums is that which studies the human condition in analytical and critical ways to enhance our understanding of modern social, cultural, technological, environmental, and economic issues, as well as our relationships to these issues. Similar to the physical and life sciences discussed earlier, humanities and social science research is also an attempt to determine what we need to know and do in order to meet the many challenges confronting society worldwide.

In concluding this discussion, I want to introduce the practice of intellectual activism. This is defined in *The Independent Scholar's Handbook* as activities which do not necessarily create new knowledge but make existing knowledge more accessible, understandable, and useful to others (Gross 1993: 164–170).) Most importantly, intellectual activism creates the conditions for fresh discoveries through "the conjunction of challenging ideas, or stimulates others to discover." These activities can range from speaking to non-professional audiences, to bringing scholarly work to a wider public, to alerting the public to knowledge and issues that have direct bearing on their well-being.

Most museums already have the requisite resources in hand or have ready access to them from sister museums or other knowledge-based organizations, notably universities and research agencies. It is no longer credible to claim the lack of a research budget or the lack of research staff. Museums must now release, promote, and celebrate the knowledge and information that is at hand in their museums and their communities, employing their particular skills and resources to ensure accessibility and meaning. This will mean prioritizing and discarding certain programs over others, so be it. This must be done as it is unconscionable to simply load more obligations and responsibilities on existing staff. Many museum executives and managers do not understand that strategic planning is as much about saying no as it is about defining priorities. Museums cannot be all things to all people. The time for engendering acute awareness of the difficulties we face is now. Museums are in an indisputable position to do so, buttressed with the grace of public trust. Intelligent and sensitive management will be essential, however, in ensuring that the well-being of staff is included as key priorities are defined and the work begins. Task saturation is a chronic problem among too many dedicated museum workers.

Fragmentation is good and bad

According to UNESCO, the current estimated number of museums worldwide ranges from 95,000 to 104,000 (Statista 2022). As noted earlier, this is the largest, self-organized franchise in the world which serves the public with no profit motive. McDonald's fast-food enterprise is the world's largest private sector franchise with 33,000 outlets worldwide. Were museums (not including the many regional, national, and international museum associations) to somehow pool even a modest portion of their resources and act in concert, the resulting momentum might well be unstoppable. Regrettably, such a possibility remains unattainable, as it is complicated by the enormous diversity of the global museum community (subject matter, financing, staffing, facilities, governing authorities, etc.), as well as being undermined by the International Council of Museum's (ICOM's) tortuous process to get agreement on a contemporary definition of a museum.

The process of redefining the museum revealed the divide between those who define museums in traditional terms (research, collecting, conservation, interpretation, education, and exhibitions) and those individuals, like me, who see museums as active agents of civil society with a capacity to enhance planetary well-being. Those opposed to this more expansive view of museums are alarmed by the use of language about social justice, global equality, and planetary well-being – disturbed that such text in a definition is too political for most museums to acknowledge. Various definitions were reviewed (International Council of Museums 2022) and, in August of 2022, the ICOM Extraordinary General Assembly approved a new one for museums. The vote was the culmination of an 18-month participatory process that involved hundreds of museum professionals from 126 National Committees from all over the world. The new definition was approved by 92% of voters (For: 487, Against: 23, Abstention: 17). Here is the result:

> A museum is a not-for-profit, permanent institution in the service of society that researches, collects, conserves, interprets and exhibits tangible and intangible heritage. Open to the public, accessible and inclusive, museums foster diversity and sustainability. They operate and communicate ethically, professionally and with the participation of communities, offering varied experiences for education, enjoyment, reflection and knowledge sharing.
> *(International Council of Museums 2022)*

This definition is not a significant departure from the *status quo*, and the only vague allusion to humankind's assault on the Planet lies in the word "sustainability" – a misused and exploited concept lacking any meaning in this definition. Regrettably, the debate resulting in this moral trade-off is specious, pitting as it does the value of tradition against the need for social responsibility. These perspectives are not antithetical, but complementary, as any museum contribution to community well-being is dependent upon the knowledge and skills inherent in museum practice – be

it research, collecting, or interpretation. The imperative is not to reject the method and theory of museum practice, but rather to discard neutrality so that the museum can employ its unique capabilities beyond the constraints of managerial and professional tribalism. This is the only way to make room for discovery, change, and transcendence, not limitation and restraint (Darren Peacock, personal communication, 9 March 2015).

Reflecting on the fractious consequences surrounding the redefinition of museums (the President of ICOM resigned midstream in the process, as did the chair of the definition committee), it is clear that the global museum community is not yet ready to reassess its role in a rapidly changing world. I have no doubt that this new definition of museums, with its half-hearted attempt at relevance, will further strengthen our descendants' contempt for us as ancestors. At a time when the world was unravelling, the international museum community stood by cloaked in insularity and a lack of courage.

There is no doubt that museums have evolved through time, albeit slowly, from the elite collections of imperial dominance, to educational institutions for the public, and now to the museum as shopping mall and appendage of consumer society (Janes 2009a: 183–184). The museum's next iteration must now be defined, and there is little time left for museums to be content with inaction and frightened by the prospect of moving beyond traditional assumptions and practices. To claim that the future of our civilization and the well-being of our Planet are too political for museum involvement is to sever the connection between one's humanity, one's personal agency, and one's work. This debate on the redefinition of the museum may, however, be the first formal expression of an embryonic paradigm shift in how museum workers perceive themselves and their museums. The museum establishment still has the upper hand, but the sacred cow of museum conservatism has now been challenged.

To separate one's consciousness from one's behaviour is not only disingenuous but also impossible to maintain in the presence of honest reflection. Although I am heartened by the historical trajectory of museums, however plodding it may be, I am dismayed by the equally ponderous discussions about what a museum is as discussed earlier. One can only hope that a sufficient number of museums will reject the familiar and, instead, reach out to both question and demonstrate their worth to their communities at a time of unfolding, socio-environmental disruption. If ICOM is unable or unwilling to support this task with the rethinking that it requires, it must ask if a new kind of global museum institution is now necessary to support this work.

Although the meaning and role of museums in society may remain paradoxical or incomprehensible to academics, practitioners, and cultural bureaucrats, there is untold strength in the diversity of museums to become a force for advocating and taking action on behalf of the Planet and the future of humanity. At the same time, a potentially fatal future for museums is conceivable if the current and fragmented understanding of their meaning and value persists, allowing museums to descend

into irrelevance and collapse without even sharing a common definition of their work. The social and cultural dimensions of collapse are the deadliest, and it is here where museums can add perspective, value, and strength. If the harbingers of collapse are ignored by the museum community, it will be too late for museums to claim their legitimacy, as individuals, families, and communities confront not only the effects of financial, commercial, and political collapse but also the consequences of social and the cultural collapse as discussed in Chapter 2.

This need not be the future of museums, and fortunately there are a growing number of international coalitions and networks that are igniting the conversation about our Planet, our civilization, and a profession under siege – ranging from webinars, to conferences, to activist museum projects. Of particular interest and concern is that these initiatives are born of the fragmented museum world and are not the property of mainstream museums or museum associations. They are a new breed of museum organization, created and served by museum workers and non-museum workers, who have taken matters into their own hands. These museum supporters and activists are frustrated and motivated by the dearth of constructive efforts to address their concerns by mainstream museums, including their boards, senior staff, and museum associations.

With one exception (Culture over Carbon), these organizations have no official charters, government remits, or inherited power, yet they are stepping up to assume a variety of responsibilities, many of which are concerned with the climate crisis. Examples of these organizations include Access Culture (https://accessculture-portugal.org/2023/01/10/our-10th-anniversary/), the Museums and Climate Change Network (www.mccnetwork.org), Sustainability in Conservation (www.sustainabilityinconservation.com), the Happy Museum Project (www.happymuseumproject.org), Climate Museum UK (https://climatemuseumuk.org/), We Are Museums (www.wearemuseums.com), the Coalition for Museums and Climate Justice (www.coalitionofmuseumsforclimatejustice.wordpress.com), Ki Culture (www.kiculture.org/), We Are Still In (www.wearestillin.com/), Creative Green Tools Canada (www.cgtoolscanada.org/), MuseumNext (www.museumnext.com/), the Inclusive Museum (http://inclusivemuseums.org/), Museums for Future (http://museumsforfuture.org/), Museums as Progress (https://museumprogress.com/what-is-map), MuseumExpert (www.museumexpert.org/), Museum Human (www.museumhuman.com/tag/museum-human/), Culture Over Carbon (https://ecprs.org/engagement/culture-over-carbon/), the Natural History Museum (https://thenaturalhistorymuseum.org/about/), the Climate Heritage Network (www.climateheritage.org/), SCALE/LeSAUT (https://scale-lesaut.ca/), and the Solidarity Action Network (SANE) (https://solidarityaction.network/about/).

Of particular note is the Climate Heritage Network's latest contribution to the climate crisis – "The Climate Heritage Manifesto for COP 27" (www.climateheritage.org/manifesto). The Manifesto intends to activate those involved in arts, culture, and heritage to take climate action through communication and engagement – by inspiring and assisting their audiences, as well as by changing

their own behaviour to engage in climate change policy development with all levels of government.

Albeit uncommon, there are also museum associations that have risen to the challenge of the climate crisis, and I will briefly mention several of them. The Alberta Museums Association (Canada) produced a seven-part video series in partnership with the Coalition of Museums for Climate Justice and Shadow Light Productions Ltd. (Alberta Museums Association 2022). The videos are free to download and are intended to inspire museum workers and their visitors to take action to combat climate change and build a more sustainable future. Containing practical examples of how individuals can take proactive action to address climate issues, these videos are shared across multiple platforms by the Alberta museum community and beyond.

Another important example of sober urgency is the "Museums for Climate Justice Campaign" launched by the UK's Museums Association (MA). In brief, this campaign is committed to supporting museums in tackling the climate and ecological crisis and offers resources, case studies, a "digital hive," and carbon management plans. Of particular note is their dictum that any COVID-19 renewal strategy must tackle the climate crisis. Unlike the majority of museums and museum associations worldwide, the MA has foreseen this as a crucial opportunity to discard the *status quo* and change direction (Museums Association 2020).

A third example of an association assuming responsibility is the American Alliance of Museums' Environment and Climate Network – working in collaboration to establish museums as leaders in environmental stewardship, sustainability, and climate action (Environment and Climate Network 2022). They believe that a museum's role in the community includes being a resource for information, as well as building awareness of issues that impact the world today. The Network explores and shares environmentally sustainable practices – assuming that climate action is fundamental to all museum missions. Although laudable, I note that this work is polite and conservative and does not compare with the substance and urgency of the MA's climate justice initiatives, discussed earlier. Unrelated to this, but most concerning for the future of critical thinking, was the American Alliance of Museums' (AAM) Museum Studies Professional Network unanimous vote to resign when asked to sign a code of ethics that mandated "loyalty" and limited public criticism of AAM (Velie 2022). What this foretells for climate action is unclear, but it would seem to indicate an organization that is uncomfortable with uncertainty.

These examples provide a glimpse of the climate action work currently underway, ranging from reducing carbon footprints to sharing resources and expertise. In addition, other initiatives also originating outside of mainstream organizations are unfolding, with a focus on a variety of persistent structural problems that plague museum practice. These, too, are essential initiatives as they address issues that are notably absent in museum conferences, directors' meetings, and professional

development programs. A noteworthy example is the National Emerging Museum Professionals Network (https://nationalempnetwork.org/about-us/), which is committed to "enacting radical change in the museum field" – ranging from leadership to professional development, to the quality of work life. Another initiative is Fully Loaded Camels (https://solvetasksaturation.wordpress.com/about/), a blog devoted to involving more museum workers in identifying and sharing solutions to rampant time poverty and task saturation in the field. The Empathetic Museum's (http://empatheticmuseum.weebly.com/) work is based on the premise that "the qualities of 21st century museums are impossible without an inner core of institutional empathy: the intention of the museum to be, and be perceived as, deeply connected with its community."

I underscore the importance of these three initiatives because they are concerned with "how" museum work gets done – a topic rarely discussed by museum practitioners and academics. Largely unrecognized in museum management, there is an intimate relationship between how one works and what one does (Janes 2009a: 71–78, 2013). Consider the typical, hierarchical museum in contrast to one where decisions are delegated to the most local level in the organization where the decisions can be made well. Which organization has greater scope for creativity, initiative, productivity, and satisfaction? The answer is clearly the less hierarchical one, although this essential truth has yet to be acknowledged by the majority of museums. Overall, these three initiatives – Emerging Museum Professionals, Fully Loaded Camels, and the Empathetic Museum – are all devoted to freeing museums from the organizational dysfunction and unquestioned assumptions that have been ignored by museum leadership for far too long. Any efforts that succeed in overcoming these deep structural challenges will be important contributions to the strength, capacity, and well-being of museums as disruption unfolds. I discuss these organizational impairments in Chapter 5.

This review of the fragmented museum world and the various non-traditional organizations it has spawned is a clear sign that museum workers, if not their managers and leaders, are restless. They are restless to redefine the meaning, purpose, and value of museum work unconstrained by the dictates of authority, power, and tradition, while also highly conscious of the world around them. This is resilience in action cloaked in optimism, but will there be sufficient time for this rethinking to displace the *status quo*? Will museum leaders and governing authorities listen and act accordingly, or will they retreat to the comfort of habit and gratuitous authority? There is no longer room for leaders with 30 years' experience – the same year repeated 30 times. Listening, reflecting, and doing something are now mandatory skills for all museum executives, irrespective of their long careers, curricula vitae, social connections, or lack of humility. In the absence of senior staff and their governing authorities truly listening or leaving, museums will likely be condemned to the brittle present – a most unfortunate squandering of the time, talent, and effort of those subordinates who are capable of designing and embracing change.

A new narrative

There are untold stories to be told and this is the stock-in-trade of the museum enterprise. The distinction between a story and a narrative is crucial, however, as a narrative is much bigger than a story – it is a way of looking at the world that influences thought, meaning, and decision-making. Narratives unfold over time and give meaning to a broader vision of what is possible and why it is desirable (Margolis 2018). A narrative "connects the dots." In short, our civilization is now in dire need of a new narrative.

Who is telling the narrative of the twenty-first century? Corporations and governments are, but they are only concerned with ceaseless economic growth. Their rhetoric is agonizingly familiar and destructive: consumption means happiness, economic inequality is unavoidable, and rampant environmental destruction is regrettable (Korten 2014). This is the heartbeat, the unifying force, of MTI society. Although this narrative is clearly corrupt and false, it is the predominant narrative in our public lives and it defines our past, the present, and our common future. This narrative remains largely unchallenged, yet is destroying the Planet upon which we depend, including all of those marginalized individuals and communities who fall victim to corporate self-interest and government inaction.

Education is a core mission of museums, and one must ask what sort of education, with its associated narrative, is necessary now? It is patently clear that global society is in urgent need of museums to provide cultural narratives that identify, explore, and challenge the myths, perceptions, and misperceptions that govern and imperil daily life. Rethinking our education system will also be essential to a new narrative, as the purpose of this system is to prepare youth for the future. What future one might ask – certainly not the one based on the *status quo* as it is already unravelling? It is questionable if school systems are willing or able to rethink their curricula to address the fundamental changes that are required. In their absence are museums – the demonstrated leaders of informal education, unbound by the educational bureaucracy.

We are also in need of a new alliance of environmental organizations, farmers, gardeners, social agencies, local businesses, universities, and museums of all kinds, in order to "re-imagine human culture from the ground up, using our intelligence and passion for the welfare of the next generations, and the integrity of nature's web, as our primary guides" (Heinberg 2010: 64–65). Public dialogue on economic growth in a world of dire environmental constraints is long overdue, and all public institutions must now consider just how invasive the reigning model of unlimited growth and consumption has become, and change direction. All public institutions must both advocate and demand government accountability.

Museums have a central role to play and can do this, as they are public storefronts – easily accessible, highly skilled storytellers, and blessed with exceptional public trust (Loewen 2022). If we expect and assume that public institutions

must change through time, as life itself does, it is no longer feasible to let the dominance of corporations, government complicity, and consumer society go unchallenged. Museums have the opportunity and obligation to provide the means of intellectual self-defence with which to both resist the *status quo* and question the way in which society is governed. When will museums, as historically conscious and knowledge-based institutions, acknowledge their civic responsibility and embark upon the creation of a new narrative?

Sketch for a new narrative

In an effort to explore the creation of a new narrative for museums and society at large, I offer the following content for a hypothetical exhibition proposal.

Introductory Panel

It is still an open question whether man will be able to survive the exceedingly complex and unstable ecological conditions he has created for himself. If he fails in this task, interplanetary archaeologists of the future will classify our Planet as one in which a very long and stable period of small-scale hunting and gathering was followed by an apparently instantaneous efflorescence of technology and society leading rapidly to extinction.

(Lee and Devore 1968: 3)

The purpose of this exhibition is to examine why and how this came to be.

Key themes

The Demise of Interconnectedness	*Ecomodernism*
Climate Trauma	*Political Ineptitude and Deception*
The Myth of Sustainability	*Corporate Greed and Deception*
Ecological Overshoot	*Mythical Beliefs and Managed Fantasies*
Civilizational Overshoot	*What Can We Do in a Troubled World?*
Undoing Colonization	*What Is My Responsibility?*

Closing Panel

Meaning in human life has been in decline for a very long time, almost since the beginning of Western civilization. This is in contrast to our hunting and gathering ancestors, whose world and its inhabitants, be they plant, animal or mineral, were saturated with meaning. Consider the Pawnee account of the Great Council of Animals as an example (Brown 1989: 124). This Council meets in perpetual session in a cave under a round mountain, and monitors the affairs of humans wherever they may be on Earth. If a man or woman is in need or in

FIGURE 4.1 A buck mule deer ruminates as the More-Than-Human World rapidly deteriorates.

Source: Photograph courtesy of Priscilla B. Janes.

trouble, and seeks aid with humility, the Council will choose one of its appropriate members – whether winged, four-legged, or crawling – who will then appear to the man or woman and give something of its own power, or present advice, that should thereafter guide the person's life.

Human wholeness, and hence meaning, thus depend on a receptiveness to the potentialities and mysteries of the natural world. Today, Western society looks on the same landscape and deems it deaf and dumb, or else sees a treasure trove of resources and feels little or no obligation for collective responsibility. The widespread belief that nature exists to serve the interests of people has eroded much of what our species once found meaningful.

(Janes and Conaty 2005: 3–4)

What can you do to reintroduce meaning in your life, recognizing that you are an integral part of the natural world?

Why are museums, their associations, their staff, and their governing authorities not exploring the changing world and the pressures that have come to bear, including the themes cited earlier? Are we so privileged and distracted that we remain mute and adrift in our collective indifference and denial?

5
THE MUSEUM AS LIFEBOAT

I acknowledge the enormity of the planetary plight confronting museums and what they must do to not only avoid, attenuate, or navigate their collapse as institutions but also, more importantly, to work with their communities in dealing with the threat of collapse. Although museums are not going to fix the polycrisis, there is a metaphorical way to see their potential role – as lifeboats equipped and ready to assist people who are in danger. This danger arises from individuals, families, and communities feeling confused, anxious, despairing, and in need of knowledge, compassion, and assistance as collapse threatens. Words come easily and action does not, however, as noted by the late distinguished museum director and museologist, Michael Ames:

> It is typically easier to see what should be done which simply requires a judgement than to get it done which requires a more extensive analysis of the situation and the marshalling of support. Despair is thus frequently the shadow to ambition in the museum world, like devils following one in the night.
> *(Ames 1992: 5)*

Although action is difficult and likely accompanied by despair, the museum as lifeboat is a singular alternative to irrelevance and decline. To explore the meaning and application of this lifeboat metaphor, I will begin by restating the truth as we now know it. Global warming is not the cause of the polycrisis – ecological and civilizational overshoot are. Second, the so-called renewable energy technologies are not solutions to climate change as they are not renewable and will only increase overshoot through the consumption of yet more energy and materials to prolong the consumption of material comforts. Third, decoupling the human enterprise from the natural world is impossible, and the idea of net-zero carbon emissions is fraudulent and ignores the need to stop using fossil fuels.

DOI: 10.4324/9781003344070-6

With these dire realities as the new context confronting the museum community, there is much to be done. This community is both broad and deep and includes buildings, staff, boards of directors, governing authorities, members, stakeholders, volunteers, vendors, donors, consultants, museum studies educators, and museum associations. I will focus on the role and responsibilities of museum workers, their organizations, and their associations, while bearing in mind their interplay and mutuality.

Regrettably, these relationships are largely ignored, as they are in all MTI organizations. Museums continue to operate while ignoring the systemic nature of their work – a complex and interdependent web of people, collections, activities, and relationships, all of which are part of the biophysical reality called the biosphere – the sum of all ecosystems including humans. Part of this chapter is devoted to examining the key aspects of museum practice that are preventing or hindering a more systemic and holistic perspective, as how one works lies at the heart of what one does (Janes 2013: *passim*). This entails breaking down hierarchy and compartmentalization, along with other outmoded practices. Strong relationships can be forged with people and communities when these obstacles are replaced with a greater understanding that the component parts of a system can best be understood in the context of their relationships with each other and with other systems, including the More-Than-Human World. The ability of museums to foster social cohesion and personal wellness will depend on both a systemic and holistic perspective, above and beyond one-off exhibitions, programs, and events. MTI civilization, with its emphasis on individualism, has done great damage to the sense of community. Museums are critically placed to assist with mending this ongoing wreckage of the growth economy.

An ecological metaphor is useful here, as ecology is about the relationships between organisms and their environments – dependent, independent, and interdependent relationships. (Janes 2016: 379). Museums have built their survival on being both materially dependent (for their economic well-being) and subjectively independent, as exemplified by commonplace comments such as "give us the money; we know what to do" or "you can't measure our performance because we have special missions." In the process of overlooking the meaning of interdependence, museums have created their own marginalization. It is time to forge an ecology of museums that recognizes that a broad web of societal relationships is the bedrock of successful adaptation in a complex and increasingly severe world.

The lack of interdependent relationships among most museums is an increasing liability, and being valued for ancillary educational offerings and leisure entertainment is no longer sufficient to ensure a future for museums. Worst of all, the majority of the world's museums have perpetuated the unfounded divide between the human and natural worlds, relying on the rhetoric of disciplinary boundaries – art, science, and history – to claim that the Planet's well-being is the property of science and natural history museums. The shift to a holistic perspective, embedded

in expanded consciousness, is now imperative and is evident when ecologically sensitive citizens, for example, confront real estate developers or when women challenge the guardians of patriarchy. This is the beginning of a new narrative based on expanded awareness.

As the global crisis unfolds, each of us fits somewhere along a continuum of awareness that can be summarized with five stages of insight (Chefurka 2012). These stages progress as follows: (1) dead asleep – happy denial; (2) awareness of one fundamental problem – global warming, for example; (3) awareness of many problems – complexity; (4) awareness of the interconnections between many problems – large-scale, systems-level thinking moving from problems to predicament; and (5) awareness that the predicament encompasses all aspects of life. This chapter is grounded in the work of individuals and organizations that have arrived at the fifth stage of insight, and they will serve as guides and mentors as I navigate these uncharted waters for museums.

As noted earlier, we are already locked into a temperature rise to 1.5°C. Policies currently in place point to a 2.8°C temperature rise before the end of the century. In the absence of the mitigation that is required, adaptation must become the priority, although mitigation and adaptation are not mutually exclusive – each may serve the other. One cannot talk about adaptation without referring to collapse, however, and its newfound expression in collapsology. Collapsology has been likened to the cultural equivalent of an advance directive in the medical world, whereby you specify what actions should be taken for your health if you are no longer able to make decisions for yourself because of illness or incapacity (Schenck and Churchill 2021). For the Planet and our civilization, the alternatives for action are numerous – anger, regret, denial, competition, grieving, survival, and constructive action – to name several.

This life-threatening predicament has been explored in an eloquent and must-read paper by David Schenck and Larry Churchill, both of whom are American medical ethicists. They write:

> We think it likely that by 2031 mitigation will be seen to have largely failed, and that adaptation to social and environmental collapse will be the task that is left. We assume that this means major portions of the Planet will be facing the kinds of major transitions that people face in hospitals, ICUs [intensive care units], and hospices every day.
>
> *(Schenck and Churchill 2021: 500)*

They also note that "radical shifts will be required everywhere to manage a future more altered in living conditions and expectations than anything in human memory" (Schenck and Churchill 2021: 500). The shifts required for successful adaptation will also be multifaceted and will require not only economic and political adjustments but also moral and social ones. The museum as lifeboat can assist.

Adaptation or a litany of sorrows?

In the final analysis, the climate crisis and its ensuing calamities are about death – the death of some of the biosphere, perhaps billions of people, and perhaps much of our way of life. As extinction of the More-Than-Human World is already well underway, it is imperative to move beyond thinking about the climate crisis and start feeling it. Individuals and organizations must now confront "climate grief" head-on, which requires that an intellectual understanding of the climate threat must also be internalized on an emotional level (Aly 2019). The climate crisis must become a constant companion, however unwanted. Joanna Macy, the environmental activist and Buddhist scholar, notes that "the depth of your grief is the measure of your love" (Macy in Bendell 2020a).

The scholar and theologian, Stephen Jenkinson, wrote that if you pay full attention to our ecological state then it "mitigates against your happiness, contentment, and your sense of wellbeing. Having a conscience now is a grief-soaked proposition. . . . If you awaken in our time, you awaken with a sob" (Bendell 2020a). We must think and feel this awareness deep in our consciousness, despite this anguish, but we must also confront it and manage it.

There are many reasons for grief and despair apart from the climate trauma and they, too, must be acknowledged even if there are no effective ways of preparing for them as individuals, families, and communities. In addition to global warming, consider the mass extinction of species and the loss of biodiversity, multiple failures in the global food systems, another major pandemic, uncontrollable artificial intelligence, and the possibility of nuclear warfare. These scenarios are now part of many peoples' daily thoughts, and it is essential that the ensuing grief and despair be approached knowingly and constructively. Efforts are well underway to do just that.

Jem Bendell (2019), a professor of sustainability leadership at the University of Cumbria (UK), writes that societal collapse due to climate change is already here. He launched the Deep Adaptation Forum (DAF) for people who want to explore what they can do professionally, personally, and collectively to promote collapse-readiness as society breaks down. Recall that the term societal collapse or breakdown is the uneven ending to our current means of sustenance, shelter, security, pleasure, identity, and meaning. Deep Adaptation refers to responses to this predicament – which people may view as likely, inevitable, or already unfolding (Deep Adaptation Forum 2022). In summary, Deep Adaptation is a way of framing the current global situation to help people refocus on what is important in life while the social order collapses under the weight of its own consumption, pollution, and inequality. "The overarching mission of the Deep Adaptation Forum is to embody and enable loving responses to our predicament, so that we reduce suffering while preserving more of humanity and the natural world" (Deep Adaptation Forum 2022).

It is important to note that the DAF does not intend to build a large institution. Instead, through a network of individuals (online and in-person), professional

communities, institutions, blogs, social media, and mainstream media, DAF aims to nurture and encourage more and more groups to adopt a similar approach, based on compassion, curiosity, and respect and develop their own plans for collapse-readiness and climate adaptation (Deep Adaptation Forum 2022). The DAF acknowledges that communities around the world will have their own initiatives to cope with a breakdown in their normal ways of life. Museums have yet to be acknowledged in this emerging mobilization, although I did sign the DAF's Scholars Warning letter on behalf of the Coalition of Museums for Climate Justice in 2020. This letter calls on policymakers to engage openly with the risk of disruption and even the collapse of our societies. It was signed by over 500 scientists and scholars from over 30 countries, representing dozens of academic disciplines including climatology, environmental science, psychology, and sociology (Initiative for Leadership and Sustainability 2021).

The scholar's letter is an example of the DAF's two-path approach to collapse, consisting of inner adaptation and outer adaptation (Deep Adaptation Forum 2022). Inner adaptation involves "exploring the emotional, psychological, and spiritual implications of living in a time when societal disruption/collapse is likely, inevitable, or already happening." Outer adaptation, as exemplified by the above letter, means "working on practical measures to support well-being and reduce harm, ahead of and during collapse (e.g., regenerative living, community-building, policy activism)." I will focus on outer adaptation for museums in the remainder of this chapter, with a focus on the practical. As inner adaptation is highly personal, with its emotional, psychological, and spiritual dimensions, I have left this discussion for the concluding chapter.

I had originally intended to provide a detailed critique of current museum practices to explain why I believe that museums are in considerable peril. Upon reflection, I changed my approach to emphasize what I think museums can and must do, as metaphorical lifeboats, to transform their practice and assume new roles and responsibilities as the threat of collapse gains definition. Museums have many strengths and qualities that can enable this transformation, but there are also obstacles, and I cannot avoid identifying various self-inflicted liabilities and dysfunctions that plague the museum world. I will outline some of the substantive changes required in order to illuminate where change and transformation are most needed.

The four questions

Bendell (2019) provides an agenda for addressing both inner and outer adaptation, consisting of four questions about resilience, relinquishment, restoration, and reconciliation. These questions are a valuable framework for exploring how museums and museum workers can serve as lifeboats and contribute to resiliency, counteract the sorrow, adopt new values, and nurture a heightened consciousness of the More-Than-Human World, as well as to empower themselves to discover and rekindle their personal and organizational agency. This will mean recognizing

current strengths, relinquishing outdated practices, restoring other practices that are insufficiently acknowledged, and reconciling with the broader world. My intention here is to view museums from both the outside and the inside and demonstrate how they can and must contribute to collective well-being for their communities. The readers will note that there is considerable overlap and interplay among these questions and the responses.

Resilience: "How do we keep what we really want to keep?"

Resilience is a popular word these days and rivals sustainability as a gateway to well-being in the popular media. Resilience means the ability to recover from, or adjust easily, to misfortune or change. Resilience also suggests a frame of mind that is not bound by deadening routine, habit, or traditional practices (Janes 2016: 247). Resilient organizations and systems are flexible, agile, and adaptable, and there is an important distinction between resilience and sustainability. Resilience emphasizes the need to increase our ability to withstand change and crises. Sustainability, on the other hand, can be a brittle state – unforeseen changes can cause its collapse. Resilience is all about being able to overcome the unexpected and, most importantly, the goal of resilience is to thrive (Homer-Dixon 2006: 20–21, 283–287). This should also be the goal of museums and communities – to thrive. Homer-Dixon (2009: 10–11, 38–39) advises that we will learn that we should not rely so much on "experts" to manipulate the systems around us, because these elites have little real understanding of how these systems work. As the twenty-first century progresses, ecology's best lesson may be that each of us, museum workers included, need to take more responsibility for our own and collective well-being.

Enter museums as social organizations in civil society. Whether it be the four global scenarios, or the five stages of societal collapse, the question is what role do museums have in negotiating and tempering the consequences of collapse? I assume that museums have no effective role to play in the realms of finance, commerce, and politics (which are already showing signs of collapse), so I will limit my speculation to their role and responsibilities in the last two stages of collapse – the social and the cultural. I assume that museums can play a significant role here, as they have numerous attributes that can directly resist, if not defy, the social and cultural hazards that constitute societal collapse.

Social capital

How do we keep what we really want to keep? This question alone is sufficient cause to acknowledge the meaning and value of museums in their role as creators of social capital – a topic examined in Chapter 4. In short, social capital is the foundation of broad-spectrum resilience. Recall that there is a widespread misconception in Western society that markets create communities. In fact, the opposite is true, as the marketplace and its activities actually deplete trust (Rifkin 1980). It is

the organizations of the non-profit sector, neither government nor business, which build and enrich the trust, caring, and genuine relationships – the social capital – upon which all of society is based. Stewarding social capital is an antidote to societal collapse, and museums are a primary source of that capital.

Although museums have little or nothing to offer in the face of financial, commercial, and political collapse, they are essential in averting or lessening the two most horrific stages of collapse, the social and the cultural. It is here where trust, caring, and values are at risk of disappearing, as discussed earlier in the anatomy of collapse. Stewarding the social and cultural dimensions of our species will be essential in reinventing our worldview with compassion and love, and museums have an unsung and untapped role to play. This alone is sufficient reason to acknowledge the civic value of museums and ensure their longevity as social and environmental pressures intensify. We must keep museums for the creation and maintenance of social capital – the networks, norms, trust, and shared values that are transferred into the social sphere and help to hold society together.

Small is more than beautiful

How do we keep what we really want to keep? The consequences of diminishing fossil fuels will mean a pronounced shift from urban to rural sensibilities, where food is produced along with the legacy of local and traditional knowledge that makes this possible (Janes 2009a: 144–145). I am not referring to large-scale, industrial food production, as its future is already collapsing with its overreliance on fossil fuels, fertilizers, and monoculture farming. Along with this new sensibility will come a renaissance for the small community museum, resulting from the massive shift of people out of the suburbs and back to labour-intensive agriculture (Rifkin 1980: 216). Community museums can offer knowledge, collections, insight, respite, and land for gardening and farming, gifted as many of them are with green spaces and the volunteer elders who serve as their organizational backbones.

In short, all those community museums that have been undervalued and ignored by larger museums will gain newfound value as the fossil fuel economy winds down. The rising cost and eventual scarcity of jet fuel will effectively eliminate low-cost jet travel, and air travel will return to the realm of the elite where it all began. For all of the museums, famous or not so famous, that continue to predicate their future on tourism, the future is bleak. The upside of this will be a renewed interest in small communities and their resources, including museums, as these communities become sources of resilience in a contracting or collapsing economy.

Seed banks and memory banks

How do we keep what we really want to keep? The role of museums in maintaining and sharing collections as knowledge seed banks is perhaps the most obvious, and the most easily understood and achieved, recognizing that museums have

permanent collections by definition. There are exceptions to this, however, such as the Canadian Museum for Human Rights in Winnipeg, Canada, which identifies itself as an "idea" museum. It has a small collection and borrows the objects it requires. Although this approach is rare, it makes a great deal of common sense in light of the excessive duplication and expense of maintaining permanent collections. These expenses are only going to increase in an uncertain world.

Museum collections are a time capsule of material diversity (albeit biased and selective) and distinguish museums as the only social institution with a three-dimensional, cultural memory bank. In this respect, museums are as valuable as seed banks. If seed banks are gene banks, then museums are tool, technology, history, and art banks – curating the most distinctive trait of our species – the ability to make tools and things of beauty (Janes 2009a: 179). The need to revisit this cumulative knowledge and adaptive genius from the past is necessary now, as industrial technology becomes increasingly maladaptive. Modernity has also led to the loss of knowledge of sustainable living practices that have guided our species for millennia, making the record of material diversity contained in museums as valuable as biological diversity. Adaptive solutions will have to be sought in an increasingly fragile world (Janes 2009a: 179).

Moreover, museums collectively contain a comprehensive catalogue of our civilization's cultural and natural diversity. Should the worst come to pass and the world plunges into some variant of a collapse or post-collapse scenario, and if museums survive, they will play a stewardship role that finally justifies the keeping of collections for posterity. As author James Kunstler asks:

> If the social and economic platform fails, how long before the knowledge base dissolves? Two hundred years from now, will anyone know how to build or even repair a 1962 Chrysler slant-six engine? Not to mention a Nordex 1500 kW wind turbine?
>
> *(Kunstler 2005: 130)*

Ronald Wright (personal communication, 24 February 2023) notes that the youth of today are already forgetting how to read and write cursive handwriting on paper, a loss that cuts them off from centuries of information, knowledge, and learning.

One immediate challenge is to assess museum collections to determine what is essential to save in advance of the inevitable, low-energy future and the cessation of unlimited economic growth. There is now a Global History Databank that gathers data into a single database that can be used to test scientific hypotheses (Seshat 2021). Why not a similar initiative for museum collections – a global database to test adaptive thinking and technology from the past to assist society in moving beyond the crumbling industrial society? Museum collections will be a fundamental source of technological memory. Initiatives such as a global databank must take priority over the current preoccupation with exhibition and programs for attracting and entertaining audiences. The question is whether the threat

of collapse will be sufficient to overcome the museum community's devotion to these traditional activities.

Knowledge for adaptation

How do we keep what we really want to keep? As implied earlier, the concept of museums as seed banks also transcends the objects themselves, to include the local and traditional knowledge that resides not only in the objects but also in the written and oral testimony that accompanies them. Both these forms of knowledge are currently under siege, for "as knowledge expands globally, it is being lost locally," writes Wendell Berry (2001: 90–91). He notes further that "modern humans typically are using places whose nature they have never known and whose history they have forgotten; thus ignorant, they almost necessarily abuse what they use."

Museums are the custodians of our collective material culture and its associated knowledge, in addition to the knowledge and memories that reside in individuals and communities, and there need not be an apocalypse to reap the benefits of the museum's unique form of stewardship. All museums are positioned to share their collections as knowledge banks now, and some have already made this connection. The Western Development Museum (WDM) in Saskatchewan, Canada, not only installed wind turbines to offset their utility costs but also created an exhibition that publicly monitors the performance of the wind turbines while featuring the pioneering innovations of early prairie farmers to capture the wind (Janes 2009b: 30–33). The result was the museum's historical consciousness at play with the present, based on the collections and a pressing environmental issue. The WDM's focus on energy use continues, with a new program that considers energy efficiency and sustainable building methods used in the past, while looking at the old buildings on display in the museum.

Although I searched for more contemporary examples of using collections as sources of past adaptive knowledge in advance of a low-energy future, I failed to find any. Nonetheless, the search for low-energy solutions will soon become imperative and the revival of past and forgotten technologies will be a critical way of coping with more expensive and less abundant fossil fuels and electricity. Museums are the custodians of many of those past technologies.

Every museum, irrespective of size and type, can make the connection between the collections and knowledge they hold, and the issues and challenges that confront society now. To do so, museums must move beyond their conventional preoccupations and start examining the compelling, societal questions that will guide a new future. One of these compelling questions is how will our civilization adapt to the unfolding consequences of global warming? The museum community has been regrettably silent in acknowledging that natural history collections are a valuable resource in addressing this question. In an article titled "Climate change and biosphere response: Unlocking the collections vault," the authors noted that "natural history collections hold billions of specimens collected over the past two centuries,

each potentially witness to past ecological conditions and irrefutable evidence of historical biogeographic distributions" (Johnson et al. 2011: 147–153).

The multiple authors of this article, most of whom work in museums, called for a strategic realignment among holders of natural history collections to expand their existing focus on taxonomy and systematics – with climate change as a priority. They also noted that setting these new priorities will require strong partnerships between collection holders and global biologists (Johnson et al. 2011: 147). This is a fine example of museum workers rethinking their role and responsibilities because of the value of their collections as seed banks. Regrettably, the necessary collaboration between natural history museums, citizens, media, business, government, and educational organizations failed to happen, and an invaluable opportunity to promote incisive climate action was lost. Even the Alliance of Natural History Museums of Canada, which recognizes the loss of global biodiversity, has failed to mobilize their collective resources to confront the climate trauma (Alliance of Natural History Museums of Canada 2015). Will collapse be the trigger for a collective response from museums, or will it be too late?

Synthesizers

How do we keep what we really want to keep? We live in a time of dissonant voices speaking in isolation, and we suffer greatly as a result (Hawken et al. 2000: 310–313). The environment is a good example of dissonant voices, which includes the free-market capitalists (economic growth is everything); the environmentalists (who see the world in terms of ecosystems and focus on depletion and damage); and the synthesizers who are few and far between. All museums have the responsibility and the opportunity to become synthesizers and foster an understanding of the interconnectedness of the problems we face, both environmental and social. Museum workers have a critical role to play in rejecting all ideologies and demonstrating that solutions will arise from place and culture "when local people are empowered and honoured (Hawken et al. 2000: 312). Museums can empower and honour all people who are affected by the threat of contraction and collapse – by creating missions, conversations, and services that focus on the interconnectedness of our world and its challenges, including the integration of disparate perspectives in their communities.

Wackernagel and Rees (1996: 137), the fathers of the Ecological Footprint, see local communities as the key to intelligent adaptation. No one would dispute the fact that most of the world's museums are expressions of locality and community, and the world is full of museums of all sizes and shapes because they are spawned by communities of interest. Museums also enjoy a certain intimacy in their communities, unlike universities that are only now acknowledging their perceived aloofness and struggling to overcome it. The ubiquity of museums and the familiarity they enjoy are the building blocks of adaptation and renewal, especially as the need increases to seek ingenuity and solutions on a smaller scale – in communities

(Janes 2009a: 180). The range of community voices and perspectives that museums can coalesce will be essential to forging resilience.

A sense of time

How do we keep what we really want to keep? Although I have discussed the unique value of museums as seed banks, I return to it here with a related quality that is the unique property of museums and directly related to the seed bank – a deep sense of time. I (Janes 2009a: 178) quoted this observation in 2009 and it is even more relevant today:

> All I can say is that we are mistaken to gouge such a deep rift in history that the things old men and old women know have become so useless as to be not worth passing on to grandchildren.
>
> *(Frazier 2006: 412)*

Novelist Charles Frazier wrote this in reaction to modernity, but his words also evoke the enduring value of museums. The "gouge" and the "rift" can be healed with the collective tangible and intangible memories that museums contain, despite the arrogance of our technological society that disavows the past and the scientific, Indigenous, and local knowledge that chronicles our species. As noted, museums are instruments in making known the lost knowledge of sustainable living practices that have guided our species for millennia.

Wonder and diversity

How do we keep what we really want to keep? Reviving a sense of wonder would be of great value in an uncertain world, as wonder is a complex and multidimensional phenomenon:

> Humans grow up with a powerful drive to learn how things work and why certain patterns and properties exist in the world. *Wonder*, a word with multiple related meanings, has one sense that captures this desire to know. . . . Wonder moves someone to seek out explanations – especially about the patterns of cause and effect that underlie phenomena. Wonder involves active thought and engagement. It invokes conjectures about 'how' and 'why'. It might even launch speculations about different possible worlds. Wonder motivates targeted explorations and discoveries.
>
> *(Keil 2022)*

Starting as cabinets of curiosities in the so-called Age of Discovery (actually conquest and colonization), museums have been steadfast purveyors of wonder and have made known the vastness and diversity of the world. To this day, museum

visitors delight in the discovery of something unknown, something precious, or something incomprehensible – museums are an embodiment of wonder. I suggest that a sense of wonder is declining, not only as the world's population ages but also as neoliberal materialism and handheld devices dominate our waking hours with meaningless distractions. The desire to know – asking "how" and "why" – is both an antidote to this domination and a prerequisite for adaptation in an uncertain and contracting world.

Although museums have always been custodians of wonder, they must now employ that wonder beyond the confines of leisure entertainment and organizational neutrality. There are diverse ways of wondering, as well as of knowing, and we need them now. We need this diversity of wondering and knowing as sources of creativity and adaptive capacity as much as an intact ecosystem needs biodiversity. This does not mean museums deciding what their communities need, as their time-honoured, self-assigned authority is obsolete. Rather, it means allowing staff and community members with wide-ranging cultural origins to share their life experiences and knowledge in pursuit of mutual concerns, aspirations, and social justice.

Collaboration

How do we keep what we really want to keep? Collaborating with individuals, communities, and organizations outside of the museum's familiar world will be a formidable challenge, as too many museums are ensconced in insularity and unfamiliar with the vulnerability that accompanies reaching out for assistance and cooperation. Collaboration will nonetheless be essential as it will pave the way for diverse perspectives, aspirations, and values. For those museums willing to take a risk with the unfamiliar, there is much to be gained, and one of the most immediate opportunities is the Transition Network or Transition Towns (Transition Network 2022). The "transition" refers to moving away from a growth-based, fossil fuel economy to one that is sustainable and resilient – reducing, restricting, and eliminating fossil fuel consumption go hand in hand with building and strengthening resilience.

Transition Towns are a massive economic, cultural, and spiritual experiment which will require unprecedented individual and community collaboration and action. Transition Initiatives currently exist or are underway in England (by far the most), Scotland, Ireland, Wales, Australia, New Zealand, Chile, Japan, Italy, the Netherlands, the United States, and Canada (Transition Network 2022). I do not know of any museums involved in the Transition Town movement nor are they mentioned in the transition literature as possible participants.

The museum is now commonly referred to as the new agora, or public gathering space, and the Transition Network is an unprecedented partnership opportunity for museums and galleries to assist their communities in becoming more informed, more resilient, and more adaptive as the MTI society breaks down. Museums as storefronts are needed to convene the conversations that will make the threat of

collapse and economic contraction visible and understandable to the community at large, including the opportunities for learning, action, compassion, and grieving. Museums are ideally suited to be these safe and familiar facilitators of the Transition Initiative, recognizing their knowledge-based legacy, their historical consciousness, and the trust and respect bestowed to them by their communities.

The ecomuseum is a highly relevant partner for the Transition Town, as the ecomuseum is "an institution which manages, studies and exploits – by scientific, educational and cultural means – the entire heritage of a given community, including the natural environment and the cultural milieu" (Davis 2011: 81). In short, the ecomuseum is a vehicle for public participation in community planning and development, allowing the public to understand and master the problems which it faces. The linking of nature and culture in the ecomuseum model is of critical importance as the polycrisis unfolds. Although the ecomuseum model has yet to receive the attention and understanding it deserves, especially in North America, its importance in a threatened world cannot be overstated.

Collaboration knows no bounds and could realistically be globally significant for museums under the threat of collapse. A worldwide scientific collaboration has been proposed to study the mechanisms that are amplifying and accelerating global systemic risks, as well as to determine practical ways humanity might intervene to tip key economic, social, and ecological systems toward better outcomes (Homer-Dixon and Rockstrom 2022). Museums have a choice to seek participation in this collaboration or create one of their own, with the intent of determining how museums can contribute both cultural understanding and practical initiatives to assist with mitigation and adaptation. Is ICOM up to this task or must we start anew?

Mutual aid

How do we keep what we really want to keep? Following on from social capital and collaboration is the model of mutual aid, which is about cooperating to serve individuals, families, and communities (Mendez 2022). Mutual aid creates networks of care and generosity to meet the immediate needs of people. Mutual aid is not new, as collective self-reliance has existed for all of human existence. With the threat of collapse, however, it will be essential in building and sustaining "relationships and interconnectedness between oneself, communities, ancestors, future generations, and the earth" (Mendez 2022).

Mutual aid also builds solidarity while respecting the unique needs of communities and their citizens by encouraging everyone to contribute their own ideas and skills. This is going to be increasingly important as governments are unwilling or unable to help (recall the five stages of collapse in Chapter 2), while the corporate world continues its neoliberal commitment to self-interest. This mutual aid can range from financial assistance, to food distribution projects, to neighbourhood pods that are self-organized groups of people who can count on each other for support (Zerkal 2022). Museums are well placed to serve all of these relationships, and

there are numerous examples of museum activism focused on mutual aid already underway (Janes and Sandell 2019: *passim*). Museums can be the hubs and storefronts of mutual aid, if imagination, experimentation, and risk-taking can overcome the limitations of traditional museum practice.

Trust

How do we keep what we really want to keep? Museums enjoy a remarkable degree of societal trust, and it is a key ingredient in building resilience. A recent report by the American Alliance of Museums (2021) indicates that the public continues to regard museums as highly trustworthy – ranking second only to friends and family, and significantly more trustworthy than researchers and scientists, NGOs generally, various news organizations, the government, corporations and business, and social media. For respondents who had visited a museum in the past two years (one-quarter of the respondents), museums are the number one trusted source of information. The same is true in Canada, where public opinion polling (Loewen 2022) revealed that 80% of the respondents perceive museums as a credible source of information, surpassing daily newspapers (48%) and television (33%). I note, however, that fewer than half (46%) of Indigenous Peoples surveyed rated museums as a "very trustworthy" source of information, with Indigenous Peoples putting more trust in family stories. Only 67% of Indigenous Peoples agreed that museums are a highly credible source of information. These latter two numbers are not surprising and clearly confirm an unresolved liability that museums must address.

There is no doubt that many, if not most, of the institutions we rely on as part of the MTI society have proven to be ill-suited to the challenges and we are losing faith in them and their leaders. They are not serving with intelligence and courage nor are they are adapting to the polycrisis we are confronting – the destructive GDP fixation, unbridled consumption, war, wealth inequality, social injustice, celebrity worship, frivolous media, and trivial entertainment persist. There is an obvious divergence between our societal needs and our societal institutions, as the latter are no longer trustworthy and we are in need of new ones. How remarkable that museums have retained a high degree of trust under the present circumstances. Many in the museum community would argue that this is because museums have maintained their neutrality – ensconced in leisure entertainment and oblivious to community issues. This is nonsense and I recall Loewen's cogent observation that "our publics are increasingly educated, engaged and demanding, and the pressure on museums to be deserving of the confidence placed in them is increasing" (Loewen 2022).

Despite the ostensible good news about societal trust in museums, it is time to question what this actually means. So what? Trusted to do what, besides providing information and entertainment? What is the "confidence placed in them" intended to do? An astute practitioner, Michael Edson (2022) recently noted "that trust in museums is like a cheque you can't cash." Rather than remaining content with this

bestowed trust, it is imperative that museums expand and steward the trust they enjoy by assisting with the durability and well-being of their communities. Museums must continually work to remain worthy of the public's trust, and the polycrisis and the threat of collapse are the imperatives to do so. Posterity has arrived and it is time to cash the cheque.

Be prepared

How do we keep what we really want to keep? My last example of how museums might contribute is a simple, if not overlooked, imperative – be prepared. The Canadian Association of the Club of Rome recently published the "Plan to Survive: A Canadian Guidebook for Dealing with Climate Change." They preface this work by noting:

> The climate is changing, with consequences for humans and all life on Earth. Extreme weather events are happening all over the Planet. The efforts of governments to restrain emissions of greenhouse gases are falling short. It is vitally important for individuals, families, and communities to begin now to prepare to live with the consequences. We all need to be resilient to survive.
> *(Canadian Association of the Club of Rome 2019)*

This sober look at a grim future is revealed in the table of contents, which includes topics such as energy, water for survival, food for survival, survival kit, protecting your health, making your residence more resilient, and working with your community. I can safely assume that the vast majority of North American citizens has not read this or similar plans, much less taken them to heart. My point in introducing this planning here is to put a finer point on the challenges we will face, as well as those that are already impacting daily life. If you haven't experienced a drought, flooding, extreme heat, or a wildfire, then you are fortunate. With the consequences of climate trauma now commonplace, preparations to alleviate, mitigate, and adapt to the unfolding crises should now be a public priority. Museums as informal educators and public storefronts have every reason to introduce mitigative and adaptive planning to their communities, as well as sharing the research and work that have been done. No one can be coerced to participate, but those individuals, families, and communities who are now increasingly anxious would undoubtedly welcome the opportunity to learn more in a safe and sensible environment – the museum.

To conclude this discussion on what museums have to offer, I have attempted to demonstrate that museums are up to the task of nurturing and maintaining societal resilience using their unique strengths and know-how "to keep what we really want to keep?" This will require that they now contemplate their role and responsibilities as the world moves from energy consumption to energy frugality. Forty-three years ago, Jeremy Rifkin, the social theorist and activist, made an observation that

could serve as a touchstone for the strategic future of museums confronting societal collapse. He wrote:

> After a long, futile search to find out where we belong in the total scheme of things, the Entropy Law reveals to us a simple truth: that every single act that occurs in the world has been affected by everything that has come before it, just as it, in turn, will have an effect on everything that comes after. Thus, we are each a continuum, embodying in our presence everything that has preceded us, and representing in our own becoming all of the possibilities for everything that is to follow.
>
> *(Rifkin 1980: 256)*

Is this not a powerful mission statement for a responsible and caring museum? As self-professed keepers of the continuum and "all those acts that preceded us," museums are ideally positioned to contribute to a more resilient future born of the continuum mentioned earlier. They need not limit themselves to the tyranny of the *status quo* or wait for deceitful corporations and faltering politicians to point the way. If museums are reluctant to assume these responsibilities in the absence of any authority to do so, they must ask themselves from what source they think their authority will come (Janes 2009a: 145)? To wait for some undefined source of authority is to wait for a long time, as it will not come from ancestors or those unborn – two of the museum's most important constituents. Museums have obligations, not rights or privileges, to all of these people, as well as to the present. Waiting around for the authority to act responsibly is unnecessary and unwise, as the constancy of the world grinds down. Clearly, museums have much to offer in nurturing and stewarding community resilience for an unknown future – it is now a priority. Therein lies the authority to act.

Relinquishment: "What do we need to let go of so as not to make matters worse?"

As noted earlier, museums have evolved through time, from the elite collections of imperial dominance to educational institutions for the public and now to the museum as an appendage of consumer society. This reinvention demonstrates some sort of adaptive intuition, whether it is conscious and intentional, or not. This is the good news. The bad news is that museums must now redefine the purpose of their work by asking "why" they are doing what they are doing and to "what" end. In addition, museums must also admit their colonial origins, start telling the truth, and use this to inform how they will do their work as collapse takes shape. In doing so, museums will have the opportunity to rise above their confinement as temples of the dominant society, transcend their insularity and entitlement, add value to the task of real-world preparations, and include those individuals and communities who have long been marginalized and excluded.

For museums, as wards of the MTI civilization and immersed in neoliberal ideology, this is understandable but no longer tenable. A new kind of museum awaits definition and enabling its realization will require the relinquishment of various traditional assumptions and practices.

The question of letting go includes assets, practices, behaviours, and beliefs, many of which are no longer of value and are only making matters worse for museums. My consideration of what to relinquish will highlight seven areas of museum practice that are particularly dominant and pernicious. Some of these practices and beliefs reflect the worst of neoliberal thinking and the museum community has adopted them uncritically to their distinct disadvantage.

The growth myth

What do we need to let go of so as not to make matters worse? Achieving a heightened level of awareness and effectiveness will require museums to reject the myth of continuous growth, be it revenues, collections, staff, or buildings. Museums are complicit in this fixation with growth, as are all contemporary arts and heritage organizations, and this cannot continue if they are to address the polycrisis that surrounds us. Undoing this mindset will require an unprecedented amount of courage because the political and business elite will object – they are powerful voices on governing authorities and boards of directors. Providing alternatives to the *status quo* will also require an unprecedented type of museum leader who is ready and able to "fly below the radar" – escaping the attention of those who denounce change as the museum becomes more conscious. There is no choice in the matter, as the end of growth is already apparent, as evidenced by the depletion of fossil fuels and minerals, the profound destruction of biodiversity, and reoccurring financial disruptions. This transition has begun and preparations for a new future must begin.

Before examining the museum addiction to growth, there is an alternative worth mentioning – the idea of degrowth. Degrowth means abolishing economic growth as a social objective. This implies a new direction for society in which societies use fewer natural resources and organize and live differently from today. Ecological economists define degrowth as an equitable downscaling of production and consumption that will reduce societies' use of energy and raw materials (Mastini 2017). Degrowth is based on three broad goals: (1) reduce the environmental impact of human activities by reducing material and energy consumption; encouraging or creating incentives for local production and consumption, and promoting changes in consumption patterns; (2) redistribute wealth both within and between countries by promoting community currencies and alternative credit institutions, promoting a fair distribution of resources through redistributive policies of income, promoting work-sharing, and creating a citizen's income; and (3) foster the transition from a materialistic to a convivial and participatory society by promoting simpler lifestyles and by exploring the value of unpaid activity (Mastini 2017).

In short, degrowth is a deliberate set of strategies to reduce the material footprint of wealthy nations, and the survival of our civilization will depend on it. As sensible and essential as degrowth is, it remains unachievable as I write. Until, if ever, degrowth becomes a policy directive for the developed world, it is incumbent upon the museum community to listen carefully to what it means. If degrowth is not planned, it would seem that post-growth or contraction will happen regardless, as we are now beginning to see. For decades now, museums in the developed world have echoed the chorus of perpetual growth, swayed by the refrain that more is better and bigger is better. This neoliberal thinking finds its most harmful expression in a persistent preoccupation with new buildings, collections, and earned revenues. I will examine these three fixations in turn.

Considering the evolutionary path of museums from custodians of imperial hoarding to their current iteration as appendages of the consumer society, these three preoccupations were inevitable. Museums, in the company of most public institutions, have benefitted greatly. This era has ended, however, and in the absence of any public policy mandating contraction and degrowth, museums are obligated to ponder their consumptive behaviour and change course. This heightened consciousness, focused on contraction, downsizing, and self-restraint, could very well become a key characteristic in the genesis of the museum as lifeboat. To model this kind of behaviour is to wed sentiment with action.

Buildings

What do we need to let go of so as not to make matters worse? Nowhere is culture as consumption more visible than in the realm of celebrity, vanity, "starchitecture," or simply new architecture – a persistent and widespread phenomenon throughout the museum world. I cannot begin to catalogue the number of new museum buildings worldwide in the past ten years and there are more on the way. Celebrity architects are not a prerequisite, however, as museums are also building and renovating without necessarily employing high-profile personalities. Although often likened to a renaissance, this architectural bandwagon doesn't merit this praise, lacking as it commonly does any vigorous intellectual or creative resurgence within the museum itself (Janes 2009a: 108–110). In fact, the opposite prevails, as the "if you build it, they will come" syndrome readily diverts attention away from a consideration of purpose, values, and the requirements to confront the unfolding polycrisis.

There is no doubt that bold and creative buildings attract visitors and can provide meaningful visitor experiences, but these inducements are irrelevant and maladaptive in a world beset by the social and environmental pressures described throughout this book. The edifice complex – promulgated by boards, self-interested museum directors, museum consulting companies, and architects themselves – has proven to be not only inadequate as a solution but also the source of major difficulties for many museums long before the threat of collapse appeared. New and larger buildings require more staff and incur substantially higher operating costs – costs

which are rarely, if ever, recognized by private or public funders who are enthralled with the building itself.

The result is that museums are required to increase earned revenues to pay the increased costs, mostly by arguing that increased visitation to the new or renovated building will generate the additional revenue. Such increases are commonly short-lived as the excitement of "new" fades away. In the absence of increased revenues and the need to pay for the edifice, operating costs are more often than not reduced and staff are dismissed. The museum sector must also admit that the cement and concrete industry is responsible for about 8% of global carbon dioxide emissions, more than double those from flying or shipping (Niranjan 2022). Although this industry is one of the most powerful causes of global warming, it is one of the most overlooked. The Planet can no longer afford any new museum buildings.

There is some indication, however, that this enthrallment with architectural showmanship is now being critically assessed. Twenty-five leading architects from around the world gathered in 2022 to imagine how future museums will look in a post-vanity architecture world (Szántó 2023). Their discussion was both encouraging and essential. Highlights include observations such as, "good architecture does not have to be expensive or superficially spectacular," or "I don't really care for the beauty pageant of 'look at me' museum design." Overall, the comments indicated a wish to avoid iconic and monumental architecture, coupled with a disdain for showing off and building attractions. These architects were determined to break down the museum's conventional formality, hierarchy, and impermeability (Szántó 2023). These observations are certainly a radical departure from conventional thinking, and time will tell if it permeates mainstream museum practice. If it is not already too late.

Irrespective of the edifice complex, there is an imperative to "green" museum buildings and reduce their profligate carbon footprints. There are now numerous organizations worldwide in place to assist with this task and several of them are listed in Chapter 4. The question is to what extent the museum community will embrace the responsibility to lighten its carbon footprint. Of particular importance in reducing the footprint is the reassessment of the current environmental standards (temperature and humidity) required for collections care (Janes 2010: 333). The Planet can no longer afford the excessive consumption of fossil fuels to maintain these arbitrary standards and, fortunately, this work has started in earnest with the first International Climate Control Conference (Ki Culture 2022). Scientific research has shown that climate control ranges do not need to be as stringent as originally thought. The time has come for museums to reconsider these arbitrary standards and make the changes needed to reduce their energy consumption. This leads to a consideration of the collections themselves.

Collections

What do we need to let go of so as not to make matters worse? Despite the obsessive preoccupation with collections, which has been described as akin to hoarding (Steketee 2018), museum collecting is now being scrutinized in a manner that could

pave the way for a broader vision of the value of museum collections in a troubled world. In a rare book that challenges the standard assumptions about museum collecting (Wood et al. 2018: 7–8), I take heart in the "Manifesto for Active History Museum Collections." It states that "collections must either advance the mission or they must go," and that "we need to change the conversation from caring for artifacts to caring about people." There are two critical considerations here – missions and people. If museums are prepared to rethink their missions to reflect their civic responsibilities and contribute to the durability and well-being of communities, then much more can be expected of museum collections as the need for societal resilience deepens.

The idea of museum collections as seed banks and memory banks has been discussed and its importance cannot be overstated in a contracting world. It is imperative that the core collections of humankind's past achievements, failures, and adaptations be selectively preserved, both as a legacy and as resources for an unknown future. The Svalbard Global Seed Vault (Government no 2023), for example, stores duplicates of seeds conserved in gene banks around the world, thereby providing security against the loss of seeds due to mismanagement, accident, war, and natural disasters. A worldwide network of collection facilities could provide a similar service by preserving a representative sample of humankind's material legacy, as we can never foresee which objects will help and inspire future ages. Is the museum community able to muster the foresight to assume this responsibility and serve as a lifeboat? In its absence, who will?

Museums continue to stagger under the burden of continuous and redundant collecting – more space, money, time, and staff are never enough. Deaccessioning has only recently been commonly acknowledged as a legitimate activity within the museum community, and every museum must now shoulder this responsibility. There is a growing and substantial literature on deaccessioning, including ethics, processes, opportunities, warnings, and best practices, such that it can no longer be claimed to be a violation of professional practice. Rather than providing a primer on how to deaccession, what follows are several questions to guide a reappraisal of the purpose of collections that invite dramatic change. I am inspired by Rainey Tisdale's (2018: 162) creative questions, all of which are remarkably prophetic while bearing collapse in mind:

1. What if museums functioned like a branch of medicine and objects were prescribed to cure what ails you?
2. What if museums functioned like lending libraries and objects circulated through communities like books?
3. What if museums functioned like reference libraries or hardware stores that help you answer questions or solve problems?
4. What if we built a museum, and its collection, totally from scratch, based on the needs of a twenty-first-century audience, without any history, baggage, or practical constraints of the museums we have today? What would it look like?

Question #4 pretty much sums up the task confronting all competent museums as the polycrisis unfolds. Whether the museum as lifeboat is achievable remains to be seen, and it will require great passion and will to overcome the inertia and the sense of scarcity that enslave museums to the *status quo* – never enough staff, money, visitors, technology, and so on. This perceived scarcity can be rethought, however, if the words of the founder of the voluntary simplicity movement are taken to heart:

> There is nothing lacking. Nothing more is needed than what we already have. We require no remarkable, undiscovered technologies. We do not need heroic, larger-than-life leadership. The only requirement is that we, as individuals, choose a revitalizing future and then work in community with others to bring it to fruition.
> *(Elgin 1993: 193)*

Values or the marketplace?

What do we need to let go of so as not to make matters worse? The foundation of MTI society is the marketplace, and it continues its tyrannical hold over museums (Janes 2009a: 94–120). This must come to an end if museums are to address the many challenges of the polycrisis. Market ideology and corporatism continue to constrain museums with a stultifying adherence to financial considerations at the expense of clearly articulated values. At the core of this dysfunction lies confusion about values – those essential and enduring beliefs that articulate how museums and their staff will treat others and how they, in turn, wish to be treated. Values such as wisdom, vulnerability, collaboration, social responsibility, humility, and courage have been ignored or dominated by the imperative for more visitors, more revenues, bigger collections, etc. These imperatives are not values, but the consequences of an unthinking adherence to marketplace ideology.

It is essential to reiterate that the private ownership of natural resources; the increased centralization of power between governments and corporations; the elimination of biological and human diversity; the irrational belief that science and technology will undo or fix the problems we have created; the refusal to set limits on production and consumption; the reductionist approach to understanding life; and the concept of progress at the expense of the biosphere – all of these things that fuel the threat of collapse are the consequences of neoliberal marketplace ideology or are in the service of this ideology (Janes 2009a: 119).

The most obvious clash of values is apparent in how museums view time, as compared to the marketplace. Museums are about time. Why would museums embrace commercial dogma as a strategy for the present and the future? Instead, museums can summon a quality that is exclusively theirs as civic organizations – a deep sense of time. Humankind is in dire need of a long-term perspective to counteract the short-term thinking that drives quarterly profits, that drives the marketplace, and that drives consumption – all of which drive collapse. A commitment

to the long term is the foundation for both mitigating and adapting to the threat of collapse. Respect for the challenges we face and the alignment required to act with inspiration and authenticity require values. Museums can help drive the change required by shaping their values to not only strengthen their organizational cultures but also take their place as stewards and agents of a new future that has yet to be defined. Money is not the measure of worth; conscious museums can provide an antidote to this belief.

Neutrality

What do we need to let go of so as not to make matters worse? Although the concept of museum neutrality is now being questioned as never before, there is a still a widely held belief, especially by senior staff, boards of directors, and governing authorities, that museums must protect their neutrality for fear they will fall prey to bias, trendiness, and special interest groups (Janes 2009a: 50; Janes 2013: 349). There is no justification for museum neutrality in the twenty-first century, however, and there never has been in the history of museums.

Claiming neutrality remains widespread as museums have increased their reliance on corporate, foundation, and private funding, and more and more business people are appointed to governing authorities. There is a palpable fear among these people of doing anything that might alienate a sponsor or donor or government, real or potential. Business tribalism is also a motivating factor, as this tribalism sets values that orient the behaviour of individuals around common interests – in this case neoliberal ideology grounded in an enduring faith in MTI society.

The question remains, however, why museum practitioners rise so readily in defence of neutrality and why is it so entrenched in museum practice? I suggest that neutrality is not a foundational principle of museum practice, but rather a result of the museum's privileged position in society. Museums have been allowed to indulge in their complacency and remain on the societal sidelines as passive observers. Underlying this unexamined privilege is the familiar rationalization that museums may abstain from addressing societal issues and aspirations because they have complex histories and unique missions which absolve them from greater accountability (Janes 2015).

There is no doubt that the claim of neutrality has greatly harmed the role and responsibilities of museums as civil society organizations. Its continued existence also reflects a disturbing lack of critical thinking by museum practitioners and academics who have remained seemingly unaware, or uncritical, of neutrality's selfish and false assumptions. This is cogently summed up by Kevin Coffee, former head of exhibitions at the American Museum of Natural History in New York (USA):

> Despite any claims to the contrary, modern museums were never intended to act as neutral arbiters of culture or narratives. Rather, these museums have always

been advocacy organizations that presume to define and describe normative practices and understandings to the rest of us.

(Coffee 2023: 3)

It is time for museum leaders and boards of directors to acknowledge the meaning of Coffee's truth-telling and discard the pretence of neutrality. If integrity can be simply defined as a "fine sense of one's obligations," museums have an opportunity to ponder what integrity entails as collapse threatens. It must certainly include obligations to ancestors, descendants, and those not yet born, as well as obligations to crew the lifeboat for an uncertain future. If enough museums awake to the present, integrity is poised to replace neutrality as a core belief.

Leadership and management

What do we need to let go of so as not to make matters worse? The first consideration in this formidable task is to reconsider the current definition of museum management as the planning, organizing, coordinating, and controlling of things, people, and organizations – for the purposes of collecting, preserving, interpreting, and communicating the world's material culture (Janes 2023). In fact, the essence of management is not methods, techniques, or procedures but to make knowledge productive. In this sense, management is a social function and a liberal art (Drucker 1995: 249–250). For the purposes of this discussion, management and leadership are considered to be one and the same.

This enlightened understanding of management is predicated on the acknowledgement that museums are of this world and cannot expect to ignore or retreat from the mounting complexity, be it fiscal restraint, social media, decolonization, or the threat of collapse. The management challenge is to identify the knowledge and solutions that will best serve the well-being of the museum and the community it serves. Since its inception, museum management has been based on the twin foundations of neutrality and authority (Janes 2023). The claim of neutrality has, in turn, empowered museum managers to claim authority as unbiased purveyors of facts and truth. The inherent political character of museums, however, is now acknowledged in the narratives they construct and disseminate, as well as the role these narratives play in shaping our collective understanding of difference, fairness, and equality (Sandell 2007).

An essential requirement in addressing the burgeoning complexity of museum management is to abandon or minimize hierarchical structures – the preferred organizational model for most museums that has been adopted uncritically from the corporate world (Janes 2023). Hierarchical structures must now be abandoned or seriously reduced, as they get in the way of staff attempting to use their personal agency, as well as to navigate across and between organizational boundaries. Self-organization is essential in overcoming hierarchy and occurs when "members of a group produce coherent behaviour in the absence of formal hierarchy within the

group, or authority imposed from outside it" (Stacey 1992: 6). Decisions are made at the most local level in the organization where they can be made well, and this requires that managers respect and nurture their informal leaders. These are individuals who exercise influence and authority by virtue of their competence and commitment and not because of any formal position in the hierarchy.

The third imperative for museum leaders is to reject presentism (only the present is real) and to engage in "second curve" thinking. This is in reference to the S-shaped or sigmoid curve "which sums up the story of life itself" (Handy 1994: 49–63). In effect, people, organizations, and civilizations start slowly, grow, prosper, and decline. Decline, however, is not inevitable if one adopts second-curve thinking. This requires museum managers and staff to challenge all the assumptions underlying their work and this must begin with questions. With the threat of collapse looming, second-curve thinking should be a strategic priority for all leaders and managers, irrespective of the type or size of museum. Is the global museum community willing and able to take museum management to this new level of social consciousness? If yes, this will mean relinquishing the museum as primarily a storage and exhibition centre, and enriching these preoccupations with a new perspective that is open to influence from outside the museum, responsive to citizens' aspirations and concerns, and belonging to and affecting the whole community as an institution of the commons. There is no other way to ensure that the museum becomes a lifeboat for its community.

I will conclude this discussion with a shocking example of what passes for leadership in some of the world's largest cultural organizations. I do so as a cautionary tale, to both emphasize that museum leadership is in crisis and to confirm that intelligent museum leadership can never be assumed. Thousands of US museums, zoos, and aquaria received US$1.61 billion in forgivable loans through the Payroll Protection Program (PPP) during the COVID-19 pandemic (AFSCME Cultural Workers United 2021). The report found that 228 of the nation's biggest cultural institutions shared US$771.4 million in PPP loans, but collectively cut 14,400 jobs during the pandemic. Many of those same institutions ended with budget surpluses in 2020, including art and history museums. This is not leadership; it is a sobering glimpse of what happens in the absence of integrity. Are we to rely on these untrustworthy organizations as collapse threatens?

Functional stupidity

What do we need to let go of so as not to make matters worse? Repairing and preventing the stupid organization is of vital importance and must be done if there is to be the capacity to confront collapse. Researchers coined the term "functional stupidity" to describe organizations that hire intelligent and talented people but create cultures and decision-making processes that inhibit staff from raising concerns or making suggestions (Marshall 2020). Functional stupidity is best described as when smart people are discouraged to think and reflect at work. Instead, staff

are encouraged to emphasize positive interpretations of events, leading to "self-reinforcing stupidity." Talented and committed staff are acutely aware of this dysfunction and feel powerless to act. Many leave or reduce their work commitments to a bare minimum.

Functional stupidity is alive and thriving in museums of all sizes, presided over by executive directors, CEOs, and senior executives with too much authority that is seldom, if ever, challenged or shared with staff (Janes 2013: 352–353). Communication is top–down, staff know little or nothing about such essentials as their operating budgets, and there is fearful adherence to following orders, not asking questions, and communicating through "proper channels." Such behaviour is characteristic of "functional stupidity" (Marshall 2020).

The consequences of functional stupidity are countless and destructive, creating disempowered staff and museums at a time when the ability and willingness to take action in the world is critical. I have come to this conclusion based on my decades of serving as an executive, advisor, mentor, and consultant to innumerable museums, staff, and board members who have had no hesitation in sharing their anguish and anger with pervasive organizational stupidity. For those leaders and managers who are reading this book, here is a brief self-assessment. Do you lead a participatory strategic planning process with staff, board, and stakeholders? Do you have a shared vision above and beyond your own and that of your senior colleagues? Do you share this vision throughout the museum and your community? Do you define strategic priorities and communicate them continuously (recall that strategy is as much about saying no as it is about adding more work)? Do you share the museum's budget with all of your staff at least annually and allow for questions and discussion? Do your board members know what individual staff do? Do you have all-staff meetings to update staff on current challenges and opportunities? Do you meet with every one of your staff at least once a year? Do you hold your managers accountable for the growth and development of the people who report to them?

There is also the matter of equitable compensation, starkly highlighted in the 2020 disclosure that Glenn Lowry, the director of the Museum of Modern Art in New York, received an annual salary of US$2.3 million, plus a US$6 million rent-free apartment (Bishara 2020). Lowry's salary is about 48 times the salary of an education assistant at the museum. This disparity confirms the deleterious presence of neoliberal values in the boardroom, where the lone director is sanctified at the expense of the rest of the organization – a deep-rooted norm in the corporate world. This income disparity, with its attendant elitism, is increasingly common in the museum world and is yet another characteristic of a stupid organization.

There is one more contemporary phenomenon that merits attention as a possible contributor to organizational stupidity – social media. It would seem that social media has instilled a fear of getting "called out" – a fear of saying or writing the "wrong thing" that then triggers a viral firestorm. This has affected numerous organizations, including universities, scholarly associations, and the creative industries (Weisberg 2023). The worry is that the threat of social media intimidation

could replace personal agency with self-censorship, adding a serious dimension to the stupid organization. The consequences of social media in museums should be monitored to avoid this needless menace.

The self-assessment questions above highlight some of the basic building blocks of an intelligent organization; there are many more. If leaders and managers are not doing most or all of these things, they are highly likely to be running a stupid organization. They may not know this either, as staff are fearful or powerless to express themselves, while the leadership persists in a protective bubble irrespective of how accomplished they may feel with their salaries, social connections, and years of experience. Status and outward appearances remain unassailable. Museum leaders and boards can take comfort in knowing that they are not alone, as functional stupidity is widespread in all sectors of society – an indictment that cannot be allowed to persist. It is essential that every museum leader confront their role in the perpetuation of organizational stupidity so as not to make matters worse as the threat of collapse looms. You will be immeasurably strengthened in this task by nurturing the personal agency of your staff – more on this shortly.

Restoration: "What can we bring back to help us with the coming difficulties and tragedies?"

Museum workers often joke about the public perception of their work, noting the widespread belief that museums must be an ideal place to work – peaceful sanctuaries, often elegant, and not buffeted by the rude demands of a "real-life" workplace. In fact, museums are complex organizations and the range of issues and pressures confronting museums in the twenty-first century is equal to that of any sector of organized life (Janes 2009a: 57). Museums house multiple professional allegiances, competing values and interests, and often a bewildering range of diverse activities. This complexity can be better understood, and made the most of, by restoring a number of principles and activities to museum practice that seem to have fallen into disuse or were never present in the first place. What follows is a sample of those that should be restored to museum work in order to render complexity an ally in facing the coming difficulties and tragedies.

The four agendas – why, what, how, and for whom?

What can we bring back to help us with the coming difficulties and tragedies? Planning for the future requires going back to fundamentals and reconsidering the purpose of museums. In distilling the complexity discussed earlier, it is useful to think of museums as having four agendas (Phillips in Janes 2009a: 57) – *why, what, how,* and *for whom*. The first agenda, *why,* is essentially ignored in the museum world, and the unwillingness or inability to address this question lies at the heart of the museum's decidedly ambiguous role and purpose in society. The second agenda, *what,* focuses on the work and content of the museum, including

the mission, exhibitions, programs, collections, conservation, marketing, audience development, and so forth. This is where boards of directors and staff focus, as well as the vast majority of professional conference programs.

The third agenda, *how*, is about how things are organized – the people and resources required to do the work, including strategic plans, organizational structure, delegation, staffing, training, communication systems, resource allocation, coordination and control, reward and recognition systems, and so on. The *how* receives far less attention, if any, in professional circles than does the *what*. In short, the third agenda is the all-pervasive culture of the organization, and the automatic pilot that keeps the museum moving along in its old and familiar track. Last is the fourth agenda, for *whom*, that is sometimes addressed in museum missions, but more often than not is lacking in meaningful specificity.

Addressing these four dimensions of organizational meaning is essential in breaking the new ground required for change. Designing museum visions and missions for an uncertain future demands that the four agendas be addressed, including why does the museum exist, what changes is it trying to effect, what solutions will it generate, and what are its non-negotiable values? Without this inquiry, the automatic pilot will continue with the *status quo*. Deep reflection on the four agendas are the *sine qua non* of museum transformation and there are no substitutes for these deliberations. Deep reflection on the four agenda questions will also create a bountiful source of meaning, intention, and action, wherein all four parts are interrelated and strengthen each other. The *why* guides the *what* and the *what* directs the *how* – all bound by a commitment to *whom*.

The importance of asking "why"

What can we bring back to help us with the coming difficulties and tragedies? Restoring the question of *why* in museum operations will engender a new awareness of the relationships between internal museum practice and civic responsibilities. Asking *why* will inevitably provoke questions about what issues are important to the museum and how the museum might respond to moral and civic challenges, such as global warming. In turn, this new thinking could be enshrined in an advocacy policy. As thinking and reflection deepen, it will become apparent that museums have ethical obligations, as noted earlier, which include being open to influence and impact from outside concerns and being responsive to citizens' interests and aspirations.

The self-reflective inquiry provoked by asking *why* will also shine a light on assumptions and practices that need critical scrutiny, such as the role of philanthropy in museums. For example, there is now a growing sensitivity to where money comes from, whether from oil and gas extraction, addictive drugs, or the arms industry (Merritt 2019). No one is immune to this newfound scrutiny, as climate change denier David Koch discovered when protests in 2016 forced him to step down from the Board of the American Museum of Natural History. Does your

museum benefit from toxic philanthropy? Have you had this conversation with your leadership, board, and staff? Do you have a policy governing your philanthropic activities? Philanthropy is but one emerging issue that promises to alter the *status quo*; there are many others noted throughout this book, including diversity, decolonization, activism, and pay equity, to mention only several. Each of these will require deliberation, policies, and action plans beyond the performative announcements now popular in museums. These are fine sentiments but mean little in the absence of behavioural change. These issues and decisions are fraught and weighty but can no longer be avoided. The four agendas will assist in a thorough examination.

Personal agency

What can we bring back to help us with the coming difficulties and tragedies? It is not clear to what extent personal agency has ever been acknowledged in museums, although given its importance it must be restored or established as a priority. By personal agency, I mean the capacity and willingness of individual museum workers, irrespective of their formal positions, to take action in the museum and the world. (Janes 2013: 360–362). Personal agency also requires that leaders and managers recognize their employees as individual human beings. I have always been concerned with the widespread disconnection between those who work in museums and the manner in which museums function as organizations. Individual staff members are insightful, committed, and motivated by concerns and values beyond the workplace, yet the relationship between their workplace and personhood remains largely unrecognized and unexplored. Individual qualities, values, and concerns that transcend the workplace are rarely translated into organizational reality. The greater the congruence between individual and organizational values, however, the stronger the organization.

Guidelines for nurturing personal agency are useful in achieving this congruence, and I (Janes 2013: 360–362) have discussed these elsewhere and will not reiterate them here, with one exception. As collapse threatens, with all of its tangible and psychological consequences, it will be essential for all museum people – staff, boards, volunteers – to share aspects of their non-work life, whether it be involvement in an environmental NGO or volunteering at a food bank. These seemingly unrelated skills, experiences, and values are essential as a museum broadens its awareness and prepares to serve as a lifeboat for its community. Continuous learning will be essential to this task, as will the unseen skills, knowledge, and experiences of staff, boards, and volunteers.

It would seem that supporting personal agency is difficult or undesirable for museum leaders, as it remains unrecognized and unappreciated in so many museums. I believed for decades that museums are potentially one of the most free and creative work environments in the world, and I now see that I was mistaken. I now place much greater emphasis on "potentially," as agency, freedom, and creativity

are dependent on the authority and responsibility given to staff by the museum hierarchy. Some museums are more respectful of staff than others, and hence good judgement and common sense are essential in pursuing personal agency. If the hierarchy is pronounced, personal agency can often be fulfilled by not drawing attention to one's self, or "flying under the radar" as the saying goes. Nonetheless, the relationship between workplace and personhood is becoming more abusive in museums, as evidenced by the earlier examples of unnecessary COVID-19 layoffs and appalling salary disparities. The vitality of personal agency is directly related to the quality of leadership and management and the stupid museum is a widespread obstacle. Happily, opposition to this inertia and intransigence is underway.

I discussed in Chapter 4 the appearance of various coalitions and organizations, created and served by museum workers and non-museum workers, who have taken matters into their own hands to address widespread leadership and management deficiencies. These organizations are not the property of mainstream museums or museum associations and represent a strong movement to strengthen museum practice in a variety of ways. One of these organizations with a more radical agenda is Museum As Site for Social (MASS) Action (MASS Action 2021). MASS Action, in collaboration with stakeholders across the field, is creating a platform for public dialogue on a variety of topics and issues affecting communities locally and globally – leading to actionable practices for greater equity and inclusion (MASS Action 2021). They ask, "How do you transform museums from the inside out?" Further:

1. What is the role and responsibility of the museum in responding to issues affecting our communities locally and globally?
2. How do the museum's internal practices need to change in order to align with, and better inform, their public practice?
3. How can the museum be used as a site for social action?

These questions lie at the heart of intelligent adaptation to the threat of collapse and set a standard for enhanced consciousness, and I have yet to see any questions so astutely relevant on the programs of current museum conferences. Is the global museum leadership listening, learning, and responding to these voices of constructive discontent and the yearning for action? Is the mainstream museum community listening?

Self-sufficiency

What can we bring back to help us with the coming difficulties and tragedies? I recall another observation by the nineteenth-century novelist, Joseph Conrad (1960: 269), who wrote, "They were two perfectly insignificant and incapable individuals, whose existence is only rendered possible through the high organization of civilized crowds." Although this was in reference to the men in charge of an

African trading station, I fear that it is an apt description of the vast majority of us living in an MTI society. There are alternatives to this helplessness, however, and this will require the restoration of the vanishing quality of self-sufficiency – also called self-reliance. In short, this means being capable of providing for one's needs.

Bearing in mind the five stages of collapse discussed earlier, self-sufficiency begins with the individual and the family and includes the hard skills that require specific technical knowledge and experience. Building the hard skills of self-sufficiency may or may not involve the museum – it will depend on what kind of museum it is and its particular expertise. These tasks are many and include growing and harvesting food, making and repairing clothing, food preservation, basic engineering skills (plumbing, electrical, water maintenance, and waste management), as well as ecological skills centred on the knowledge of the community where one lives, its resources, and how to sustain them. Self-sufficiency must also extend beyond individuals and families to include museums if they are to serve as community lifeboats.

Although we have no idea when or how collapse will unfold, museums can make preparations now that will serve them well irrespective of the threat of collapse. My focus here is on the so-called soft skills – those non-technical skills concerned with how one works and interacts with others and includes teamwork, communication, adaptability, critical thinking, sharing, and interpersonal interaction. The following skills and activities will strengthen organizational self-sufficiency and do much to position the museum as a key source of community support, assistance, and self-sufficiency (Pollard 2022b). These are also key ingredients in fostering networks and interdependence. I have modified Pollard's suggestions with museums in mind:

1. Critical thinking – the capacity to study, research, and problem-solve, by analyzing available facts, evidence, observations, and arguments in order to form a judgement. Critical thinking is self-directed, self-disciplined, and self-corrective.
2. Facilitation – the ability to help individuals and groups work and think collectively, achieve consensus, resolve conflicts, and manage themselves.
3. Helping people cope – hosting meetings, workshops, and conversations to provide information and insights to assist individuals and communities who are dealing with the loss, uncertainty, fear, grief, shame, anger, anxiety, and other emotions that will inevitably accompany the threat of collapse.
4. Mentoring – museums can serve as mentors in the same way that individuals do, by using their knowledge and experience to guide their communities and other museums in collaborating, solving problems, advocating, fostering research, and sharing collections as knowledge seed banks. In short, by modelling best practices.
5. Conversations – The importance of hosting community conversations cannot be overstated, as the ability to clearly convey the issues and the imperatives of the day are essential tools for adaptation.

All of these soft skills have in common the purpose of community building. This means contributing to a healthy community culture, organizing, sharing responsibility, building on what works, and making both the museum and community more collaborative, cooperative, enterprising, resilient, and competent – together (Pollard 2022b). It has been clearly demonstrated that the most defining social movements – from decolonization to feminism – are formed in quiet, closed networks that allowed a small group to incubate their ideas before broadcasting them widely (Beckerman 2022). The museum as community incubator is feasible.

Community building will also require resistance to the prevailing norms and values of the MTI society which, in turn, requires being alert to the dangers of postmodernism. This is the school of thought based on the assumption that an "objective evaluation of competing points of view is impossible, since all points of view are to some extent biased by race, gender and culture" (Woodhouse 1996: 22). The biases are undoubtedly true, but the real danger in adopting this perspective is that we abandon passion and critical thought in the name of relativism. Postmodernism has been called the culture of no resistance (Zernan 2001), and preparing for collapse will require resistance.

Elder culture and the honourable life

What can we bring back to help us with the coming difficulties and tragedies? Indigenous cultures throughout the world celebrate their elders, as do various countries such as Korea, China, and India. Elders in Indigenous North American cultures are considered to be sources of cultural and philosophical knowledge, as well as storehouses and transmitters of information. They are also regarded as living libraries on a wide variety of practical and spiritual matters and have earned the respect of not only their own communities but also their societies. It is important to note, however, that not all elderly people are considered elders, as an elder is a person who has accumulated a great deal of wisdom and knowledge throughout his or her lifetime. I submit that mainstream North American society would benefit greatly by restoring an elder culture to assist with overall societal well-being as well as addressing the threat of collapse.

Instead, ageism is pervasive in the Western world – the stereotypes (how we think), prejudice (how we feel), and discrimination (how we act) toward others or ourselves based on age. Ageism is discrimination against people who are seen to be "old." Ageism goes beyond individual interactions, as it is structured into our social institutions including the healthcare system and the workplace. Our ageist society idealizes youth and marginalizes, makes invisible, and devalues older adults. With the threat of collapse and the imperative to adapt to a diminished future, ageism is maladaptive and constitutes a squandering of wisdom, knowledge, and perspectives that younger generations cannot presume to possess. This lack is especially true for those brought up in a digital culture where much of their

life experience has been confined to a small screen – beset by toxic social media platforms, disinformation, and mind-boggling trivia.

With no traditional knowledge to guide the restoration of an elder culture, what could it be and how would it work? It could be, in effect, a new social form detached from the competitive, overly consumptive, trivial entertainment priorities that drive daily life. It would be countercultural and based on the acknowledgement that conscious aging opens one up to certain truths, such as being mindful of mortality and the importance of compassion (Roszak 2009: 14, 39, 72). Above all, an elder culture would look out for the best interests of the future and "preserve the precious compact between the generations." With the benefit of long life experiences, elders are in a position to take risks and have far less to lose in doing so. They can serve as advocates and mentors for the collective good, while helping to illuminate an unknown future. In short, an elder culture is the missing part of a well-functioning civil society – a need that grows more urgent daily.

Museums of all kinds are ideally positioned to foster an elder culture – to host, facilitate, and steward this work. This is not about audience development focused on attracting seniors, however. Nor is it about creative aging or managing old age. Rather, it is about stewarding a civic resource by making use of the creativity already present among community elders. This could begin by inviting elders to the museum for a conservation to gauge their interest and availability. The next step would be to form an elders council, as a pilot project, to serve as an advisory body to the board of directors or governing authority. This is not essential, however, as the elders could simply form a stand-alone group with a museum affiliation. Important lessons to guide this initiative are available from those exceptional museums which have First Nations, Inuit, or Metis advisory councils.

The Western world's fixation with presentism and digital technology cannot be overestimated. Many museums continue to uncritically adopt the methods and impulses of the private sector, including the magical thinking of the digital priesthood, artificial intelligence, non-fungibles, and digital collectables. Elder councils can serve as a source of reason and reflection to help mitigate the cumulative harm of techno-utopia, as well as other ills of the MTI society grounded in digital technology. Wisdom, knowledge, and a moral compass are required to transcend the corporatist manipulation of society, and not all elders are prepared or equipped to confront these threats. Building an elder culture and creating elder councils will require judicious assessment by museums, as well as self-selection by the elders themselves.

Reconciliation: "With what and whom can we make peace as we face our mutual mortality?"

Before addressing this last question, two additional questions are necessary to emphasize the challenges that lie ahead. Kevin Coffee (2023: 172), a veteran scholar/practitioner, poses them. "Are modern museums hopelessly bound by the

FIGURE 5.1 The author's naming ceremony where he received a traditional Blackfoot name in 1995. Kainai First Nation (Blood Tribe), Alberta, Canada.

Source: Photograph courtesy of Priscilla B. Janes.

colonialist-capitalist social relationships through which they were created? Further, "can museums be liberated, or are they outdated nineteenth century technology, like the internal combustion engine, hazardous to humanity and the Planet?" The three previous questions about resilience, relinquishment, and restoration provide ideas and guidance as to what is feasible for museums to do. Reconciliation is also essential in coming to grips with adaptation, recognizing that the history of museums is marked by the consequences of power, privilege, and sanctioned disrespect for marginalized peoples the world over.

As noted earlier, Indigenous Peoples in the United States and Canada have been the unremitting casualties of settlers, armies, and successive governments, and the legacy of settler colonialism is still unfolding in North and South America (Janes 2021). Consider also the prolonged societal indifference and government inaction to address the cumulative effects of this ongoing malfeasance, not to mention the contemporary disregard of Indigenous treaty rights. The result is now a resolute and growing movement to address and redress the wrongdoings of the past in the name of truth and reconciliation, at the core of which lies decolonization. Honouring Indigenous worldviews, decolonization, and the repatriation of Indigenous belongings (including human remains) are critical issues that can no longer be ignored by the global museum community (Conaty and Janes 1997). These issues demand truth and reconciliation.

In seeking truth and reconciliation, it is important to be aware of an unsettling development in the meaning of decolonization. Decolonization means bringing about the repatriation of Indigenous lands and life. "It is not a metaphor for other things we want to do to improve our societies and schools" (Tuck and Yang 2012: 1). Tuck and Yang note that there are increasing calls to "decolonize our schools," or use "decolonizing methods," or "decolonize student thinking." This is not the work of decolonization. The spoken and written communication about decolonization is turning into a metaphor for things that have nothing to do with decolonization, including its real meaning and the obstacles that surround its realization. They (Tuck and Yang 2012: 36) observe that "decolonization offers a different perspective to human and civil rights based approaches to justice, an unsettling one, rather than a complementary one." There is much to learn here.

Embedded within the relationship between museums and Indigenous Peoples are concerns about identity, power, and history, as well as arguments over the possession of Indigenous belongings (Janes 2021). Museums, as self-proclaimed defenders of knowledge and the keepers of society's material memory, commonly feel that their reason for being is threatened by demands for repatriation. While few curators, and even fewer administrators, are at ease amid these discussions, this issue is gaining momentum as the world continues to polarize around wealth inequality, racial inequality, and the continued marginalization of Indigenous Peoples. Conceding that there are other ways of knowing the world we inhabit together is an essential first step in reconciliation.

Other ways of knowing

With what and whom can we make peace as we face our mutual mortality? There are two prerequisites in acknowledging that there are other ways of knowing, the first of which is recognizing and doing away with "othering," as discussed in Chapter 1. To reiterate, othering is viewing or treating a person or group of people as intrinsically different from, and alien to, one's self. In short, "they are not us." Indigenous Peoples continue to suffer this marginalization by the dominant society. The other prerequisite is recognizing that cultural diversity is as important as biological diversity, and other ways of knowing are the foundation of this diversity. Othering becomes meaningless whenever one is directly exposed to human beings who possess different worldviews, because othering is based on ignorance and fear. We are, despite our different worldviews, all human beings and I understand that far too many people have not had the opportunity to step outside the familiar to interact with unfamiliar cultures on their own terms. Packaged trips to Mexico do not count. Northern Canada is a case in point, with the majority of southern Canadians woefully ignorant of its history, geography, and cultural diversity.

I have been blessed throughout my museum work with a range of lived experiences, including time and work among two of the world's greatest hunting

cultures – the K'á lot'ine Dene of Canada's Northwest Territories and the Inuit of Canada's Arctic. I have also worked with other First Nations, including the Blackfoot Confederacy and the Plains Cree in Alberta and Saskatchewan respectively, and the Vuntut Gwitchin First Nation in Old Crow, Yukon, as well as the nomadic Manasir Tribe in Northern Sudan, Africa. I acknowledge my good fortune in experiencing these other ways of knowing and the influence they have had on my efforts to reconcile museum practice with the realities of cultural diversity. Two examples of reconciliation are summarized here – one concerned with collections and the other with cosmology.

When I began my career as a museum director in Yellowknife, Northwest Territories, I began to listen more deeply when it became clear that the majority of people in the Northwest Territories' remote communities were not interested in adhering to professional museum practice. This was not out of any disrespect or hostility but rather because of their particular worldview. As a result of listening and learning together, we developed alternative approaches to museum work (Janes 1982). For example, young women and elders in a Dene community joined together to create and preserve various forms of decorative art, ranging from porcupine quill embroidery to bead sewing. Most importantly, the group transmitted these skills to succeeding generations. It is important to note that the initiative and interest were local, and that elaborate facilities, environmental controls, and high operating budgets were not required. I cannot overemphasize the values I experienced among the Dene, the Inuit, and the Metis. This was the nature of their societies – open, sharing, and respectful. It was their way of knowing and I absorbed this into the conduct of our work, as did my colleagues.

The second example of other ways of knowing has nothing to do with objects or collections – it is about relationships. To the Blackfoot, almost everything is considered animate (Janes 2021: 165–166). Their understanding has been developed over thousands of years of observing the world and taking note of the constant change and flux, which encompasses everything. Animals, plants, rivers, and even rocks are always undergoing some kind of change. As things change physically, there is an accompanying change in their energy levels. This energy, or spirit, as it is often referred to, is the unifying feature which defines creation as animate.

The Blackfoot understanding that everything has inherent energy or spirit, together with the observation that there is continual change among all things, leads to the conclusion that there is a relational network among all animate beings. The Blackfoot contribute to the relational balance through ceremonies and songs given to them by other living beings and by Creator. The ceremonies and the songs are represented physically by the Holy belongings that are often referred to as medicine bundles or sacred bundles. A bundle may be as small as one item or as large as several hundred items. The Blackfoot use the physical representations within the bundles as a means of connecting with the intangible (i.e., the spirits and their power), as the bundles are tangible evidence of the relational networks between the Blackfoot and the rest of Creation.

Even this rudimentary explanation of the Blackfoot worldview demonstrates the enduring value of sacred belongings and their importance to the Blackfoot people. To remove any part (such as the Holy belongings) is to risk making the entire worldview dysfunctional and to risk unbalancing the relational network (Conaty and Janes 1997: 34). Regrettably, museums have made a practice of removing parts from the whole, failing to understand that sacred bundles are not merely collections of physical objects – they are living entities that require vigilant care within an Indigenous way of life. Sacred bundles do not belong in museums, and the only way to know this is for museum workers to pay heed to other ways of knowing.

Reconciliation is a multidimensional learning process with both organizational and personal meaning, and there is much to be gained and gifted by welcoming other ways of knowing. As a novice museum director, it empowered me with curiosity, humility, and reflection. Without encountering Indigenous worldviews, I would have adhered to the traditional assumptions and methods of conventional museum practice – bound by professional constraints at the expense of the peoples we were intended to serve. I would not have asked the following questions – questions which guided me beyond the shadow of orthodoxy, to think anew, and develop alternatives.

1. How do you address the stated perception among Indigenous Peoples that museums are a colonial legacy and do not address the needs of living cultures?
2. How do you involve Indigenous Peoples in the development of a museum in their homeland, at a time when their political aspirations were demanding acknowledgement and redress?
3. Are environmentally controlled museums in remote Subarctic and Arctic communities necessary, achievable, or preposterous?
4. What is the best organizational design to unleash individual talent and commitment?
5. Should a museum have a single focus or be multidisciplinary?

Without encountering the worldview of the K'á lot'ine Dene, would I have learned about the dynamics of small group culture that are universally applicable to the management of organizations and people? My time among these Subarctic hunters abounded with enduring lessons and knowledge that remain with me today – in social ecology; environmental stewardship; leadership based on competence and respect (not hierarchy); self-organization; the importance of personal agency; and the meaning of generosity in a severe environment where scarcity is ever-present (Janes 1983). Museums are free to choose reconciliation to help prepare themselves for collapse, and it must begin with Indigenous Peoples. It is only through reconciliation that museums will be able to overcome their legacy of colonialist–capitalist social relationships. Can museums be liberated, or have they become increasingly hazardous to humanity and the Planet? As we face our mutual mortality, the time has come for museums to make reconciliation with Indigenous and marginalized peoples an essential condition of museum integrity, accountability, and adaptation.

Honouring the More-Than-Human World

With what and whom can we make peace as we face our mutual mortality? I have referred to the More-Than-Human World repeatedly throughout this book in an effort to demonstrate our collective disregard for its well-being. It is not too late to reconcile this disregard and this will require a deep consideration of one's thoughts and feelings for the many living things that form the web of life upon which we depend. This is not an easy task in MTI society.

One would certainly treat a plant species differently, for example, if the plant were seen to be a nuisance, or an economic externality (cost), or a relative (Lemille and Chesnais 2019). We lack a unified perception of the natural world, based on the awareness that all living things are connected. With the threat of collapse, reconciliation with the natural world means confronting everything we do that is destroying the Planet – what we eat, what we buy, how we get around, the pace of our lives, and our expectations that we can have whatever we want, whenever we want it. Understanding that the Earth is a single system – and that human behaviour is imperiling this system on a global scale – is essential to understanding what reconciliation means. It must begin with the recognition that we do not have the right to destroy the Planet which, in turn, will incite a critical question. If we can destroy life as we are doing, what are our obligations to plants, animals, mountains, rivers, forests, oceans, and reefs – for all living organisms in the biosphere? What do we owe to the More-Than-Human World?

Our welfare is dependent on the welfare of all that is not human, as Indigenous Peoples have always known and are now acting upon. A recent assessment of Indigenous resistance to fossil fuels in North America showed that victories in infrastructure fights alone have prevented the carbon equivalent of 12% of annual US and Canadian pollution of 779 million metric tons of CO_2 equivalent (Goldtooth and Saldamando 2021). Another analysis showed that if direct resistance efforts were funded, they have the potential of mitigating 1,300 gigatons of CO_2 equivalent by 2050, or the equivalent of carbon in the standing stock of all global forests. Indigenous Peoples have done this by protecting their lands from resource extraction and development.

There is a threat to this stewardship, however, when Indigenous Peoples are offered "partnerships" with oil, gas, mining, and logging companies. The conflict in Canada, for example, lies in some band councils (appointed under the Indian Act) making agreements with industry, without the support of their traditional Indigenous governing authorities and leaders. Like all peoples and all nations, Indigenous Peoples are divided by opposing notions about how to secure their common good. It has been noted that these partnerships are, in fact, another example of exploitation by the dominant society.

This is a reminder that we must take a stand against land grabs which are on the rise globally, as well as another reason for faith in a possible future, as long as we are aware of this treacherous trend and refuse to accept it. The term land grab is the practice of governments paving the way for industry by handing over

communally held parcels of land for economic development (Hosgood 2022). The traditional territories of Indigenous Peoples are particularly at risk in Canada, the Philippines, and Liberia, to mention only a few, as governments and corporations push through oil and gas pipelines, mining, logging, and agriculture developments for the sole purpose of economic gain. More land grabs can be expected in coming years "as opportunities to prioritize industry during times of extreme destabilization will become increasingly common, because . . . society faces overlapping and intersecting emergencies caused by climate change" (Hosgood 2022).

This is the opposite of what should be happening as we contemplate collapse. We must conserve, protect, and restore habitats as healthy ecosystems help nature and people adapt to climate trauma. Not only do these places conserve biodiversity, but they also protect ecosystem services, connect landscapes, store carbon, build knowledge and understanding, and inspire people. Neoliberal thinking lacks wisdom, understanding, and other ways of knowing, and museums are in a position to counteract this blindness with information, knowledge, and community conversations.

Traditional Indigenous Peoples do not have to reconcile with two critical obstacles that are preventing the Western world from honouring the More-Than-Human World – dualism and reductionism – both legacies of Enlightenment thinking. At its worst, reductionism is oversimplification, based on the belief that "complex wholes

FIGURE 5.2 The late Rosa Bernarde and the late Alice Bernarde smoke a moose hide at the K'á lot'ine Dene hunting camp in Canada's Northwest Territories.

Source: Photograph courtesy of Priscilla B. Janes.

and their properties are less real than their constituents, and that the simplest part of something is the most real." Put another way, "the whole is not greater than the sum of its parts" (Woodhouse 1996: 11, 15). This in turn leads to fragmented thinking and the assumption that things are understandable in isolation from their contexts. The other Enlightenment burden that pervades our failed stewardship is dualism – the belief that "alternatives to thought and endeavour are polarized, and guided by the law of the excluded middle" (Woodhouse 1996: 14). This is also called "either-or" thinking. More specifically, this kind of thinking underlies the view that nature exists to serve the interests of human beings. Dualism separates people and nature, and we must make peace with both reductionism and dualism by rejecting them as illusory. Doing so will require both organizational and personal agency.

Moral injury

With what and whom can we make peace as we face our mutual mortality? In addition to the moral hazard discussed in Chapter 1 stemming from the oil industry's consistently fraudulent behaviour at the COP climate conferences, all of us must now contend with a revelation that also requires reconciliation – the emerging recognition of moral injury. Living in the MTI society "means that life is generally lived in ways that harm the Planet, people and animals. To know at a feeling level that one has participated exposes one to moral injury, a violation of what is right and fair" (Weintrobe 2020: 351–352). Most importantly, feeling that you have been morally injured "is a sign of mental health, not disorder. It means one's conscience is alive." Underlying moral injury is the loss of trust in contemporary society and its leadership.

In her seminal paper on the culture of uncare, Weintrobe (2020: 351) writes that the experience of moral injury requires that people acknowledge that they have participated in a damaging way of living that has caused irreparable harm to the Planet, people, and animals. This is more difficult than it may seem, as the technological-industrial society covers this up and denies the consequences of our collective behaviour and, instead, pretends that all is "normal." Weintrobe (2020: 356) notes that neoliberal culture fabricates "bubbles" of denial, creating idealized worlds that function to minimize the moral unease, anxiety, rage, and grief that people would feel if the real world was seen clearly. This is no longer working, however, because the fictitious bubble has begun to shrink as more and more people awake to the consequences of global warming. The museum community must also resist this falsehood by reconciling with what is actually going on. Because it is now permissible to discuss the climate crisis in polite company, it may not be too long before the threat of collapse will be openly discussed. Silence is the biggest obstacle to reconciliation and mobilization.

If enough people and their communities are able to admit to moral injury, several outcomes are conceivable. First will be the revelation that you are not alone and that many others share in your moral injury, grief, and remorse for quietly

participating in a culture that is destroying the Planet. Acknowledging others with similar feelings is the first step in constituting a network of like-minded people who acknowledge the damage that has been done. This awareness, in turn, can lay the groundwork for the most important outcome – the creation of collective efforts to abandon the current culture and set limits on the way we live (Weintrobe 2020: 359). I have written about restraint, reduction, limitations, suffering, privation, and degrowth throughout this book – all of these are alienating options for free-market capitalists and for those who choose denial. Not so for those who are morally injured, as the injury serves as a common ground to connect all those who feel the need to set limits but think they are on their own. As Richard Heinberg (2023) notes, the key will be a new attitude toward limits – "a willingness to view them not as restrictions always to be fought against, but as boundaries that enable systems to work." To continue to ignore these boundaries is to replace instability with collapse.

The experience of moral injury is both an invitation and a catalyst to inspire all those affected to work together to honour the biosphere rather than destroy it. There is undefined empowerment in the admission of moral injury and the opportunity this presents to redefine individual and collective responsibilities for a truly sustainable future. This future, however, cannot be the so-called clean energy transitions, whereby the Global North puts even more pressure on the Global South to plunder their countries and their peoples for raw materials (for batteries, wind turbines, solar panels, etc.) to fund the decarbonization of the Northern rich. This is yet another means for the neoliberal market to externalize costs to the environment and to poor people in poor countries. We will need much more imagination, discipline, and moderation in defining and living a sustainable future, and museums can serve as hosts and agents in exploring what this means for their communities.

Museums, as civic resources, can be lifeboats to assist with the creation of a new narrative for a new future. The fulfillment of this organizational and personal agency must begin with reconciling and making peace with personal moral injury. Admitting our individual and collective complicity in the destruction of the earth will inevitably be cathartic, liberating, and sustaining. We must make peace with this complicity, individually and collectively. I feel this moral injury daily but have yet to share it beyond a personal circle of family, friends, and colleagues. With this book, I am encouraging the museum community – both organizations and individuals – to step out of the neoliberal bubble and transform museums as a force for good.

Listening while saying goodbye

With what and whom can we make peace as we face our mutual mortality? I took this subtitle, "Listening while saying goodbye," from a recent article on biodiversity as I find it to be a tragic invitation to reconcile with yet another catastrophe of our making. As I am near the end of this appraisal of museums as lifeboats,

the loss of biodiversity strikes me as perhaps the most unacceptable and disgraceful consequence of humanity's madness. We are destroying a profuse range of sentient beings who have no voice or representation in human affairs. As discussed in Chapter 1, the sixth mass extinction is now well underway and we are doing this while increasingly aware of what is happening.

Whether reconciliation has any enduring value is uncertain, considering that scientists estimate that 150–200 species of plant, insect, bird, and mammal become extinct every 24 hours. This is nearly 1,000 times the "natural" or "background" rate and is greater than anything the world has experienced since the vanishing of the dinosaurs nearly 65 million years ago (Jamail 2019). Dahr Jamail, a writer and journalist, notes that we have a limited time left to spend with those parts of the biosphere that are now dying, including alpine glaciers, coral reefs, and all the creatures mentioned earlier. Saying goodbye to these irreplaceable wonders is inconceivable and falls far short of what reconciliation demands. It demands that every effort be made to protect all that remains, despite the ecomodern and techno-utopian falsehoods that dominate our behaviour. Saying goodbye is simply not sufficient for reconciliation and for making peace, as these ecosystems and their inhabitants are mute – they are defenseless. This muteness alone is a sufficient reason for museums and their communities to give voice to what remains of the biosphere. There are no other organizations with a clearer mandate to preserve diversity than museums with their capacity to integrate nature and culture.

We have no choice but to return to what preceded the worship of economic growth and consumption – a reasonable and restrained accommodation to the Planet upon which we depend. This is a relationship that Indigenous Peoples have worked out over their hundreds of thousands of years on the Planet. They are not saying goodbye; they are saying that they remain as stewards of the biosphere. Given that a substantial proportion of the world's biodiversity inhabits lands managed by Indigenous Peoples, there is a growing recognition among researchers and conservationists that Indigenous perspectives, knowledge systems, and histories hold essential lessons (Schuster et al. 2019). These are the gifts of an Indigenous worldview and these lessons are essential in assisting with deep adaptation to a diminished Planet. Although there are many Indigenous Peoples and many Indigenous worldviews, there are commonalities – the most notable being the understanding that everything and everyone is related. Social justice alone demands that all museums acknowledge and support these other ways of knowing.

Uncertainty

With what and whom can we make peace as we face our mutual mortality? As I complete the last of the four questions, there is a fundamental consideration that pertains to all that has been written in this book. It lies at the heart of resilience, relinquishment, restoration, and reconciliation and underlies the transformation

of the museum into a new kind of institution. It is everywhere and makes us uneasy, passive, and annoyed, yet we must make friends with it. I am referring to uncertainty – when something is not known or certain. Considering all that is inherent in the polycrisis, uncertainty is an inevitable and unwelcome guest with no plans to leave. The key is to accept uncertainty as a constant companion and not let it diminish one's capabilities. There are various ways to accommodate this unwelcome guest (Janes 2016: 117–118).

Living with uncertainty is easier when one realizes that it is okay to make up solutions as you go along, because there is no "right way" waiting to reveal itself or be discovered, especially considering the daunting challenges that lie ahead. This cannot be overstated, as this self-imposed freedom is fundamental to the creative process. It is most important, however, to pay attention to other peoples' experiences – read, reflect, talk, and learn. Second, do not fear uncertainty. Because the museum world is obsessed with perfection, it has raised the practice of "no surprises" to a high art. Few things make museums workers more frantic than uncertainty, as they have a hard time with questions that have no readily available answers. This is an opportunity in disguise, however, if control is relinquished by getting comfortable with uncertainty – not moving too quickly to solutions, assessing novelty, seeking to understand, listening deeply and empathetically, and always recognizing that existing approaches and solutions may not work (Schmachtenberger 2022). Broaden your perspective, no matter how uncertain it may seem, and accept other ways of knowing and being that could enable planning for the unimaginable.

A third way to turn uncertainty to advantage is to stir things up – to provoke, stimulate, and experiment. This applies to all those involved in museum practice, irrespective of rank, position, or specialty. This must be done to provoke questions and new solutions. One writer observed that when things finally become chaotic, we will reorganize our work at a new level of effectiveness (Wheatley 1992: 116). It is sensible to assume that chaos must also become a constant companion, along with paradox. The most useful thinking I have encountered in dealing with paradoxes is that of Charles Handy (1994: 12–13, 63), who notes that paradoxes are like the weather, "something to be lived with, not solved, the worst aspects mitigated, the best enjoyed and used as clues to the way forward." He also observes that "the secret of balance in a time of paradox is to allow the past and the future to co-exist in the present." Uncertainty might just be that middle ground between hope and hopelessness.

It is important to remember that we are the predominant creative forces in our lives, as well as in the lives of the organizations where we work, and we must ensure that this vast creative potential contributes to individual, organizational, and community betterment. To do this means we must get comfortable with the fact that, despite all the work devoted to designing for the future, no one will be able to assess its value until it is over. Although we may never know the outcome of our actions, this cannot be used as an excuse for inaction.

Last, and certainly of equal importance in a state of uncertainty, is admitting your feelings – be they anger, grief, sadness, or hopelessness. If societal collapse comes to pass, not to mention all of the hardships that will precede it, stress and distress will also become constant companions. The strength to endure will be both individual and collective, emanating from reciprocal regard, openness, and vulnerability – at home with yourself, your partner, your children, your parents, grandparents, friends, and relatives, as well as with your museum colleagues. Should there be sufficient strength and courage, then the region where you live, other people in other countries, future generations, and all sentient beings might well be considered as part of our awareness and responsibility.

Hopeless but not helpless

I will conclude this chapter with some final thoughts on the meaning of hope for the museum as lifeboat and can only conclude that hope has little to offer despite the many real and potential threats that are now familiar to the reader. It is hopeless to believe that we will limit global warming to 1.5°C; it may be hopeless to assume that Big Oil and small oil will stop fossil fuel production; it may be hopeless to think that governments in the Global North will enact austerity measures to curb overshoot; it may be hopeless to believe that the GDP monetary measure will be replaced with an actual accounting of environmental and social costs; and it may be hopeless to assume that the Global North will admit that the "green technology" transition means pillaging the environment and poor people. This is only a modest list of the many consequences inherent in the polycrisis.

Assuming that any or all of the above will be achieved is not realistic at this time and there are many reasons why. This, however, is a good thing. In the words of Derrick Jensen (2006), the American eco-philosopher, "Hope is what keeps us chained to the system, the conglomerate of people and ideas and ideals that is causing the destruction of the Earth." Jensen further notes that hope means longing for a future condition over which you have no agency; it means you are essentially powerless.

Hopeless need not mean helpless, however. On the contrary, hopelessness is the springboard to helpfulness – supportive, effective, and useful. Over half of this book is devoted to demonstrating why museums are vital in addressing an unknown future and, further, how they are equipped and able to play this role by adding perspective and substance for moving beyond the *status quo*. Relinquishing hope does not mean staring into a dark abyss. Nor does it mean being consumed by a black hole, as one of my colleagues suggested. In the place of a dark abyss or a black hole, museums have abundant qualities that will help lead the way for individuals, families, and communities.

In assessing the four questions about resilience, relinquishment, restoration, and reconciliation, the reader will note that the discussion of the museum qualities that enable and strengthen resilience is the longest. Following on from these

demonstrated strengths is a more difficult topic – what museum practitioners and academics must relinquish and reform if museums are to unlock and steward their inherent force for good. Herein lies the challenge and the opportunity. Museums can choose to be hopeful, hopeless, helpless, or helpful in any combination, but none are preordained. All museums and museum workers have agency, real or potential. Hope is not required. Vision and courage are required.

6
AFTERTHOUGHTS

As discussed earlier, the North American frame of reference is the MTI society, with its particular values and aspirations. In short, we are the products of the culture we are born into (Nelson 2020). We are now desperately in need of not only a new cultural narrative but also new institutions to create and steward this new narrative. Contemporary institutions in all sectors are not fulfilling the requirements for a new future.

Needed: new institutions

An apt illustration of the cultural sector's lack of foresight and discernment was the 2022 National Cultural Summit hosted by the Minister of Canadian Heritage. The Summit's four themes were:

1. The promotion of long-term competitiveness and growth;
2. The return of visitors and engaging new audiences;
3. The role of digital platforms in arts, culture, and heritage sectors; and
4. The contribution of cultural sectors to reconciliation, combatting climate change and building an open and more inclusive society.

Note the continued emphasis on growth, enlarging audiences, and digital platforms – constituting three of the four themes. As for the fourth theme, which acknowledged several contemporary issues, there was no sense of urgency and only polite consideration of "greening" the arts community. Invited guests were allowed to consider these themes in discussion groups, but online participants were not. Climate trauma, as in suffering, shock, and loss, is unfolding around the world but was apparently not important enough to merit consideration at this Summit.

DOI: 10.4324/9781003344070-7

The performing arts were the focus, with continual reference to entertainment, consumption, and money. Knowledge- and value-based organizations, such as museums and archives, were invisible, and only rarely acknowledged in the multiple sessions. In Canada, culture seems to be about leisure consumption and not about how we lead our lives.

The Summit was yet another example of the timid and predictable conduct of politicians and bureaucrats that is designed to neither provoke nor unsettle the participants, while ensuring that self-congratulations are abundant. Overall, the Summit can best be described as a sideshow which distracted attention from far more critical issues. Arriving from another Planet as a participant in this Summit, one would have no idea that the world is confronting a societal and ecological crisis. What is the fate of our cultural and social enterprise as multiple crises unfold and, equally as important, what is the role of the arts, culture, and heritage in charting a path to sustainability that will preserve and use our irreplaceable cultural legacy (Janes 2016: 384)? These questions remain unexamined.

Had the Summit been intelligently planned, it could have generated substantive discussions on how the arts and heritage sectors could assist the government and citizens of Canada in planning for a future that will be devoid of the privileges and opportunities we now take for granted. The cultural sector could have started to define its role and responsibilities as a very large lifeboat. In addition, the Summit could have assisted in redefining the vision and purpose of the arts and heritage sectors – replacing economic instrumentalism and a yearning for popularity with a commitment to the durability and well-being of individuals, communities, and the natural world. A lost opportunity, indeed.

An equally disturbing example of this myopic inertia is the Canadian Museum Association's (CMA) inability or unwillingness to address the climate crisis, although I praise them for their commitment to truth and reconciliation with Canada's Indigenous Peoples. This priority seems to have overshadowed all others, however. Despite repeated requests (beginning in 2019) from the Coalition of Museums for Climate Justice and the CMA Fellows, the CMA's board of directors and staff have failed to declare a climate crisis, while also failing to provide any resources or assistance to support their organizational and individual members in doing so. This is even more alarming, considering that the majority of the CMA's membership endorsed a resolution calling for climate action at their annual general meeting in 2021. It is disheartening that these two national organizations, Canadian Heritage and the CMA, are seemingly unaware of what museum workers now require to truly serve their publics. These two examples confirm the pressing need for new institutions with effective governance, relevant visions, and realistic values to replace those that are no longer serving their purpose. There is no question that the change required of organizations, like Canadian Heritage and CMA, is fraught with much difficulty and complexity, and will require the efforts of all who care. Failing to do so will exact a great cost – the bewildered condemnation of future

generations who will wonder why these organizations, and cultural organizations in general, remained silently ineffective as the polycrisis unfolded.

Although the museums's next iteration, beyond consumer society, remains unexamined and undefined, it will surely involve catagenesis as discussed earlier – renewal through breakdown and the birth of something new, unexpected, and potentially good. There are good reasons to believe that a new kind of museum is possible, even if this vision flies in the face of conventional wisdom and time-honoured practices. If this new vision appeals to enough museum practitioners, it could be revolutionary in breaking the mould of traditional museum practices, assumptions, and the lethal baggage of the MTI society.

It is liberating to consider what might be possible for the museum as lifeboat: a seed bank of sustainable living practices that have guided our species for millennia; the museum as public advocate; the museum as problem solver; the museum as a community laboratory; the museum as an open source for sustainable technologies; and the museum as cultivator of personal and community agency. There is also an opportunity for the museum of rapid transition to help us understand the dynamics of change and the stories of how we have made a home in the world. These are only several of the new frontiers that await the caring museum. The past is no longer the guide to the future and it is clear that the changes required will not occur by struggling against the current model of museum practice. Instead, a new model of museum practice must be articulated and installed that will make the existing model obsolete.

There is no doubt that the process of change and transformation will be anxious, uncertain, and troubled, but there is no avoiding these difficulties. It would seem that our collective reluctance to move beyond the familiar has something to do with the psychic discomfort that it creates (Saul 1995: 2). Allowing this discomfort to limit the vision and purpose of museums at this point in history is disastrous – abetting the decline or collapse of the More-Than-Human World and society as we know it. Mitigating and adapting to the perils we face will require participation and to participate is to be permanently uncomfortable – psychically (Saul 1995: 190). Museums must embrace this discomfort, the uncertainty, and the non-conformity that it requires in order to become the authentic participants they are equipped to be, and to make good on their singular combination of historical consciousness, sense of place, and public accessibility. Is this not an extraordinary opportunity for museums to accept these tensions and this questioning, and determine who they are and what they want to become as the Planet and our civilization confront cascading failures?

The call for new institutions with holistic visions and new values is not about museums choosing cosmetic or incremental changes to maintain their comfort level. This will require something far more fundamental – a complete reassessment and redefinition of the museum as an organization in service to its community during a dangerous time. There are no half measures to be had – a complete rethinking

is essential. If this is inconceivable for current museum leaders and managers, then it is time for them to move out of the way. The same applies to all board officers and members, as well as all governments that serve as governing authorities. The transformed museum will also require the courage, the imagination, and the creativity to transcend the preoccupation with wealthy elites, high value collections, and celebrity directors and curators. Regrettably, these illusory markers of success continue to monopolize the public's perceptions of these institutions, notably art museums. All museums, irrespective of size and seniority, however, have the opportunity to rid themselves of these neoliberal shackles.

Hospicing museums: an alternative

As the world we know becomes increasingly unpredictable and unfamiliar, I suggest that thoughtful museums, their governing authorities, and staff consider hospice care for their organizations. By this I mean acknowledging the museum's inability or unwillingness to honestly address the future, record what has been learned and is valuable to keep, mothball the collections or share them, and, most importantly, refrain from taking any extraordinary measures to prolong the life of the museum. Then honour its legacy, cease operations, and let the museum go. Move on. Perhaps this could lead to a new era of meaning and opportunity for those dedicated staff and volunteers who have committed their life energy to a museum that prospered in happier times but is now no longer willing or able to change what needs to be changed. There are many museums in this position, and there is no reason to feel angry, ashamed, or betrayed. Such a decision requires becoming reality-based and acknowledging that the weight of organizational inertia can prevent the transformation required to ensure the museum's next iteration as a force for good. This is understandable and forgivable. It is essential for museums to have this honest conversation as soon as possible, acknowledge the results, and proceed with the hospice care, if appropriate.

Further motivation for weaning the world off some of its museums is to unlock the funding they control – assuming that it can be reallocated to other sectors of higher priority. Compared to most non-profits devoted to community service, such as food banks, homeless shelters, drop-in centres, youth services, and humane societies, most museums are remarkably well off. They more often than not have annual or multi-year public funding, access to established grant programs, a donor base, and reliable volunteer support that amounts to significant economic value. Museums also have an abundance of motivated, intelligent, and committed staff. It is now necessary to ask if these valuable resources are genuinely serving their communities, or should they be allocated elsewhere? With respect to collections, their importance as seed banks is obvious and the world's most important artistic, technological, and archaeological objects could be bunkered to assist with deep adaptation and to allow our descendants to ponder, learn, and appreciate them (Ronald Wright, personal communication, 24 February 2023).

Is there sufficient justification for hospicing any museum? An unwelcome question, but it must be asked irrespective of one's personal devotion to these venerable institutions. As planetary systems adjust to our failures and reality hardens, museums will not be the only organizations to suffer the anguish of societal triage. Museums, however, are equipped with an historical consciousness, a knowledge base, and community connections that might very well qualify them not only as survivors but also as lifeboats. Because survival is not a purpose, however, it will be incumbent on museums to ensure that they are ready and able to demonstrate their meaning and value in addressing the challenges of collapse. If not, hospicing the museum may be in order. What follows are some recommendations to help museums prepare for a future they may not like, but one that they have helped to create.

There is an important cautionary note that must guide the discussion about hospicing. For too long, museums have chosen incrementalism over systemic and substantive change, claiming that small changes will add up to comprehensive change. These incremental changes have not and will not deliver the degree of change that is necessary. The urgency of impending collapse requires much more than organizational tinkering. Hospicing is the alternative, if museums are unable or unwilling to confront their chronic difficulties and embrace a new agenda based on their particular circumstances. Because museums have a choice under these circumstances, unlike human beings who are terminally ill, I am not yet prepared to envision the International Association of Terminal Museums.

The small picture

It is now imperative that all of the museum community – academics and practitioners, consultants and educators, architects and engineers – adopt risk-taking, experimentation, and episodic failure and learning as a matter of course. These are the paths with which to investigate and determine what museums can and should be, and this process of inquiry and action will be contingent upon collaboration and sharing both within and outside the museum sector. I have provided a glimpse of the benefits of new and unorthodox thinking spawned by the international museum coalitions and networks described in Chapter 4.

With this in mind, there are some fundamental considerations in nurturing this new mindset and getting the lifeboat ready for service – off its davits so to speak. This small picture is based on some general principles (Janes 2013: 124–126) that will assist museum workers in preparing themselves mentally as agents of their own transformation as well as for their communities.

The first of these principles is a sense of shared purpose. Every staff member, board member, and volunteer must have a clear understanding of their collective purpose, and this purpose needs to be continually revisited and reclarified to test its relevance to ongoing conditions. This is an unfinished process that requires ongoing attention. The second principle is active experimentation. This means

translating shared purpose into specific results under complex changing conditions. No museums workers, including CEOs, can predefine everything, so flexible arrangements that encourage experimentation are essential. Active experimentation applies to everything – strategies, programs, services, policies, work practices, and, above all, the transformation necessary to ensure a workable lifeboat. There are three important conditions for active experimentation (Joiner 1986: 48–49):

1. Small, semi-autonomous work units

 - This means decentralized decision-making.

2. Rapid action

 - Don't try to analyze and design everything before taking action.
 - Take risks, innovate, create, and get feedback.
 - Learn from the action and then take further action.

3. Support for learning

 - Foster a new attitude toward success and failure.
 - Failure is something to learn from.
 - Don't punish. Punishment will set the organizational tone and there will be no active experimentation.

The third principle is that of open integrity. Autonomous teams and work units could result in parochial perspectives out of step with the museum. Instead, openness is required based on encouraging experimentation in the workplace and continually balancing the needs of the individual with those of the organization. There will always be tension between the individual and the organization, and this conflict must be dealt with openly and honestly. There are ways to do this (Janes 2013: 125).

- Remain open to the forces operating inside and outside the museum.
- Treat resistance and conflict as opportunities for learning.
- Manage resistance and conflict openly, directly, and creatively.
- Be inclusive in your thinking.
- Be staff-centred, not leadership or management-centred.
- Make sure that organizational boundaries are permeable, as information, people, and resources must flow easily and freely among them.

All of these principles and guidelines have proven their worth over decades of organizational change, with its inevitable anxiety and distress. They are offered here as modest recommendations to help prepare museums for their internal transformations, as well as with enhancing community well-being and assisting their communities with the eventual replacement of the MTI culture. William James, the American philosopher and psychologist, wrote about the morally significant

life and noted that such a life "is organized around a self-imposed, heroic ideal and is pursued through endurance, courage, fidelity and struggle" (Brooks 2014). Is it not possible and desirable for museums to adopt a perspective similar to that of the "morally significant life," in a quest to ensure the well-being of their organizations and their communities – above and beyond collections, entertainment, and the corporatist and elitist ideology embedded in so many museum boards. This transformation is indeed possible, but with a critical proviso – "Sentiment without action is the ruin of the soul" (Abbey 1989: 40).

The big picture

This is a glimpse of the big picture that goes far beyond the insularity of contemporary museums, and I appreciate at the outset how distant and unrelated the ensuing discussion may appear to mainstream museum practitioners. To help guide the museum as lifeboat, it is time to move beyond the confusion and self-absorption brought on by COVID-19, and consider the pandemic as a glimpse of what is now required if we are to manage the destruction of the Planet with contraction and slow decline. The information and commentary contained herein demonstrate that the polycrisis we have created is systemic in nature, and all the calamities are deeply interrelated in a web of now incomprehensible complexity.

We, and the MTI culture, have meddled long enough in biophysical realms we know nothing about, and partial or full collapse is a tangible threat that can no longer be ignored. Acknowledging the big picture has profound implications for museums as civil society organizations, because our communities and our civilization will need a plan, and the first step in realizing a plan is to acknowledge its necessity. If museums are to fulfill their role as key civil and intellectual resources, it is no longer conscionable for them to claim neutrality, privilege, and a lack of means. If this book has assisted in advancing this acknowledgement, I will have exceeded my expectations. After acknowledging our collective crisis, the next step for museums is to accept responsibility for assisting with the planning as required. Such involvement by the museum community is not as far-fetched as it may appear.

It is useful to provide a glimpse of what this formidable planning process will entail, as forewarned is forearmed. For some clear thinking on what societal reinvention will require, I am again indebted to Richard Heinberg (2022e) for his clear and comprehensive thinking. For brevity's sake, I will condense much of his work into a summary of key points. The first requirement will be a technical plan devoted to how a country will change and adapt its electrical generation and transmission, transportation (including trucking, shipping, and aviation); food (farm machinery fuels, fertilizers, pesticides, packaging, and transport); manufacturing (for minerals needed in the renewable energy industry); building construction (substituting low-carbon materials for current ones, and building operations (optimum insulation and heat pumps to replace furnaces and air conditioners). I note that there is not one aspect of current museum operations and practice that is not directly impacted by these initiatives.

The second part of the process is to develop an economic and political plan to support the implementation of the technical plan summarized earlier (Heinberg 2022e). Heinberg notes that this technical transition will not be possible without some form of fossil fuel rationing. The remaining fuels will be needed for the transition and not for purposes like consumerism and tourism. If you are in the process of building a new museum with tourism as an essential part of your business plan, or if your current business plan relies heavily on tourism, you are not paying attention. The consequences for not doing so promise to be severe. As discussed earlier, the use of rationing and the ensuing economic disruption will not be viewed kindly by privileged people or their institutions. A host of political and social challenges will undoubtedly ensue.

This is where a direct connection with museums is both feasible and desirable, as Heinberg (2022e) suggests the planning should be as granular as possible with the big technical tasks assigned to governments and separated from the transition work that can be done locally in communities. Enter museums as public storefronts and conveners of conversations and workshops to alert citizens to the transitional tasks that can be done locally, as compared to the large-scale, technical initiatives. Museums not only have longevity as compared to elected governments, but they are also in a position to nurture a sense of responsibility, ownership, pride, and

FIGURE 6.1 Back to the land – this homestead begins with the construction of a tiny home. Note the membrane in preparation for a green or living roof.

Source: Photograph by the author.

participation at the local level. As discussed in Chapter 2 on the stages of collapse, social and cultural cohesion are essential to successful adaptation, not to mention the preservation of our species. As generators of social capital, and thus cohesion, museums have a yeoman's role to play in assisting with the transition. The details of local transition work will depend on the community and its needs and aspirations, but it will certainly be grounded in enhancing self-sufficiency, food production, cooperation, mutual support, simplifying lifestyles, and building strong neighbourhood networks to support each other in times of need, as well as for fun.

Calling all museum people

The only effective response to ecological and civilizational overshoot (the core problems) is the comprehensive contraction of human activities. This will mean reducing the size of the global population, ending our unbridled consumption in the West, and rejecting once and for all the crippling belief in unlimited economic growth. Perhaps the greatest challenge is accepting that real renewable energy consists of biomass (wood, plant-based material), wind and water power, passive solar, and human muscle power. None of these energy sources will allow life as we know it now to continue, and MTI civilization will cease when we stop using fossil fuels. And stopping the use of fossil fuels we inevitably must. Such radical change and contraction will require a new kind of society that includes the restoration of ecosystems; resettlement from dense urban areas; and a return to decentralized, smaller communities. Relearning essential skills will also be paramount and museums are the storehouses of such knowledge as noted numerous times throughout this book.

Irrespective of the grim commentary in this book that outlines the scientific, environmental, and social contexts, I have made every effort to be as measured as I could be in recounting the facts of the polycrisis we face – unlike Umair Haque, a British economist, who wrote:

> Take a hard look at *right now*. Do you really think our civilization's going to survive another *three decades* of *this*? Skyrocketing inflation, growing shortages, runaway temperatures, killing heat, failing harvests, shattered systems, continents on fire, masses turning to lunacy and theocracy and fascism as a result?
>
> *(Haque 2022b)*

I included this quote to provide a more unsettling and frank assessment of the catastrophe we have created. If you are frightened, upset, or deeply concerned by what you have read, you are thinking. I must also note, if not already apparent, that too many people still believe that global warming will mean just that – the world will get a little warmer, but we will be able to cope. Regrettably, the Planet has moved far beyond that complacent assumption. As I write in July of 2022, over 1,900 people have died in Spain and Portugal alone from heat-related causes over the past week as an unprecedented heat wave moved through Europe (Smith 2022).

As these dreadful events unfold, it is time for the global museum community to seek clarity and purpose in what they intend to do. Will it be to carry on collecting, preserving, and entertaining? Or will it be to inform, engage, and assist their communities in addressing the critical issues that are foreshadowing collapse. Although the future is not knowable, as the links between cause and effect are complex (especially now) and mostly lost in the detail of what actually happens in between (Stacey 1992: 12–13), this does not preclude deep reflection on what collapse will mean if we are forced to abandon our conventional lives and assumptions. If we can sense the shape of things to come, all of society, including museums, will be better able to undertake the essential preparations, utilizing the precautionary principle.

In closing this chapter of afterthoughts, a final reflection on the use of the word "we" is in order as I have used it throughout this book in various contexts. I have used the universal or collective "we" to mean members of the MTI civilization, a particular nation, a society, a community, and a family. With respect to transforming museums as lifeboats, however, the use of "we" means the museum community explicitly and exclusively, as the self-reflective work to transform museums systemically is the purview of museums and their workers, leaders, and governing authorities. The MTI civilization is unstoppable yet doomed, and the challenge now is to mitigate and adapt on the local level. When it comes to coupling thought with action, the use of "we" on a global, or even a national scale, is not achievable as there are no governance mechanisms or leadership to permit this collective organization and expression. It is on the local level where "we," the museum community, can and must fulfill its role. Everyone must help. All hands on deck.

7
CODA

Having taken it upon myself to study and report on the dire world we have created, and how museums can assist with acknowledging and adapting to it, I am compelled to discuss what motivated me to do so as I conclude this book. I have reflected on my lived experience in an attempt to understand and critique cultural beliefs, practices, and experiences, as they relate to the wider cultural, political, and social issues affecting museums and the world at large (Poulos 2021: 4). I have felt this need to promote awareness in the museum community throughout my career, with a view to providing suggestions and recommendations on changing and improving museum practice to better serve society. I have often had to say and write uncomfortable things and this book is no different.

I aspire to combine intellectual and methodological rigour with my emotions, be they anger, despair, passion, grief, or confusion. This allows one to use writing as a research practice that drives inquiry (Poulos 2021: 4). Put another way, writing for me is a way of discovering what I think. This book has allowed me to make connections between a variety of seemingly unrelated ideas, experiences, and assumptions. The interconnection of scholarly perspectives with human sentiments lies at the core of this book, as I cannot separate my personal agency and life experiences from the work I do as a museum scholar/practitioner.

Writing about personal values and beliefs in the museum field is rare, as it is in all professions, but it is important because these observations demonstrate the inescapable relationship between personal agency and professional agency – how the personal is embedded in the professional if we choose to do so. This degree of reflection is beginning to change, as demonstrated by BIPOC (Black, Indigenous and people of colour) museum workers, in particular, who are pushing back against exclusionary museum practices with forceful and compelling writing grounded in honesty, values, and beliefs (Adams 2021).

Indivisible benefits

I now find myself enmeshed in the quandary of humanism – a quandary because I share David Ehrenfeld's view that humanism abounds with arrogant assumptions that are largely responsible for the catastrophe we now have created. In his words (Ehrenfeld 1978: 6), "We have defiled everything, much of it forever." He notes that "among the correlates of humanism is the belief that humankind should live for itself, because we have the power to do so." This hubris is aided and abetted, if not motivated, by a marked deterioration among all levels of government worldwide in safeguarding our indivisible benefits. Neoliberal thinking is the foundation of this irresponsibility, and I am indebted to the brilliant physicist and humanist, Ursula Franklin (1999: 65–67), for her clear thinking.

In short, divisible benefits are those which accrue to the individual or organization because they earned them or created them. Indivisible benefits, on the other hand, are concerned with the "common good" – such things as justice, peace, clean air, drinkable water, and protecting wilderness. Indivisible benefits belong to everyone and each of us is responsible for their durability. Citizens give up their autonomy and pay taxes to governments in order to protect and advance this common good. Indivisible benefits are disappearing the world over, and government failure to protect them is a major causal factor in both civilizational and ecological overshoot, accompanied by a scandalous lack of accountability. Multinational corporations and the world's elite, second only to governments in their influence on public policy, continue to demonstrate that the common good is an inexhaustible arena for private gain.

Personal agency and organizational agency are now essential in protecting the world's indivisible benefits, and to do so now requires citizens to "just get in the way":

> This is the work of witness. This is the lawsuit, the parade, the boycott, the co-op, the newsletter – the steadfast, conscientious refusal to let a hell-best economy wash over us. We know how to do this. Every child who has ever constructed a careful row of stones in a stream knows how to do this. We just have to wade into the silty green water with our shoelaces dancing and our socks sagging around our ankles, and start piling rocks. . . . Build something new. Doesn't matter what. Just get in the way.
>
> *(Moore 2022: 32)*

Getting in the way means doing something. Protesting, in which people gather to show disapproval of something, is becoming less and less effective, however. Some argue that protest does nothing, as it is "a choreographed bullhorn and not much else' (Daley 2022). Moreover, Daley argues that protest actions accomplish nothing because you are doing nothing – it is theatre. To effect real change:

> You have to do something to create those changes. Change is work, not theatre. If you want tangible benefits, you have to craft something more tangible than a

message. Change requires building social and physical infrastructures, creating new ways of doing things, making new actual things – like orchards and vegetable patches, care networks, heat pumps, mini-hydropower generators, rooftop solar panels, car-share cooperatives – as well as ideas. And certainly you can't rely on those in power, those who benefit from the status quo, to do this work for you.

(Daley 2022)

The unfortunate fact is that those in power see protest actions as an irritant that must be removed, so they deal with the protestors, not the protest message (Daley 2022). I have digressed here but for an important reason – one that I have learned through the school of hard knocks, various protests, and being arrested for civil disobedience earlier in my life. I am in complete agreement with Daley (2022) that when we do actual things with our lives and our resources, we can change the system by using our thoughts and actions. I have learned, however, that we must own our frustration and anger (Schenck and Churchill 2021: 503). Then comes the realization that blaming ourselves and others is also not helpful. My frustration has been a motivating force, however, to do actual things including writing books.

Despair can also be a pathway to hope, although as discussed earlier I don't accept the conventional view of hope. It is more often an obstacle to action and a source of apathy and inertia. I am more suited to Schenck and Churchill's (2021: 503) observation that "[w]hat is called for is a faith in a possible future," although my faith in the future of museums remains uncertain. I acknowledge once again that mitigating and adapting to the perils we face will require participation as individuals, and to participate is to be permanently uncomfortable – psychically (Saul 1995: 190). As citizens and museum workers, each of us must consider embracing this discomfort, the uncertainty, and the non-conformity that it requires, in order to become the authentic participants we can be.

In summary, we are confronted with two narratives that embody the warp and weft that will define the future of our species – antithetical yet interwoven. One narrative embodies the values of the dominant MTI society, and the other a commitment to the well-being of the More-Than Human World. These narratives will either destroy the future or sow the seeds for its recovery. These conflicting choices confront us every day, whether it be what we eat, what we wear, what we buy, where we go, and what constitutes meaning in our lives. In essence, what we value.

Who will steward the future?

This is not a rhetorical question. By stewardship, I mean a commitment to the planning and management of our collective well-being, in all of its manifestations – physical, emotional, mental, spiritual, and the More-Than-Human World. In the absence of effective global governance, we have a litany of aspirants including the neoliberals, the ecomodernists, the Green New Deal adherents, the techno-utopians, green anarchists, eco-socialists, the eco-utopians, the baby boomers, the

preppers, and so on. The result is a dog's breakfast of fragmented ideologies each grounded in their own certainty and seemingly oblivious to a systemic understanding of the enormity of our catastrophe. We must set aside the blame game, however, something that is difficult to do when thinking about climate change deniers, the mainstream media immersed in triviality, and all those who are still booking ocean cruises and long-distance jet travel.

All of us are addicted to oil and gas and the comforts and conveniences they provide – we remain energy blind. Here's what one future could look like as a result:

> We're fucked, and there's nothing we can do about it. We *are* going to burn the rest of the world's fossil fuel reserves (or substitute wood and coal and anything else that will burn if/when those reserves become unavailable or uneconomic) sooner or later, because we will never tolerate the immense short-term suffering that will come from not doing so.
>
> *(Pollard 2022a)*

Unfortunately, our denial is considerably more expansive than our addiction to energy. It also encompasses moral and practical considerations, including the denial of the colonial violence that continues to afflict Indigenous Peoples, the denial of the reality of ecological overshoot and unsustainability, and the denial of our human interdependence with the More-Than-Human World – all of which are embedded in the denial of the many other problems we have created.

With widespread denial and a persistent unwillingness to tolerate any constraints in our materialistic sense of well-being, what hope is there for the future of our species and the Planet? Will any sense of stewardship prevail? The seed of any meaningful action under these circumstances must begin with revisiting the five stages of insight as discussed in Chapter 5. The reader may recall the stages – dead asleep, awareness of one fundamental problem, awareness of many problems, awareness of the interconnections between many problems, and awareness that the predicament encompasses all aspects of life. Only the fifth level is useful now – the recognition that all the good and bad, sentient creatures or not, are interconnected in an all-encompassing relationship. The dots are all connected in the real world. Without this fifth stage of insight, with its awareness and courage, it will not be possible to steward the future.

This broader insight must also be accompanied by a sober reassessment of our collective expectations. All Canadians born after 1945, for example, have lived in an era of military security, economic prosperity, and political stability – all comfortably contained in a confident liberal-democratic consensus (Gurney 2021). The problem is that we, and I include all of the prosperous Western world, are neither owed nor guaranteed what we have already experienced. As I write, we are experiencing a world of chaos – climate trauma, armed conflicts, the threat of nuclear warfare, ongoing pandemics, migration crises, and so on. In short, whatever

expectations we may have of our privileged lives are no longer relevant and we must give them up. With reference to the COVID-19 pandemic, Matt Gurney, the Canadian journalist, wrote:

> If your imagination can't conceive of anything worse than the last 20 months, and if your grasp of history is so weak that you think that the last 20 months have been some unprecedented catastrophe, that's a comment on your imagination and historical literacy, not on the last 20 months.
>
> *(Gurney 2021)*

The failure of our systems and institutions to steward the future becomes more apparent every day. Instead, we must look to local communities, to individuals, and to families, just as most people have done throughout human history. It is here that stewardship begins and ends. There are at least two possibilities, however, in what form this stewardship might take. It could be dominated by the green anarchists, who aspire to empower local communities and individuals through mutual and decentralized aid (Wikipedia 2023a). Conversely, the eco-socialists wish to use the coercive power of government for a centralized intervention that will transform society nationally and globally (Wikipedia 2023b). If the current ineffectiveness of governments at all levels is any indication of their commitment to stewardship, the green anarchists may have the advantage with their focus on individuals and communities.

Another obstacle to stewarding the future is our growing tolerance of the massive suffering that is now well underway, be it the flooding in Pakistan, the COVID-19 death toll, the drought in Australia, or the California wildfires – the numbing is well underway. Herein lies perhaps the greatest threat to the future – the creeping normalization of catastrophe (Schenck and Churchill 2021: 508). For the majority of us in the Western world, life continues with business as usual. Accepting what is actually going on will be of great value, as this new reality of chaos and suffering now belongs to each of us, whether we feel it or not. In short, the MTI society is beyond repair. The sooner we accept this, the easier it will be to understand that our civilization needs to change at a far deeper level than the vast majority of people realize.

I have attempted to indicate why this is necessary, what this transformation and contraction will entail, and how museums can assist. Museums will remain powerless, however, unless enough people recognize the destructive nature of our worldview and habits and reject them. To do this will require the realization of personhood, both personally and professionally, guided by some fundamental questions that are at once both simple and profound:

1. Who am I?
2. Why am I here?
3. Who do I want to be in this time of polycrisis?

4. What am I here to do?
5. What can I learn from others?
6. What stories shall I tell?
7. What legacy shall I leave?

Museums can start these conversations and it is essential to do so now. Our collective failure to ask and answer these questions will only perpetuate our sleep walking into the future. Regrettably, the reawakening that these questions engender will be accompanied by great suffering – suffering that remains abstract for much of the privileged world and yet is now a tangible reckoning for those who are disempowered and live far away, as well as for the More-Than-Human World. One thing is for certain, as aptly summarized by Richard Heinberg (2022d: 6), "Continuing to build a global industrial economy on the basis of the ever-increasing extraction and burning of finite fossil fuels, along with its polluting byproducts, was and is utterly insane." We must concede that economic growth must end if we are "to prevent all sorts of unnecessary blundering and suffering."

Bearing witness is a core trait of museums, as noted earlier, and this witnessing is now essential to our survival. Wendell Berry, with his usual eloquence, opened the door to this beckoning prospect:

> One thing worth defending, I suggest, is the imperative to imagine the lives of beings who are not ourselves and are not like ourselves: animals, plants, gods, spirits, people of other countries and other races, people of the other sex, places – and enemies.
>
> *(Berry 1993: 24)*

Are not museums founded on "imagining the lives of beings who are not ourselves?" (Janes 2016: 250). All museums specialize in assembling evidence based on knowledge, experience, and belief, and in making things known – the meaning of bearing witness. The scope for bearing witness now exceeds our current sensibilities and includes ecological overshoot and the threatened collapse of our society. The Planet will endure, regardless of our collective stupidity. Not so for us, our societies, and our cultures. We are at grave risk. Museums, as creatures of civil society, can confront the risk of collapse and assist in providing what is needed for our descendants to endure with love, compassion, joy, and durability. Anything less is unthinkable if we are to fulfill our role as good ancestors.

FIGURE 7.1 Plaque on a forest trail in Haida Gwaii, Canada. This Indigenous perspective is a radical departure from conventional park signage.

Source: Photograph courtesy of Priscilla B. Janes.

REFERENCES

Abbey, E. 1989. *A Voice Crying in the Wilderness: Notes From a Secret Journal (Vox Clamantis in Deserto)*. New York: St. Martin's Press.
Activist Museum Award. 2021–2022. *Research Centre for Museums and Galleries*. UK: The University of Leicester. Available online: https://le.ac.uk/rcmg/research-archive/activist-museum-award (accessed 12 July 2022).
Adams, G.K. 2021. "Black lives matter: One year on." *Museums Association Analysis*, 25 May. Available online: www.museumsassociation.org/museums-journal/analysis/2021/05/black-lives-matter-protests-one-year-on/ (accessed 5 May 2022).
Adams, T.E., Holman, S., Jones, S.H. and Ellis, C. 2015. *Autoethnography: Understanding Qualitative Research*. New York: Oxford University Press, Inc.
AFSCME Cultural Workers United. 2021. *Report: Cultural Institutions Took Federal Money but Still Let Go of Workers*. Washington: Cultural Workers United [affiliate of] American Federation of State, County & Municipal Employees, AFL-CIO posted 4 October. Available online: www.afscme.org/blog/report-cultural-institutions-took-federal-money-but-still-let-go-of-workers (accessed 21 October 2021).
Ahmed, N. 2019. "The collapse of civilization may have already begun." *Vice*, 22 November. Available online: www.vice.com/en/article/8xwygg/the-collapse-of-civilization-may-have-already-begun (accessed 13 June 2022).
Alberta Museums Association. 2022. *Climate Change Videos: Taking Action on Climate Change*. Available online: www.museums.ab.ca/get-involved/digital-engagement/climate-change-videos.aspx (accessed 13 May 2022).
Alliance of Natural History Museums of Canada. 2015. Available online: www.naturalhistorymuseums.ca/index_e.htm (accessed 10 May 2022).
Aly, H. 2019. "Director's dispatch: Stop looking for hope on the climate crisis. Try this instead." *The New Humanitarian. Opinion*, 4 December. Available online: www.thenewhumanitarian.org/opinion/2019/12/04/climate-crisis-climate-change-COP25-global-warming (accessed 5 May 2020).
American Alliance of Museums. 2021. "Museums and trust." *American Alliance of Museums*, 30 September. Available online: www.aam-us.org/2021/09/30/museums-and-trust-2021/ (accessed 31 October 2022).

References

Ames, M. 1992. *Cannibal Tours and Glass Boxes: The Anthropology of Museums*. Vancouver, Canada: UBC Press.

Andreotti, V. de O. 2020. "The house that modernity built." *YouTube*, 1 September. Available online: www.youtube.com/watch?v=nAke2iQ53jc (accessed 16 March 2022).

Andreotti, V. de O. 2021. *Hospicing Modernity: Facing Humanity's Wrongs and the Implications for Social Activism*. Berkeley, CA: North Atlantic Books.

Atkinson, R. 2013. *The Guns at Last Light*. New York: Henry Holt and Company.

Banking on Climate Chaos. 2022. "Fossil fuel finance report 2022." *Bankingon ClimateChaos.org*., 30 March. Available online: www.bankingonclimatechaos.org//wp-content/themes/bocc-2021/inc/bcc-data-2022/BOCC_2022_vSPREAD.pdf (accessed 27 May 2022).

Bardi, U. 2017. *The Seneca Effect: Why Growth Is Slow but Collapse Is Rapid*. New York: Springer International Publishing.

Bardi, U. 2020. *Before the Collapse: A Guide to the Other Side of Growth* (First edition). New York: Springer International Publishing.

Beckerman, G. 2022. *The Quiet Before: On the Unexpected Origins of Radical Ideas*. New York: Random House.

Bendell, J. 2018. "Deep adaptation: A map for navigating climate tragedy." *IFLAS Occasional Paper 2*. Revised Second edition released, 27 July 2020. Available online: https://mahb.stanford.edu/wp-content/uploads/2018/08/deepadaptation.pdf (accessed 16 March 2023).

Bendell, J. 2019. "Because it's not a drill: Technologies for deep adaptation to climate chaos." Conceptual paper prepared for a speech at Connect University Conference on Climate Change, DG Connect, European Commission, Brussels, 13 May. Available online: http://insight.cumbria.ac.uk/id/eprint/4776/1/Bendell_BecauseItsNot.pdf (accessed 16 March 2023).

Bendell, J. 2020a. *Climate Science and Collapse – Warnings Lost in the Wind*, 15 July. Available online: https://jembendell.com/2020/06/15/climate-science-and-collapse-warnings-lost-in-the-wind (accessed 24 June 2020).

Bendell, J. 2020b. "Deep adaptation opens up a necessary conversation about the breakdown of civilization." *Open Democracy. Opinion*, 3 August. Available online: www.opendemocracy.net/en/oureconomy/deep-adaptation-opens-necessary-conversation-about-breakdown-civilisation/ (accessed 14 June 2022).

Bendell, J. 2020c. "Jem Bendell – The biggest mistakes in climate communications, part 2 – Climate brightsiding." *Brave New Europe*, 15 September. Available online: https://braveneweurope.com/jem-bendell-the-biggest-mistakes-in-climate-communications-part-2-climate-brightsiding (accessed 11 October 2022).

Bendell, J. and Carr, K. 2019. *The Love in Deep Adaptation – A Philosophy for the Forum*, 17 March. Available online: https://jembendell.com/2019/03/17/the-love-in-deep-adaptation-a-philosophy-for-the-forum/ (accessed 14 June 2022).

Berry, W. 1993. *Sex, Economy, Freedom and Community*. New York and San Francisco: Pantheon Books.

Berry, W. 2001. *Life Is a Miracle: An Essay against Modern Superstition*. Berkeley, CA: Counterpoint.

Bishara, H. 2020. "Spreadsheet highlights major income disparities at cultural institutions." *Hyperallergic*, 29 April. Available online: https://hyperallergic.com/560132/spreadsheet-highlights-major-income-disparities-at-cultural-institutions/ (accessed 1 February 2023).

Blumberg, M. 2012. "Canadian federal budget – March 29, 2012 and its impact on charities." *Canadian Charity Law*, 29 March. Available online: www.canadiancharitylaw.

ca/blog/2012_canadian_federal_budget_-_march_29_2012_and_its_impact_on_charities/ (accessed 1 March 2023).
Brooks, D. 2014. "Becoming a real person." *The New York Times*, 8 September. Available online: www.nytimes.com/2014/09/09/opinion/david-brooks-becoming-a-real-person.html (accessed 25 October 2022).
Brown, J.E. 1989. *The Spiritual Legacy of the American Indian*. New York: Crossroad Publishing Company.
Brundtland, G. 1987. "Our common future." *Report of the World Commission on Environment and Development*, United Nations General Assembly Document A/42/427. Available online: https://sustainabledevelopment.un.org/content/documents/5987our-common-future.pdf (accessed 15 June 2022).
Bullock, A. and Trombley, S. eds. 1999. *New Fontana Dictionary of Modern Thought*. Hammersmith and London: Harper Collins.
Callahan, C.W. and Mankin, J.S. 2022. "Globally unequal effect of extreme heat on economic growth." *Science Advances* 8 (43), 1–12, October. Available online: www.science.org/doi/10.1126/sciadv.add3726 (accessed 10 January 2023).
Campbell, B. 2021. "Climate crisis and extreme wealth inequality: Joined at the hip." *The Monitor*, 31 August. Available online: https://monitormag.ca/articles/climate-crisis-and-extreme-wealth-inequality-joined-at-the-hip (accessed 27 May 2022).
Canadian Association of the Club of Rome. 2019. *Plan to Survive: A Canadian Guidebook for Dealing With Climate Change*. Ottawa, Canada: Canadian Association of the Club of Rome. Available online: https://canadiancor.com/wp-content/uploads/2021/11/Plan-to-Survive-First-Edition-July-12-2019.pdf (accessed 26 July 2022).
Canadian Museum of Nature. 2021. *A Voice for Nature: Canadian Museum of Nature Joins Global Coalition United for Biodiversity*. Available online: https://nature.ca/en/about-us/museum-news/news/press-releases/voice-nature-canadian-museum-nature-joins-global-coalition- (accessed 16 May 2022).
Carbon Brief. 2022. *UN Land Report: Five Key Takeaways for Climate Change, Food Systems and Nature Loss*, 27 April. Available online: www.carbonbrief.org/un-land-report-five-key-takeaways-for-climate-change-food-systems-and-nature-loss/ (accessed 26 May 2022).
Chefurka, P. 2012. *Climbing the Ladder of Awareness*, 19 October. Available online: www.paulchefurka.ca/ (accessed 21 July 2022).
Coffee, K. 2023. *Museums and Social Responsibility: A Theory of Social Practice*. London and New York: Routledge.
Conaty, G.T. and Janes, R.R. 1997. "Issues of repatriation: A Canadian view." *European Review of Native American Studies* 11 (2), 31–37.
Conrad, J. 1960. *Tales of Heroes and History*. Garden City, NY: Doubleday and Company, Inc.
Conroy, F. 1988. "Think about it – Ways we know and don't." *Harper's Magazine* 227 (1662), 68–70.
CorpWatch. 2021. "What is neoliberalism? A brief definition for activists." *CorpWatch: Holding Corporations Accountable*, 1 January 1997. Available online: www.corpwatch.org/article/what-neoliberalism (accessed 14 July 2022).
Coulter, A. 2021. "The future of cruises and the cruise industry, 2020 and beyond." *CruiseCritic*, 8 January. Available online: www.cruisecritic.com/articles.cfm?ID=4481 (accessed 6 July 2022).
Cribb, J. 2022. "Surviving the 21st century." *YouTube*, 27 May. Canadian Association for the Club of Rome. Available online: https://canadiancor.com/julian-cribb-

surviving-21st-century/?utm_source=mailpoet&utm_medium=email&utm_campaign=the-last-newsletter-total-posts-from-our-blog_7 (accessed 1 June 2022).

Dahrendorf, Sir R. 1990. "Threats to civil society, east and west." *Harper's* 281 (1682), 24–26.

Daley, E. 2022. "Just . . . stop . . ." *Resilience, Post Carbon Institute*, 13 May. Available online: www.resilience.org/stories/2022-05-13/just-stop/?utm_source=Post+Carbon+Institute&utm_campaign=df07938b7f-EMAIL_CAMPAIGN_2022_05_23_09_48&utm_medium=email&utm_term=0_f78cfc4539-df07938b7f-15899850&mc_cid=df07938b7f&mc_eid=c528265476 (accessed 2 August 2022).

Davis, P. 2011. *Ecomuseums: A Sense of Place* (Second edition). London and New York: Continuum International Publishing Group.

Deep Adaptation Forum. 2022. *Deep Adaptation*. Available online: www.deepadaptation.info/about/ (accessed 16 May 2022).

Demos. 2023. *Reports*. Available online: https://demos.co.uk/?s=public%20value (accessed 3 March 2023).

Drucker, P.F. 1995. *Managing in a Time of Great Change*. New York: Truman Talley Books/Plume.

Dyke, J., Watson, R. and Knorr, W. 2021. "Climate scientists: Concept of net zero is a dangerous trap." *The Conversation*, 22 April. Available online: https://theconversation.com/climate-scientists-concept-of-net-zero-is-a-dangerous-trap-157368 (accessed 12 March 2023).

Edson, M. 2022. "Create dangerously: Museums in the age of action." *YouTube*, 10 October. Keynote Presentation – Network of European Organisations. Available online: www.youtube.com/watch?v=35Kj4-B46ds (accessed 5 March 2023).

Ehrenfeld, D. 1978. *The Arrogance of Humanism*. New York: Oxford University Press, Inc.

Ehrlich, P.R. and Ehrlich, A.H. 2013. "Can a collapse of global civilization be avoided?" *Proceedings of the Royal Society B: Biological Sciences* 280, 20122845. Available online: https://royalsocietypublishing.org/doi/10.1098/rspb.2012.2845 (accessed 12 March 2023).

Elgin, D. 1993. *Voluntary Simplicity* (Revised edition). New York: Quill, William Morrow.

Encyclopaedia Britannica. 2022. *Moral Hazard*. Available online: www.britannica.com/topic/moral-hazard (accessed 2 June 2022).

Environment and Climate Network. 2022. "Environment and climate network." *American Alliance of Museums*. Available online: www.aam-us.org/professional-networks/environment-and-climate-network/ (accessed 13 May 2022).

ETC Group. 2017. *Who Will Feed Us: The Industrial Food Chain vs. The Peasant Food Web* (Third edition). Available online: www.etcgroup.org/sites/www.etcgroup.org/files/files/etc-whowillfeedus-english-webshare.pdf (accessed 31 October 2022).

Ferguson, R. and Janes, R.R. 2022. "Opinion: Plight of the museum: Why won't these institutions use their voices?" *The Globe and Mail*, 4 February. Available online: www.theglobeandmail.com/opinion/article-plight-of-the-museum-why-wont-these-institutions-use-their-voices/ (accessed 2 June 2022).

Franklin, U.M. 1999. *The Real World of Technology* (Revised edition). Toronto: House of Anansi Press Limited.

Frazier, C. 2006. *Thirteen Moons*. Toronto: Vintage Canada.

Friedman, A.J. 2007. "The great sustainability challenge: How visitor studies can save cultural institutions in the 21st century." *Visitor Studies* 10 (1), 3–12.

Galbraith, J.K. 1994. "Interview." *Financial Post*, 2 July.

Gibney, B.C. 2017. *A Generation of Sociopaths: How the Baby Boomers Betrayed America*. Paris: Hachette Book Group.

Global Footprint Network. 2022. *Tools and Resources*. Available online: www.footprintnetwork.org/ (accessed 24 May 2022).

Goldtooth, D. and Saldamando, A. 2021. *Indigenous Resistance Against Carbon*. Washington, DC: Oil Change International, August. Available online: www.ienearth.org/wp-content/uploads/2021/09/Indigenous-Resistance-Against-Carbon-2021.pdf (accessed 8 February 2023).

Government. no. 2023. *Svalbard Global Seed Vault*. Government of Norway, Ministry of Agriculture and Food. Available online: www.regjeringen.no/en/topics/food-fisheries-and-agriculture/svalbard-global-seed-vault/id462220/ (accessed 28 March 2023).

Graeber, D. and Wengrow, D. 2021. *The Dawn of Everything*. Toronto: Penguin Random House Canada Limited.

Greenfield, P. 2022. "World spends $1.8tn a year on subsidies that harm environment, study finds." *The Guardian*, 17 February. Available online: www.theguardian.com/environment/2022/feb/17/world-spends-18tn-a-year-on-subsidies-that-harm-environment-study-finds-aoe?utm_term=620dd653293a7d76d3b14b06409ae6d9&utm_campaign=GuardianTodayUK&utm_source=esp&utm_medium=Email&CMP=GTUK_email (accessed 24 May 2022).

Greer, J.M. 2011. *The Wealth of Nature*. Gabriola Island, Canada: New Society Publishers.

Gross, R. 1993. *The Independent Scholar's Handbook*. Berkeley, CA: Ten Speed Press.

Gurney, M. 2021. "Matt Gurney: Your expectations are a problem." *The Line*, 3 December. Available online: https://theline.substack.com/p/matt-gurney-your-expectations-are (accessed 4 October 2022).

Hagens, N. 2022. "Energy blindness." *Frankly #3. YouTube*, 19 June. From The Great Simplification. Available online: www.youtube.com/watch?v=mVjhb8Nu1Sk (accessed 23 June 2022).

Handy, C. 1994. *The Age of Paradox*. Boston: Harvard Business School Press.

Hansen, J., Sato, M. and Ruedy, R. 2022. "June 2022 temperature update & the bigger picture." *Climate Science, Awareness and Solutions Program*, 29 July. New York: Earth Institute, Columbia University. Available online: www.columbia.edu/~jeh1/mailings/2022/JuneTemperatureUpdate.29July2022.pdf (accessed 29 July 2022).

Haque, U. 2022a. "Life during the age of extinction – And how it'll change." *Eudaimonia and Co.*, 31 May. Available online: https://eand.co/life-during-the-age-of-extinction-and-how-itll-change-c994b5ef5f7c (accessed 14 June 2022).

Haque, U. 2022b. "We're not going to make it to 2050." *Eudaimonia and Co.*, 17 July. Available online: https://medium.com/eudaimonia-co/were-not-going-to-make-it-to-2050-5398cf97b805 (accessed 19 July 2022).

Hawken, P., Lovins, A. and Lovins, L.H. 2000. *Natural Capitalism*. New York: Back Bay Books/Little Brown and Company.

Hedges, C. 2022. "Chris Hedges: The dawn of the apocalypse." *Scheerpost*, 26 July. Available online: https://scheerpost.com/2022/07/26/chris-hedges-the-dawn-of-the-apocalypse/?fbclid=IwAR2MRYHnhgTWauQ23H5ztu3SnAQb5yEFvNRDURZEUQvK_4MRe_grrN6OJ0U (accessed 27 July 2022).

Heinberg, R. 2010. *Peak Everything: Waking Up to the Century of Declines*. Gabriola Island, Canada: New Society Publishers.

Heinberg, R. 2011. *The End of Growth*. Gabriola Island, Canada: New Society Publishers.

Heinberg, R. 2022a. "The failure of global elites." *Post Carbon Institute Articles and Blog*, 27 April. Available online: www.postcarbon.org/the-failure-of-global-elites/ (accessed 27 May 2022).

Heinberg, R. 2022b. "The 1970s again?" *Post Carbon Institute Articles and Blog*, 28 June. Available online: www.postcarbon.org/the-1970s-again/?utm_source=Post+Carbon+Institute&utm_campaign=5007f4cdbaEMAIL_CAMPAIGN_2022_06_28_05_27&utm_medium=email&utm_term=0_f78cfc4539-5007f4cdba-15899850&mc_cid=5007f4cdba&mc_eid=c528265476 (accessed 6 July 2022).

Heinberg, R. 2022c. "The human superorganism." *Post Carbon Institute Newsletter*, 28 June. Available online: www.resilience.org/stories/2022-06-28/power-chapter-4-power-in-the-anthropocene/?mc_cid=8eaf27c6e9&mc_eid=c528265476 (accessed 14 July 2022).

Heinberg, R. 2022d. "What you need to know about the energy crisis." *Museletter #354*, September. Available online: https://richardheinberg.com/wp-content/uploads/2022/09/museletter-354.pdf (accessed 10 October 2022).

Heinberg, R. 2022e. "Post-carbon visionary Richard Heinberg sets scene for EA Global Business Summit." *Environment Analyst/Global*, 26 July. Available online: https://environment-analyst.com/global/108301/post-carbon-visionary-richard-heinberg-sets-scene-for-ea-global-business-summit?utm_source=Post+Carbon+Institute&utm_campaign=e0602f7d99-EMAIL_CAMPAIGN_2022_07_26_04_36&utm_medium=email&utm_term=0_f78cfc4539-e0602f7d99-15899850&mc_cid=e0602f7d99&mc_eid=c528265476 (accessed 26 October 2022).

Heinberg, R. 2022f. "The final doubling." *MuseLetter* #356, November. Available online: https://richardheinberg.com/museletter-356-the-final-doubling (accessed 10 January 2023).

Heinberg, R. 2023. "Why understanding limits is the key to humanity's future." *Resilience*, 19 January. Available online: www.resilience.org/stories/2023-01-19/why-understanding-limits-is-the-key-to-humanitys-future/ (accessed 10 February 2023).

Henderson, H. 1980. "Making a living without making money." *East West Journal* 22–27, March.

Heritage Saskatchewan. 2022. *The Saskatchewan Food, Culture and Heritage Survey*, 17 March. Available online: https://heritagesask.ca/about-us/news/blog/the-saskatchewan-food-culture-and-heritage-survey-1 (accessed 18 May 2022).

Hester, K. 2020. "We're actually heading for a 10C global mean temperature increase in the coming decade or two. Probably much sooner." *Kevin Hester*, 26 May. Available online: https://kevinhester.live/2020/05/26/were-actually-heading-for-a-10c-global-mean-temperature-increase-in-the-coming-decade-or-two-probably-much-sooner/ (accessed 26 May 2022).

Hickel, J. 2015. "Five reasons to think twice about the UN's Sustainable Development Goals." *London School of Economics and Political Science*, 23 September. Available online: https://blogs.lse.ac.uk/southasia/2015/09/23/five-reasons-to-think-twice-about-the-uns-sustainable-development-goals/ (accessed 30 June 2022).

Hickel, J., O'Neill, D.W., Fanning, A.L. and Zoomkawala, H. 2022. "National responsibility for ecological breakdown: A fair-shares assessment of resource use, 1970–2017." *Lancet Planet Health* 6, e342–e349. Available online: www.thelancet.com/journals/lanplh/issue/vol6no4/PIIS2542-5196(22)X0004-1 (accessed 25 May 2022).

Homer-Dixon, T. 2001. *The Ingenuity Gap*. Toronto: Vintage Canada Edition.

Homer-Dixon, T. 2006. *The Upside of Down: Catastrophe, Creativity, and the Renewal of Civilization*. Toronto: Alfred A. Knopf.

Homer-Dixon, T. 2009. "The newest science: Replacing physics, ecology will be the master science of the 21st century." *Alternatives Journal* 35 (4), 8–38. Available online: https://homerdixon.com/wp-content/uploads/2017/05/the_newest_science1.pdf (accessed 13 March 2023).

Homer-Dixon, T. and Rockstrom, J. 2022. "What happens when a cascade of crises collide?" *The New York Times*, 13 November. Available online: https://homerdixon.com/what-happens-when-a-cascade-of-crises-collide/ (accessed 24 January 2023).

Hosgood, A.F. 2022. "Disaster 'land grabs' worldwide and in British Columbia." *The Tyee*, 20 June. Available online: https://thetyee.ca/News/2022/06/20/Disaster-Land-Grabs-Worldwide-BC/ (accessed 13 March 2023).

Howarth, R. 2019. "Ideas and perspectives: Is shale gas a major driver of recent increase in global atmospheric methane?" *Biogeosciences* 16, 3033–3046. Available online: https://bg.copernicus.org/articles/16/3033/2019/ (accessed 27 May 2022).

IATA (International Air Traffic Association). 2022. "Strong international traffic propels continuing air travel recovery." *Press Release No. 25*, 9 June. Available online: www.iata.org/en/pressroom/2022-releases/2022-06-09-01/#:~:text=Total%20demand%20for%20air%20travel,10.6%25%20demand%20rise%20in%20March (accessed 6 July 2022).

Initiative for Leadership and Sustainability. 2021. "Over 500 sign #ScholarsWarning on collapse risk." *University of Cumbria, Initiative for Leadership and Sustainability (IFLAS)*, 8 February. Available online: http://iflas.blogspot.com/2021/02/over-500-sign-scholarswarning-on.html (accessed 22 July 2022).

Initiative for Leadership and Sustainability. 2022. "People will suffer more if professionals delude themselves about sustainable development – Letter to UN." *University of Cumbria, Initiative for Leadership and Sustainability (IFLAS)*, 23 May. Available online: http://iflas.blogspot.com/2022/05/people-will-suffer-more-if.html (accessed 1 July 2022).

Institute for Media, Policy and Civil Society. 2004. *Not-for-Profits: Brand Superstars in the Making?* Available online: https://coco-net.org/wp-content/uploads/2012/08/non-profit-brand-superstars.pdf (accessed 13 March 2023).

International Council of Museums. 2019. Resolution No. 1 "On sustainability and the implementation of Agenda 2030, Transforming our World." Available online: https://icom.museum/wp-content/uploads/2021/01/Resolution-sustainability-EN-2.pdf (accessed 29 June 2022).

International Council of Museums. 2022. *Museum Definition*, 24 August. Available online: https://icom.museum/en/resources/standards-guidelines/museum-definition/ (accessed 12 May 2022).

International Energy Agency. 2021. "The role of critical minerals in clean energy transitions." *World Energy Outlook Special Report*. IEA Publications, May. Available online: www.iea.org/ (accessed 28 June 2022).

International Labour Organization. 2019. "Child labour in mining and global supply chains." *International Labour Organization, Child Labour Platform*, May. Available online: www.ilo.org/wcmsp5/groups/public/–asia/–ro-bangkok/–ilo-manila/documents/publication/wcms_720743.pdf (accessed 28 June 2022).

Jamail, D. 2019. "Learning how to say goodbye to our broken planet." *Truthdig*, 16 January. Available online: www.truthdig.com/articles/saying-goodbye-to-our-broken-planet/ (accessed 10 February 2023).

Janes, P.B. 2022. "We are facing a strict conflict." *Email*, 20 September. Unpublished Essay.

Janes, R.R. 1982. "Northern museum development: A view from the north. *Gazette* (Former Journal of the Canadian Museums Association) 15 (1), 14–23.

Janes, R.R. 1983. *Archaeological Ethnography Among Mackenzie Basin Dene*. The Arctic Institute of North America Technical Paper No. 28. Calgary, Canada: The University of Calgary.

Janes, R.R. 1997. *Museums and the Paradox of Change: A Case Study in Urgent Adaptation* (Second edition). Calgary, Canada: Glenbow Museum and the University of Calgary Press.

Janes, R.R. 2007. "Museums, corporatism and the civil society." *Curator* 50 (2), 219–237. Available online: https://onlinelibrary.wiley.com/doi/abs/10.1111/j.2151-6952.2007.tb00 267.x (accessed 16 March 2023).

Janes, R.R. 2009a. *Museums in a Troubled World: Renewal, Irrelevance or Collapse?* London and New York: Routledge.

Janes, R.R. 2009b. "It's a jungle in here: Museums and their self-inflicted challenges." *MUSE* 27 (5), 30–33.

Janes, R.R. 2010. "The mindful museum." *Curator* 53 (3), 325–338. Available online: https://onlinelibrary.wiley.com/doi/10.1111/j.2151-6952.2010.00032.x (accessed 16 March 2023).

Janes, R.R. 2013. *Museums and the Paradox of Change* (Third edition). London and New York: Routledge.

Janes, R.R. 2014a. "Museums for all seasons." *Museum Management and Curatorship* 29 (5), 403–411. Available online: http://dx.doi.org/10.1080/09647775.2014.967109 (accessed 16 March 2023).

Janes, R.R. 2014b. "Museums in a dangerous time." The Fellows Lecture, Canadian Museums Association Annual Conference, Toronto, Canada, April 10, 2014.

Janes, R.R. 2015. "The end of neutrality: A modest manifesto." *Informal Learning Review* 135, 3–7.

Janes, R.R. 2016. *Museums Without Borders: Selected Writings of Robert R. Janes*. London and New York: Routledge.

Janes, R.R. 2020. "Museums in perilous times." *Museum Management and Curatorship* 35 (6), 587–598. Available online: www.tandfonline.com/doi/abs/10.1080/09647775.2020. 1836998 (accessed 16 March 2023).

Janes, R.R. 2021. "Humanizing museum repatriation." In Eid, H. and Forstrom, M. eds. *Museum Innovation: Building More Equitable, Relevant and Impactful Museums*. London and New York: Routledge, 159–172.

Janes, R.R. 2022. "The value of museums in averting societal collapse." *Curator, The Museum Journal* 65 (4), 729–745. Available online: https://doi.org/10.1111/cura.12503 (accessed 16 March 2023).

Janes, R.R. 2023. "Management." In Mairesse, F. ed. *ICOM Dictionary of Museology*. London and New York: Routledge, 285–289.

Janes, R.R. and Conaty, G.T. eds. 2005. *Looking Reality in the Eye: Museums and Social Responsibility*. Calgary, Canada: The University of Calgary Press and the Museums Association of Saskatchewan.

Janes, R.R. and Sandell, R. eds. 2019. *Museum Activism*. London and New York: Routledge.

Jensen, D. 2006. "Beyond hope." *Orion Magazine*, May/June. Available online: https://orion magazine.org/article/beyond-hope/ (accessed 14 February 2023).

Johnson, K.G., Brooks, S.J., Fenberg, P.B., Glover, A.G., James, K.E., Lister, A.M., Michel, E., Spencer, M., Todd, J.A., Valsami-Jones, E., Young, J.R. and Stewart, J.R. 2011. "Climate change and biosphere response: Unlocking the collections vault." *BioScience* 61 (2), 147–153. Available online: https://academic.oup.com/bioscience/article/61/2/147/242805 (accessed 16 March 2023).

Joiner, W.B. 1986. "Leadership for organizational learning." In Adams, J.D. ed. *Transforming Leadership*. Alexandria, VA: Miles River Press, 45–52.

Jones, M. 2022. "Climate change putting 4% of global GDP at risk, new study estimates." *Reuters*, 27 April. Available online: https://money.usnews.com/investing/news/articles/2022-04-27/climate-change-putting-4-of-global-gdp-at-risk-new-study-estimates (accessed 14 July 2022).

Kallbekken, S. and Victor, D.G. 2022. "A cleaner future for flight – Aviation needs a radical redesign." *Nature* 609 (22), 673–675, Comment. Available online: www.nature.com/articles/d41586-022-02963-7 (accessed 16 March 2023).

Kalmus, P. 2021. "I'm a climate scientist. 'Don't Look Up' captures the madness I see every day." *The Guardian*, 29 December. Available online: www.theguardian.com/commentisfree/2021/dec/29/climate-scientist-dont-look-up-madness (accessed 8 June 2022).

Keil, F. 2022. "How to revive your sense of wonder." *PSYCHE*, 18 May. Available online: https://psyche.co/guides/how-to-have-a-life-full-of-wonder-and-learning-about-the-world?utm_source=Psyche+Magazine&utm_campaign=6bd4c04d64-EMAIL_CAMPAIGN_2022_05_18_12_11&utm_medium=email&utm_term=0_76a303a90a-6bd4c04d64-71982584\ (accessed 26 July 2022).

Kemp, L., Xuc, C., Depledged, J., Ebie, K.L., Gibbins, G., Kohler, T.A. . . . Lenton, T.M. 2022. "Climate endgame: Exploring catastrophic climate change scenarios." *PNAS* 119 (34), 1–9. Available online: www.pnas.org/doi/10.1073/pnas.2108146119 (accessed 11 October 2022).

Ki Culture. 2022. *International Climate Control Conference*, 1, 2 December. Available online: https://us02web.zoom.us/webinar/register/WN_XNd1YS1-SjWyCVozWTO8Fw (accessed 1 November 2022).

Klein, S. 2020. *A Good War: Mobilizing Canada for the Climate Emergency*. Toronto: ECW Press.

Korten, D. 2014. "Change the story, change the future: A living economy for a living earth." Presentation at the Praxis Peace Institute Conference, San Francisco, California, 7 October. Available online: https://davidkorten.org/wpcontent/uploads/Korten%20Change%20the%20Story%20Change%20the%20Future%201st%20chapter%20excerpt.pdf (accessed 16 March 2023).

Koster, E. 2011. "The Anthropocene: An unprecedented opportunity to promote the unique relevance of geology to societal and environmental needs." *Geoscientist* 21 (9), 18–21.

Koster, E. 2020a. "Anthropocene: Transdisciplinary shorthand for human disruption of the earth system." *Geoscience Canada* 47 (1–2), 59–64, Commentary. Available online: https://doi.org/10.12789/geocanj.2020.47.160 (accessed 16 March 2023).

Koster, E. 2020b. "Relevance of museums to the Anthropocene." *Informal Learning Review* 161, 18–34.

Kotler, N. and Kotler, P. 2000. "Can museums be all things to all people? Missions, goals and marketing's role." *Museum Management and Curatorship* 18 (3), 271–287.

Kubanek, G. 2022. "Overpopulation denial syndrome." *Canadian Association for the Club of Rome*, 25 February. Available online: https://canadiancor.com/overpopulation-denial-syndrome/ (accessed 24 May 2022).

Kunstler, J.H. 2005. *The Long Emergency: Surviving the End of Oil, Climate Change, and Other Converging Catastrophes of the Twenty-First Century*. New York: Grove Press.

Lawrence, M., Janzwood, S. and Homer-Dixon, T. 2022. *What is a global polycrisis?* Technical Paper No. 2022–4, Version 2.0. Cascade Institute, 16 September. Available online: https://cascadeinstitute.org/technical-paper/what-is-a-global-polycrisis/ (accessed 5 January 2023).

Lee, R.B. and DeVore, I. eds. 1968. *Man the Hunter*. Chicago: Aldine Publishing Company.

Lemille, A. and Chesnais, A.K. 2019. "Empathy for the future – Building resilient societies on empathy to preserve humanity." *ResearchGate*, August. Available online: www.researchgate.net/publication/343851510_Empathy_for_the_Future_Building_resilient_societies_on_empathy_to_preserve_humanity (accessed 6 March 2023).

Loewen, C. 2022. "Sources of trust in uncertain times." *MUSE Magazine Online*, Winter. Available online: www.museums.ca/site/reportsandpublications/museonline/winter2022_sourcestrust (accessed 31 May 2022).

Lyons, S. and Economopoulos, B. 2015. "Museums must take a stand and cut ties to fossil fuels." *The Guardian*, 7 May. Available online: www.theguardian.com/environment/2015/may/07/museums-must-take-a-stand-and-cut-ties-to-fossil-fuels (accessed 10 May 2022).

Macy, J. and Johnstone, C. 2012. *Active Hope: How to Face the Mess We're in Without Going Crazy*. Novato, CA: New World Library.

Margolis, M. 2018. "Story vs narrative?" *Michael Margolis/Storied*, 30 April. Available online: https://medium.com/@getstoried/whats-the-difference-between-story-and-narrative-9e410b13ace5 (accessed 19 May 2022).

Marshall, M. 2020. "Why we find it difficult to recognize a crisis." *BBC FUTURE*, 14 April. Available online: www.bbc.com/future/article/20200409-why-we-find-it-difficult-to-recognise-a-crisis (accessed 31 January 2023).

Marstine, J. 2011. "The contingent nature of the new museum ethics." In Marstine, J. ed. *The Routledge Companion to Museum Ethics*. London and New York: Routledge, 3–25.

MASS Action. 2021. *Museum as Site for Social Action*. Available online: www.museumaction.org/ (accessed 3 February 2023).

Mastini, R. 2017. "Degrowth: The case for a new economic paradigm." *Open Democracy*, 8 June. Available online: www.opendemocracy.net/en/degrowth-case-for-constructing-new-economic-paradigm/?utm_source=Museletter&utm_campaign=bb9ae5eae5-EMAIL_CAMPAIGN_2022_06_21_03_43&utm_medium=email&utm_term=0_f31b338470-bb9ae5eae5-15925927&mc_cid=bb9ae5eae5&mc_eid=c528265476 (accessed 27 June 2022).

McCarthy, S. 2022. "Canada ranks dead last among G7 on climate progress: Earth Index." *Corporate Knights Inc., Earth Index*, 20 April. Available online: www.corporateknights.com/issues/2022-04-earth-index-issue/earth-index-canada/ (accessed 27 May 2022).

McGuire, B. 2022. "The big takeaway from Cop27? These climate conferences just aren't working." *The Guardian. Opinion*, 20 November. Available online: www.theguardian.com/commentisfree/2022/nov/20/big-takeaway-cop27-climate-conferences-arent-working (accessed 9 January 2023).

McKenzie, B. 2012. "Seeing museums in 2060." *The Learning Planet Blog*, 8 May. Available online: http://thelearningplanet.wordpress.com/tag/museums/ (accessed 6 May 2022).

McKibben, B. 1989. *The End of Nature*. New York: Random House.

McKibben, B. 2019. "The new climate math: The numbers keep getting more frightening." *YaleEnvironment360*, 25 November. Yale School of Forestry and Environmental Studies. Available online: https://e360.yale.edu/features/the-new-climate-math-the-numbers-keep-getting-more-frightening (accessed 26 May 2022).

Meinshausen, M., Lewis, J., McGlade, C., Gütschow, J., Nicholls, Z., Burdon, R., Cozzi, L. and Hackmann, B. 2022. "Realization of Paris Agreement pledges may limit warming just below 2°C." *Nature* 604, 304–309, 13 April. Available online: https://doi.org/10.1038/s41586-022-04553-z (accessed 26 May 2022).

148 References

Melore, C. 2022. "Baby boomers are the new climate change villains, study claims." *Study Finds – Earth and Environment*, 26 March. Available online: www.studyfinds.org/baby-boomers-climate-change/ (accessed 23 June 2022).

Mendez, V. 2022. "What is mutual aid, and how can it transform our world?" *Global Giving Viewpoints*, 3 February. Available online: www.globalgiving.org/learn/what-is-mutual-aid?mc_cid=affab1431c&mc_eid=c528265476 (accessed 31 October 2022).

Merritt, E. 2019. "Toxic philanthropy." *American Alliance of Museums, Center for the Future of Museums Blog*, 11 December. Available online: www.aam-us.org/2019/12/11/toxic-philanthropy/ (accessed 2 November 2022).

Miller, A. 2021. "5 trillion dollars and 700,000 fracked wells." *Post Carbon Institute Newsletter*, 9 December. Available online: www.resilience.org/stories/2021-12-09/energy-reality-for-the-usa/ (accessed 27 May 2022).

Monbiot, G. 2022. "The banks collapsed in 2008 – and our food system is about to do the same." *The Guardian. Opinion*, 19 May. Available online: www.theguardian.com/commentisfree/2022/may/19/banks-collapsed-in-2008-food-system-same-producers-regulators (accessed 2 March 2023).

Moore, K.D. 2022. "Get in the way: The great avulsion." In *Take Heart: Encouragement for Earth's Weary Loves: Essays by Kathleen Dean Moore*. Corvallis, Oregon: Oregon State University Press.

Mulcair, T. 2022. "Trudeau's hopeless performance on environment is not unique." *Special to CTVNews.ca*., 19 April, 9:26 a.m. MDT. Available online: www.ctvnews.ca/business/tom-mulcair-trudeau-s-hopeless-performance-on-environment-is-not-unique-1.5866946?msclkid=9755d2d1c0f111eca1079528ddc5a59e (accessed 27 May 2022).

Museums. 2020. "Introduction." *Mindsets for Museums of the Future*. Available online: https://museumofthefuture.the-liminal-space.com/2/ (accessed 21 October 2021).

Museums Are Not Neutral. 2021. Available online: www.museumsarenotneutral.com/ (accessed 18 March 2023).

Museums Association. 2020. *Museums for Climate Justice*. Available online: www.museumsassociation.org/campaigns/museums-for-climate-justice/# (accessed 19 September 2022).

National Aeronautical and Space Administration. 2022. *Global Climate Change: Vital Signs of the Planet*, 25 May. Available online: https://climate.nasa.gov/faq/17/do-scientists-agree-on-climate-change/ (accessed 26 May 2022).

Natural History Museum. 2022. *About the Natural History Museum*. Available online: https://thenaturalhistorymuseum.org/about/ (accessed 10 May 2022).

Nature Briefing. 2023. "How to defuse the climate time bomb." *Nature Briefing*, 21 March. Available online: Nature Briefing (campaign-archive.com) (accessed 24 March 2023).

Nelson, R. 2020. "Exploring civilizational overshoot." *YouTube*, 13 May. Canadian Association for the Club of Rome. Available online: https://canadiancor.com/ruben-nelson-2020-05-13-civilization-overshoot/ (accessed 24 May 2022).

Nikiforuk, A. 2022. "Get ready for the forever plague: Public health officials' COVID complacency has opened the door to new illnesses and devastating long-term damage." *The Tyee*, 4 July. Available online: https://thetyee.ca/Analysis/2022/07/04/Get-Ready-Forever-Plague/?utm_source=weekly&utm_medium=email&utm_campaign=040722 (accessed 6 July 2022).

Niranjan, A. 2022. "Fixing concrete's carbon footprint." *Deutsch Welle*, 4 February. Available online: www.dw.com/en/concrete-cement-climate-carbon-footprint/a-60588204#:~:text=The%20cement%20and%20concrete%20industry,those%20from%20flying%20or%20shipping (accessed 20 February 2023).

Orlov, D. 2013. *The Five Stages of Collapse: Survivor's Toolkit*. Gabriola Island, Canada: New Society Publishers.

Oxfam International. 2022. "Inequality kills: The unparalleled action needed to combat unprecedented inequality in the wake of COVID-19." *Oxfam International Policy Papers*, 17 January. Available online: www.oxfam.org/en/research/inequality-kills (accessed 27 May 2022).

Oxford Reference. 2022. *Human Exceptionalism Paradigm*. Available online: www.oxfordreference.com/view/10.1093/oi/authority.20110803095949791#:~:text=The%20view%20(paradigm)%20that%20humans,Dictionary%20of%20Environment%20and%20Conservation%20%C2%BB (accessed 14 July 2022).

Pearce, F. 2019. "As climate change worsens, a cascade of tipping points loom." *YaleEnvironment360*, 5 December. Yale School of the Environment. Available online: https://e360.yale.edu/features/as-climate-changes-worsens-a-cascade-of-tipping-points-looms (accessed 26 May 2022).

Pearce, F. 2022. "Why the rush to mine lithium could dry up the high Andes." *YaleEnvironment360*, 19 December. Yale School of the Environment. Available online: https://e360.yale.edu/features/lithium-mining-water-andes-argentina (accessed 11 October 2022).

Petersen, B., Stuart, D. and Gunderson, R. 2019. "Reconceptualizing climate change denial: Ideological denialism misdiagnoses climate change and limits effective action." *Human Ecology Review* 25 (2), 117–141. Available online: http://press-files.anu.edu.au/downloads/press/n6244/pdf/08_petersen.pdf (accessed 15 June 2022).

Pinto-Bazurco, J.F. 2020. "The precautionary principle." *Brief #4*, 23 October. International Institute for Sustainable Development. Available online: www.iisd.org/system/files/2020-10/still-one-earth-precautionary-principle.pdf (accessed 9 June 2022).

Plumer, B. 2023. "Climate change is speeding toward catastrophe. The next decade is crucial, UN panel says." *The New York Times*, 21 March. Available online: www.nytimes.com/2023/03/20/climate/global-warming-ipcc-earth.html?unlocked_article_code=ciI1x8ADaetKU4lWLE6Qn1C0UWaavcopPpguT2USPC2IXOmOQaTXHOkkfGGWJh2T2wYLGXrFbXn_hSG41Cii6n7UAAiLVFNQ4AzpWL1KqVfhd9tv69VCecb-BoF0moA_M-VYxUeoJ5_qOj3JtJtseEupYOlI_j5sfsHxK_7CDOYnCdMx2tuYZs1tNThoB26T9yvbQOF-PbIE9M3Rl9BhpZwl54pP8ILLDcCEVpbUYSBNdp0A9wIim_ZcfrHvmdmwP8_pNYqah9PxZA6uMKy9NlVuZOrIgeK9rA-snWQWrkAzpGqLd_ftuG-fUXtOCzJzZ9SRWrIq31imWCOMGkxEB_Hatw&smid=url-share (accessed 24 March 2023).

Pollard, D. 2022a. "Collapse, not apocalypse." *How to Save the World*, 27 July. Available online: https://howtosavetheworld.ca/2022/07/27/collapse-not-apocalypse/ (accessed 28 July 2022).

Pollard, D. 2022b. "How do we teach the critical skills needed to face collapse?" *Resilience*, 14 October. Available online: www.resilience.org/stories/2022-10-14/how-do-we-teach-the-critical-skills-needed-to-face-collapse/ (accessed 3 February 2023).

Posen, P. 2015. "Slower growth – disaster or blessing? A debate." *The Economist*, 1 July. Available online: https://worldif.economist.com/article/12121/debate (accessed 9 June 2022).

Potter, A. 2022. "Nowhere to go but down? Past year proves civilization is in decline: Author." *CBC Ideas*, 7 June. Radio Interview. Available online: www.cbc.ca/radio/ideas/nowhere-to-go-but-down-past-year-proves-civilization-is-in-decline-author-1.6192307 (accessed 9 June 2022).

Poulos, C.N. 2021. *Essentials of Autoethnography*. The American Psychological Association, 4–11. Available online: www.apa.org/pubs/books/essentials-autoethnography-sample-chapter.pdf (accessed 29 July 2022).

Powers, R. 2018. *The Overstory*. New York and London: W.W. Norton and Company.

Putnam, R.D. 2000. *Bowling Alone: The Collapse and Revival of American Community*. New York: Simon and Schuster.

Ramachandran, V. 2022. "Blanket bans on fossil fuels hurt women and lower-income countries." *Nature – World View* 607 (9). Available online: https://doi.org/10.1038/d41586-022-01821-w (accessed 8 July 2022).

Rees, W.E. 2017. "Global population, growth and sustainable development." Presentation at the Vancouver Island University Elder College, Nanaimo, British Columbia, Canada. Available online: https://adm.viu.ca/sites/default/files/global-population-growth-%26-sustainable-development-william-e-rees-phd-frs-ubc-scarp-nanaimo14oct17.pdf (accessed 25 May 2022).

Rees, W.E. 2020. "Ecological economics for humanity's plague phase." *Ecological Economics* 169 (106519), March. Available online: https://doi.org/10.1016/j.ecolecon.2019.106519 (accessed 18 March 2023).

Rees, W.E. 2021a. "To save ourselves, we'll need this very different economy." *The Tyee*, 10 August. Available online: https://thetyee.ca/Analysis/2021/08/10/Save-Ourselves-Need-Very-Different-Economy/?utm_source=weekly&utm_medium=email&utm_campaign=160821 (accessed 27 May 2022).

Rees, W.E. 2021b. "A note on climate change and cultural denial." *Population Matters Newsletter*, 24 November. Available online: https://populationmatters.org/news/2021/11/bill-rees-a-note-on-climate-change-and-cultural-denial/?s=09 (accessed 13 January 2023).

Rees, W.E. and Nelson, R. 2020. "Will modern civilization be the death of us?" *Institute of Religion in an Age of Science – Part 1*, 29, 30 June. Available online: www.youtube.com/watch?v=U3GB191UDiI (accessed 24 May 2022).

Research Centre for Museums and Galleries. 2022. *About RCMG*. School of Museums Studies, University of Leicester. Available online: https://le.ac.uk/rcmg/contact (accessed 18 May 2022).

Rifkin, J. 1980. *Entropy: A New World View*. New York: The Viking Press.

Robinson, M. and Borden, T. 2020. "Here's a look inside a 15-story underground doomsday shelter for the 1% that has luxury homes, guns, and armored trucks." *Insider*, *Executive Lifestyle*, 18 February. Available online: www.businessinsider.com/photos-of-survival-condo-project-luxury-doomsday-shelter-2017-4 (accessed 14 June 2022).

Rosane, O. 2022. "Record-breaking heat wave strains limits of human survivability in India and Pakistan." *EcoWatch*, 3 May. Available online: www.ecowatch.com/heat-wave-india-pakistan.html (accessed 26 May 2022).

Roszak, T. 2009. *The Making of an Elder Culture*. Gabriola Island, Canada: New Society Publishers.

Sachs, J.D. 2008. *Common Wealth: Economics for a Crowded Planet*. New York: Penguin.

Safina, C. 2021. "Avoiding a 'ghastly future': Hard truths on the state of the planet." *YaleEnvironment360*, 27 January. Yale School of the Environment. Available online: https://e360.yale.edu/features/avoiding-a-ghastly-future-hard-truths-on-the-state-of-the-planet (accessed 18 March 2023).

Sandell, R. 2007. *Museums, Prejudice and the Reframing of Difference*. Abingdon and New York: Routledge.

Saul, J.R. 1995. *The Unconscious Civilization*. Concord, Canada: House of Anansi Press.

Schenck, D. and Churchill, L.R. 2021. "Ethical maxims for a marginally inhabitable planet." *Perspectives in Biology and Medicine* 64 (4), 494–510, Johns Hopkins University Press. Available online: https://acrobat.adobe.com/link/review?uri=urn%3Aaaid%3Ascds%3AUS%3Ab5dff5ac-a535-3717-8c05-f8ce83dc0ba0#pageNum=6 (accessed 21 July 2022).

Scherer, G. 2019. "Facing a possible climate apocalypse: How should we live." *Mongabay Series: Covering Climate Now*, 15 September. Commentary. Available online: https://news.mongabay.com/2019/09/facing-a-possible-climate-apocalypse-how-should-we-live-commentary/ (accessed 1 July 2022).

Schmachtenberger, D. 2022. "Bend not break part 5." *The Great Simplification, #50*, 19 December. Podcast. Available online: www.youtube.com/watch?v=Kep8Fi_rUUI (accessed 17 February 2023).

Schuster, R., Germain, R.R., Bennett, J.R., Reo, N.J. and Arcese, P. 2019. "Vertebrate biodiversity on Indigenous-managed lands in Australia, Brazil, and Canada equals that in protected areas." *Environmental Science & Policy* 101, 1–6. Available online: www.rcinet.ca/en/wp-content/uploads/sites/3/2019/07/Schuster-et-al-Indigenous-lands.pdf (accessed 14 February 2023).

Science Museum of Minnesota. 2022. *From Awareness to Action*. Available online: https://new.smm.org/action-for-earth (accessed 6 May 2022).

Scott, C. 2000. "Branding: Positioning museums in the twenty-first century." *International Journal of Arts Management* 2 (3), 35–39.

Seibert, M.K. and Rees, W.E. 2021. "Through the eye of a needle: An eco-heterodox perspective on the renewable energy transition." *Energies* 14 (15), 1–19. Available online: https://doi.org/10.3390/en14154508 (accessed 23 June 2022).

Servigne, P. and Stevens, R. 2020. *How Everything Can Collapse*. Cambridge: Polity.

Seshat. 2021. *Global History Database*. Available online: https://seshatdatabank.info/ (accessed 31 January 2023).

Simms, A. 2019. "Museum of rapid transition: Museums in a world facing existential crisis." *Museum-iD*, Issue 23, 26 March. Available online: https://museum-id.com/museum-of-rapid-transition-the-role-of-museums-in-a-world-facing-existential-crisis/ (accessed 10 October 2022).

Smil, V. 2022. "Beyond magical thinking: Time to get real on climate change." *YaleEnvironmet360. Opinion*, 19 May. Yale School of the Environment. Available online: https://e360.yale.edu/features/beyond-magical-thinking-time-to-get-real-about-climate-change (accessed 8 July 2022).

Smith, M-D. 2020. "10 pivotal First Nations rights disputes to watch in 2021: First Nations are demanding recognition of rights in a chain of potential flashpoints across the country." *MACLEAN'S*, 15 December. Available online: www.macleans.ca/news/10-pivotal-first-nations-rights-disputes-to-watch-in-2021/ (accessed 6 June 2022).

Smith, S. 2022. "Heatwaves deaths in Spain and Portugal approach 2000." *INDEPENDENT*, 21 July. Available online: www.independent.co.uk/climate-change/news/spain-portugal-deaths-heatwave-b2128345.html (accessed 7 March 2023).

Stacey, R.D. 1992. *Managing the Unknowable: Strategic Boundaries Between Order and Chaos in Organizations*. San Francisco: Jossey-Bass Inc.

Stanish, C. 2008. "On museums in a postmodern world." *Daedalus – Journal of the American Academy of Arts and Sciences* 137 (3), 147–149. Available online: www.jstor.org/stable/40543808 (accessed 18 March 2023).

Statista. 2022. *Number of Museums Worldwide as of March, 2021, by UNESCO Regional Classification*. Available online: www.statista.com/statistics/1201800/number-of-museums-worldwide-by-region/ (accessed 11 May 2022).

Steinberg, E. ed. 2008. *The Pocket Pema Chodron*. Boston and London: Shambala Publications, Inc.

Steketee, G. 2018. "Hoarding and museum collections." In Wood, E., Tisdale, R. and Jones, T. eds. *Active Collections*. New York and London: Routledge, 49–61.

Szántó, A. 2023. "A balance between wonder and humility: 25 leading architects imagine how future museums will look in a post-starchitecture world." *Artnet News*, 9 February. Available online: https://news.artnet.com/art-world/imagining-the-future-museum-andras-szanto-2252816 (accessed 15 February 2023).

Szántó, A. and Schell, O. 2022. "Art institutions aren't doing enough to lead on climate change: Here's how the industry should rethink its responsibility." *Artnet News*, 17 January. Op-Ed. Available online: https://news.artnet.com/opinion/climate-change-institutions-op-ed-2060240?utm_content=from_artnetnewsmodal&utm_source=Sailthru&utm_medium=email&utm_campaign=US%20News%20Morning%201%2F18%2F22&utm_term=New%20US%20Newsletter%20List%20%5BMORNING%5D (accessed 6 May 2022).

Tainter, J.A. 1988. *The Collapse of Complex Societies*. Cambridge: Cambridge University Press.

Thunberg, G. 2022. "Greta Thunberg on the climate delusion: We've been greenwashed out of our senses. It's time to stand our ground." *The Guardian*, 8 October. Available online: www.theguardian.com/environment/2022/oct/08/greta-thunberg-climate-delusion-greenwashed-out-of-our-senses (accessed 31 October 2022).

Tigue, K. 2022. "Scientists again call for civil disobedience to spur climate action, saying 'time is short'." *Inside Climate News*, 22 August. Available online: https://insideclimatenews.org/todaysclimate/scientists-again-call-for-civil-disobedience-to-spur-climate-action-saying-time-is-short/#:~:text=For%20the%20second%20time%20this,the%20threats%20it%20poses%20to (accessed 19 September 2022). See also: https://elifesciences.org/articles/83292 (accessed 6 January 2023).

Tisdale, R. 2018. "Epilogue: Imagine with us." In Wood, E., Tisdale, R. and Jones, T. eds. *Active Collections*, New York and London: Routledge, 162.

Tollefson, J. 2022. "IPCC's starkest message yet: Extreme steps needed to avert climate disaster." *Nature* 604, 413–414. Available online: https://doi.org/10.1038/d41586-022-00951-5 (accessed 26 May 2022).

Tortelero, C. 2022. "Stop being accomplices to society's racism." *Museums Journal. Opinion*, 24 November. (Museums Association – UK). Available online: www.museumsassociation.org/museums-journal/opinion/2022/11/stop-being-accomplices-to-societys-racism/# (accessed 5 January 2023).

Transition Network. 2022. "A movement of communities coming together to reimagine and rebuild our world." *Transition Network.org*. Available online: https://transitionnetwork.org/ (accessed 26 July 2022).

Tuck, E. and Yang, K.W. 2012. "Decolonization is not a metaphor." *Indigeneity, Education & Society* 1 (1), 1–40. Available online: https://jps.library.utoronto.ca/index.php/des/article/view/18630/15554 (accessed 21 February 2023).

United Nations. 2015. "Open working group proposal for Sustainable Development Goals." *Sustainable Development Knowledge Platform*. Available online: https://sustainabledevelopment.un.org/focussdgs.html (accessed 28 June 2022).

United Nations. 2020. "The sustainable development goals report 2020." *United Nations Digital Library*. Available online: https://digitallibrary.un.org/record/3887571/files/TheSustainableDevelopmentGoalsReport2020.pdf (accessed 26 May 2022).

United Nations. 2022. "UN climate report: It's 'now or never' to limit global warming to 1.5 degrees." *UN News*, 4 April. Available online: https://news.un.org/en/story/2022/04/1115452 (accessed 26 May 2022).

Velie, E. 2022. "Museum org demanded loyalty; Scholars resigned." *HYPERALLERGIC*, 4 November. Available online: https://hyperallergic.com/775411/museum-org-demanded-loyalty-scholars-resigned/ (accessed 25 January 2023).

Wackernagel, M. and Rees, W.E. 1996. *Our Ecological Footprint: Reducing Human Impact on the Earth*. Gabriola Island, British Columbia, Canada: New Society Publishers.

Watson, S. ed. 2007. *Museums and Their Communities*. Oxford: Routledge.

We Are Still In. 2022. *About*. Available online: www.wearestillin.com/about) (accessed 10 May 2022).

Weart, S. 2012. "The discovery of global warming [excerpt]." *Scientific American, Environment*, 17 August. Available online: www.scientificamerican.com/article/discovery-of-global-warming/ (accessed 14 July 2022).

Weil, S. 1999. "From being *about* something to being *for* somebody: The ongoing transformation of the American museum." *Daedalus – Journal of the American Academy of Arts and Sciences* 128 (3), 229–258.

Weintrobe, S. 2020. "Moral injury, the culture of uncare and the climate bubble." *Journal of Social Work Practice* 34 (4), 351–362. Available online: www.tandfonline.com/doi/full/10.1080/02650533.2020.1844167 (accessed 8 February 2023).

Weisberg, R. 2023. "The war of all against all: Review of the persuaders, part 2." *Museum Human*, 21 February. Available online: www.museumhuman.com/the-war-of-all-against-all-review-of-the-persuaders-part-2/?ref=museum-human-newsletter (accessed 24 February 2023).

Whalley, S. 2023. "Reaching 1.5°C of global heating by 2024 isn't even the whole story." *Common Dreams*, 26 January. Available online: www.commondreams.org/reaching-1-5c-global-heating?mc_cid=3c7a31255c&mc_eid=c9194adbac (accessed 27 January 2023).

Wheatley, M.J. 1992. *Leadership and the New Science*. San Francisco: Berrett-Koehler Publishers, Inc.

White, L. 1967. "The historical roots of our ecologic crisis." *Science* 155 (3767), 1203–1207.

Wikipedia, The Free Encyclopedia. 2022a. *Ecomodernism*. Available online: https://en.wikipedia.org/wiki/Ecomodernism (accessed 27 May 2022).

Wikipedia, The Free Encyclopedia. 2022b. *Jevon's Paradox*. Available online: https://en.wikipedia.org/wiki/Jevons_paradox (accessed 15 July 2022).

Wikipedia, The Free Encyclopedia. 2022c. *Systems Theory*. Available online: https://en.wikipedia.org/wiki/Systems_theory (accessed 17 October 2022).

Wikipedia, The Free Encyclopedia. 2023a. *Green Anarchism*. Available online: https://en.wikipedia.org/wiki/Green_anarchism (assessed 9 March 2023).

Wikipedia, The Free Encyclopedia. 2023b. *Eco-Socialism*. Available online: https://en.wikipedia.org/wiki/Eco-socialism#:~:text=Eco%2Dsocialism%20(also%20known%20as,%2Dglobalization%20or%20anti%2Dglobalization (assessed 9 March 2023).

Wilber, K. 2001. *A Theory of Everything*. Boston: Shambhala Publications.

Wilson, E.O. 1998. *Consilience – The Unity of Knowledge*. New York: Alfred A. Knopf Inc.

Wilson, E.O. 2006. *Creation: An Appeal to Save Life on Earth*. New York: W.W. Norton and Company.

Wilson, E.O. 2016. *In Oxford Essential Quotations* (Fourth edition). Ratcliffe, S. ed. Oxford: Oxford University Press. Available online: www.oxfordreference.com/view/10.1093/acref/9780191826719.001.0001/q-oro-ed4-00016553 (accessed 8 June 2022).

Wood, E., Tisdale, R. and Jones, T. eds. 2018. *Active Collections*. London and New York: Routledge.

Woodhouse, M.B. 1996. *Paradigm Wars*. Berkeley, CA: Frog, Ltd.

Wright, R. 2004. *A Short History of Progress*. Toronto: House of Anansi Press, Inc.

Yale School of the Environment. 2021. "A vast South American wilderness is under siege from illegal mining." *Yale School of the Environment Video*, 5 August. Available online: https://e360.yale.edu/features/a-vast-south-american-wilderness-is-under-siege-from-illegal-mining (accessed 7 June 2022).

Zarnett, B. 2022a. "Climate change is coming for us." *Substack*, 2 February. Available online: https://bradzarnett.substack.com/ (accessed 2 June 2022).

Zarnett, B. 2022b. "Where will mainstream climate propaganda take us?" *Substack*, 5 May. Available online: https://bradzarnett.substack.com/p/where-will-mainstream-climate-propaganda?s=r (accessed 6 June 2022).

Zarnett, B. 2022c. "Why is 'mainstream thinking' at the epicentre of our climate emergency?" *Substack*, 9 January. Available online: https://bradzarnett.substack.com/p/why-is-mainstream-thinking-at-the?s=r (accessed 7 June 2022).

Zerkal, M. 2022. "How to create a mutual aid network." *American Friends Service Committee News and Commentary*, 7 January. Available online: www.afsc.org/blogs/news-and-commentary/how-to-create-mutual-aid-network?mc_cid=affab1431c&mc_eid=c528265476 (accessed 31 October 2022).

Zernan, J. 2001. "Greasing the rails to a cyborg future." *Adbusters*, May/June, 35, 88.

INDEX

Note: Page numbers in *italics* indicate a figure on the corresponding page.

AAM *see* American Alliance of Museums
accountability 6, 14; of government and private sector 64–66, 74; lack of 18, 132; of managers 101; museum 98, 112
accountability imperative 64
activist museums 63, 65, 66, 71
activist networks 63
activists 2, 63, 68, 71; Macy 80; McKenzie 29; Monbiot 32; Rifkin 91; Zarnett 25
Activist Museum Award 62
adaptation: branding 58–59; community conversations as essential tools for 106; Deep Adaptation 80–81, 117; inner and outer 81; intelligent 86, 105; knowledge for 85–86; litany of sorrows or 80–81; museums and 88–89, 112; reconciliation and 109; successful 78, 129; *see also* Deep Adaptation Forum (DAF)
ageism 107
agency: museum 120; museum ethics *and* 60; personal 5, 35, 70, 81, 99, 102, 104–105, 112, 115–116; social 63
Ahmed, N. 16
Alberta, Canada 7; *see also* Blackfoot Confederacy; Kainai First Nation; Plains Cree
Alberta Museums Association 72

Alliance of Natural History Museums of Canada 86
Amazon rainforest 13, 15, 27
American Alliance of Museums (AAM) 65, 72, 90
American Museum of Natural History, New York City 98
Ames, M. 77
ancestors: human 23; hunting and gathering 75; Neolithic 57; our role as 137
anger 7, 79, 101, 106, 119, 131, 133
Antarctic 15
anthropocentrism 26
antihumanism 13
anxiety 106, 115, 126
Arctic 17, 111–112; Subarctic 112
Arrhenius, S. 15
Atkinson, R. 48
Australia 88, 135

baby boomers 133; curse of 41–42; living time horizon of 48
Bardi, Ugo 37
batteries 14, 44–46, 116
Bendell, J. 35–36, 80–81
Berry, W. 85, 137
Big Lie 25
big money 20; *see also* toxic philanthropy
big oil 20
big picture, the 127–129

biocapacity, of Earth 13
biodiversity: allowing recovery of 30; biological 110; collapse of 4, 25; destruction of 93; conserving 114; ecological 23; Global Coalition for Biodiversity 2021 (Canada) 66; loss of 15, 16, 33, 46, 80, 117; material biodiversity 84; museum collections in relationship to 67
biomass 129
biosphere: big money's destruction of 20; capitalism and 25; damage of 21, 31; death of some of 80; definition of 78; destruction of 42, 64, 113, 116, 117; ecological diversity and 23; ecotopia and 30; honouring 116; inherent value of 30; museum institutions as stewards of 55; museums and 78; Nature as 5; progress at the expense of 97; protecting 29; technosphere and 21, 41; techno-utopia and 31
BIPOC *see* Black, Indigenous, and People of Color
Blackfoot Confederacy xii, 7, *109*, 111–112
Black Global Scenario 30–31
Black, Indigenous, and People of Color (BIPOC) 131
blundering hubris 21–22
Boulding, K. 31
branding 58–59
Breakthrough Institute, Berkeley 53
British Columbia, Canada *12*, 16
Build Back Better, United States 19
bunker communities 38
bunker mentality 37–39

Campbell, B. 19
Campbell, J. 63
Canada: British Columbia *12*, 16; culture as leisure consumption in 122; erosion of funding for museums of 2; Indian Act 113; Inuit 7, 108, 111; museums of 1–2; National Cultural Summit 2022 121–122; poor climate policy of 18–19; Trudeau 19
Canadian Association of the Club for Rome 91
Canadian Heritage 122; Minister of Canadian Heritage 121
Canadian Museum Association (CMA) 6, 122
Canadian Museum for Human Rights 84
Canadian Museum of Nature 66
Canadian Rockies *34*
capitalism 11, 25–26, 53, 58, 61
carbon capture and storage 21, 25, 51, 114
carbon dependency 53
carbon dioxide: Amazon forest and 27; Culture Over Carbon 71; global warming and 36–37; low-carbon transportation *52*
carbon emissions 17, 19, 36; concrete and cement industry and 95; Indigenous resistance to fossil fuel, impact on 113; net-zero 77
carbon footprint, reducing 72, 95
carbon offset 54
carbon sink 27
cascading failures 123
catagenesis 37, 123
catastrophism 54
celebrity worship 90, 94
child servitude 45–46
China 13, 54, 107
Churchill, L. 79
civil disobedience 17, 133
civil society: museums and 56–58
civilizational overshoot 10–12
clean technology 42, 43–45, 46, 51, 52; *see also* technology
climate action 19, 20; climate justice and 27; moving the conversation forward on 61; United States 63–65; "We Are Still In" 65
climate advocacy 62
climate catastrophe 26
climate change 10, 15; adapting to 114; catastrophic 36; economic impact of 21; feedback 30; IPCC's failure to address 36
climate chaos 5
climate conferences 23, 115; *see also* COP
climate crisis 5, 12, 15; CMA and 122; museum associations confronting 72; museums and 47; root causes of 41, 46; World War II, resemblance to 48
climate denial 24, 65–66, 134
climate disaster policy 22
climate emergency 15
climate grief 80; *see also* grief
Climate Heritage Manifesto 71–72
climate justice 27; Coalition of Museums for Climate Justice 71, 72, 81, 122
climate models, conservatism of 37
climate policies 51

climate stress 9
climate trauma 3, 15–18, 26, 121; activist 25; COVID-19 and 49; ecotopia and 31; global food systems disturbed by 67; impacts of 50
CMA *see* Canadian Museum Association
coal 14, 16–19, 43, 53, 134
Coalition of Museums for Climate Justice 71, 72, 81, 122
coffee 14; acorn-based 48
Coffee, K. 98–99, 108
Cold War 37
collaboration 88–89
collapse, stages of 32–35
collapsology 3, 28, 79
collections (museum) 95–97
colonial-capitalist social relations 112
colonialism 39, 63; capitalism and 58; modernity and 24; museums and 65, 92; settler 109
communities: agricultural 10; bunker 38; Indigenous 45; local 86, 135; marginalized 16; museums and 4, 5; scholarly and scientific 47; *see also* museum communities
community: building 107; collecting 63; conversations 114; culture 107; elders 108; resilience 92; voices 87
Conference of the Parties (COP), United Nations 23, 65, 115; COP21 65; COP27 18, 71; COP28 18
Conrad, J. 39, 105
consumerism 2, 52, 57, 128
contraction 48–51, 54, 86, 89, 94, 127
COP *see* Conference of the Parties
corporate deceit 18–21
corporate duplicity 18; *see also* duplicity
corporatism 2, 97
cosmology 111
COVID-19 3, 49–50, 72, 100, 105, 127, 135
Culture Over Carbon 71
cruise industry (ships) 2, 27, 49, 50–51, 134

DAF *see* Deep Adaptation Forum (DAF)
Dahrendorf, Ralf (Sir) 57
Daley, E. 132–133
deaccessioning 96
decarbonization and electrification 43, 116
decolonization 2, 5, 24, 99, 104, 107, 109–110
Deep Adaptation Forum (DAF) 35, 80–81
degrowth 13, 93–94, 116
Dene Nation xiii, 8, 111–112, *114*
denialism 24, 51, 55; *see also* climate denial

despair 77, 80, 131, 133
destitution 11
DeVore, I. 75
dispossession 11, 24
Don't Look Up (film) 27
dualism 114–115
duplicity 15, 18, 23
Dyke, J. 17

eco-economic tools 14
ecological: balance 40; blindness 42; collapse 12, 32; cost 43, 45; crisis 122; destruction 51; diversity 23; economists 93; metaphor 78; skills 106; state 80; systems 89
Ecological Footprint 86
ecological overshoot 13–14, 17–18, 20–22, 32, 38, 137; civilizational overshoot and 10; as cost of doing business 25; denial of reality of 134; ecotopia made impossible due to 31; fiscal and regulatory mechanisms to address 20; indicators of 13; indivisible benefits and 132; museums as bearing witness to 137; new narrative for museums addressing 75; only effective response to 129; political incompetence and 18; polycrisis caused by 77
ecomodernism 21–22, 25, 30–31, 41, 117
ecomuseum 89
economic growth *see* growth
economic inequality 4, 20, 74
economics as pseudoscience and form of brain damage 22, 31
Economopoulos, Beka 66
eco-philosophers 119
eco-socialists 133, 135
ecotopia 30–31
eco-utopians 133
edifice complex 94–95
Edson, M. 90
Ehrenfeld, D. 132
elder culture 107–108
elders: council of 32; Dene 111; museums and 83
Elgin, D. 97
elites: corporate 23–24; failure of 20, 82, 124
Encyclopaedia Britannica 23
endgames 36
Entropy Law 92
Environment and Climate Network (American Alliance of Museums) 72

ethnocentrism 24
e-waste 44
exceptionalism (human) 11, 24, 55
expropriation 11, 24

fantasies and lies 24–26
First Nations 65, 108, *109*, 111
flooding 91, 135
food supply 32, 38
fossil fuel 13, 14, 16, 42; Africa 52; bans on 53; burning of finite 137; corporations 51; cruise ship industry and 50; depletion of 93; economy 83, 88; excessive consumption of 95; industry 18, 20, 23, 29; Indigenous resistance to consumption of 113; infrastructure 17; reliance on 45; rationing 128; replacing 30; reserves 134; solar panels replacing 43; stopping use of 129; uncontrolled consumption of 26
fracking 19
Frankenthaler Foundation 63–64
Franklin, U. 132
Frazier, C. 87
free market 21, 61, 86, 116; rhetoric of 57
free will 26
functional stupidity *see* stupidity
fuzzy thinking 19

Galbraith, J.K. 21, 38
genocide 11, 24
geoengineering 21
Glasgow Climate Pact 16
Glenbow Museum, Canada xii, 1
Global Coalition for Biodiversity 66
global heating 38, 91, 129
Global History Databank 84
globalization 49, 58
globalized society 3, 28
Global North 116, 119
Global South 13, 116
global warming 13–19; adapting to 85; cement and concrete industry's contributions to 95; consciousness of 115; denial of 21, 129; existential crisis of 49; five stages of insight and 79; hopelessness and 119; mass extinction of species and 80; museum response to 103; polycrisis and 77; truth and consequences of 26; warnings of temperature readings by end of century due to 36

Graber, D. 10
Great Council of Animals 75–76
Green Global Scenario 30
"green": arts community 121; Creative Green Tools Canada 71; going beyond 52–53; museum buildings 95; politics of 21, 29
green growth, promise of 40
greenhouse effect 15
greenhouse gasses 16, 29, 30, 43; government efforts to restrain 91; industrial agriculture and 33; Koch Industries and 66; mining and 46; reducing 50; United States as largest source of 43, 65
Green New Deal 133
green roof *128*
green spaces 83
green technology 41, 42, 46, 119; techno-utopia of 54
Greenland 15
Greer, J.M. 4
grief 7, 80, 106, 115, 119, 131
Gross Domestic Product (GDP) 24
groundwater 13, 19
groupthink 39
growth: degrowth 13, 93–94, 116; economic 4, 24, 31, 34, 40, 41, 46–48, 54, 74, 117, 129, 137; exponential 31; fallacy of 58; "green" 40; museum addiction to 93; perpetual 14; population 9, 13, 20, 60; post-growth 13; social 37; sustaining 22; unsustainable 11, 24
growth economy 78
growth myth 55, 93–94
Gurney, M. 135
Guterres, A. 16, 48

Hagens, N. 42
Handy, C. 118
Hansen, J. 20–21
Haque, U. 129
heat waves 129
Hedges, C. 28–29
Hegel, G.W.F. 56
Heinberg, R. 14, 20, 24–25, 51–52, 116, 127–128, 136–137
helplessness 106, 119–120
Henderson, H. 22, 31
Heritage Saskatchewan 67
hierarchy 78, 95, 99–100, 105
historical consciousness *see* museums
Homer-Dixon, T. 23, 36–47, 82

Homo sapiens 26–27, 41, 51
hope 118, 120
hopefulness 120
hopelessness 119–120; hope and 118
hospicing: modernity 12; museums 124–125
hubris 12, 31, 132; *see also* blundering hubris
humanism 6, 132
hyper-capitalism 21, 49
hyperindividualism 42

ICOM *see* International Council of Museums
immorality of inaction 7, 35
impending collapse 27, 125
imperialism 24, 70, 92, 94
income inequality 19, 33; *see also* inequality
India 16, 53, 107
Indian Act, Canada 113
Indian Wars, United States 24
Indigenous knowledge and cultures 87, 107, 117
Indigenous Peoples 27, 45, 58, 67, 90; Canada 24, 114, 122; colonial violence inflicted upon 134; museums and 110; resistance to fossil fuels 113; worldviews and treaties 109, 112, 117
indivisible benefits 132–133
inequality: collapse of social order due to 80; economic 4, 20, 74; gender 45; income 19; reducing 46; resource 29; social 10; wealth 33, 47, 90, 110
Initiative for Leadership and Sustainability 48
initiatives, climate-justice/museum-related 71–73, 84, 88–89, 108, 111, 127
insight, five stages of 79, 134
Institute for the Study of Energy and Our Future 42
intellectual activism 68
interdependence 53–54, 55, 78, 106, 134
Intergovernmental Panel on Climate Change (IPCC) 16, 36
International Association of Terminal Museums (hypothetical) 125
International Climate Control Conference 95
International Council of Museums (ICOM) 69–70, 89
International Energy Agency 46
International Labour Organization 45
International Renewable Energy Agency 44

Inuit of Canada 7, 108, 111
IPCC *see* Intergovernmental Panel on Climate Change

Jamail, D. 117
James, W. 126
Janes, P. 34
Janes, R. xii–xiv, 2, 76
Jenkinson, S. 80
Jensen, D. 119
Jevon's Paradox 41

Kainai First Nation *109*
K'á lot'ine Dene 111, 112, *114*
Keil, F. 87
Kemp, L. 36
Ki Culture 71
Koch, D. 66, 103
Korea (South) 107
Kunstler, J. 84

Lakota people 27
land grabs 113–114
leadership: American 65; civic 54; competence-based 112; heroic 97; leadership-centred models 126; management and 99–100; museum 5, 6, 73, 99–100, 102, 105; sustainability 80
leadership models 4
Lee, R. B. 75
leisure and leisure entertainment 27, 78, 88, 90, 122
Liberia 114
lithium-ion batteries 44–45; *see also* batteries
Loewen, C. 90

Macleod, S. 67
Macy, J. 80
madness of humanity 22–27, 41, 51, 117
Manaseer Tribe, Sudan 111
"Manifesto for Active History Museum Collections" 96
marketplace ideology 56–57, 97
Marstine, Janet 60
MASS Action 105
mass extinction 10, 17, 80, 117; Sixth Mass Extinction 10, 22, 38, 117
McDonald's fast food 69
McKenzie, B. 29–31
McKibben, B. 15
medicine bundles 111
mega-cities 9–19

mega-risks 9
methane 15, 19
modernity 24, 84, 87; hospicing 12; MTI culture and 10–11
modern techno-industrial (MTI) civilization 129–130
modern techno-industrial (MTI) culture 126–127
modern techno-industrial (MTI) society 10–13, 18–19; baby boomers and 42; as beyond repair 135; breakdown of 88; business tribalism and 98; civilizational overshoot and 10; commodification and 55; community building and 107; consumption narrative of 74; ecological overshoot and 13; failure of institutions of 90; frame of reference of 121; hyperindividualism and 42, 78; marketplace and 97; mindset of 11; museum practices and 123; museums and 78; museums as wards of 93; narratives of 74, 133; political ineptness and 18; power of status quo and 19; privatization and 38; unrestrained consumption and 46
Monbiot, G. 32
money 3, 19–20; big money 20; charities' use of donations for political purposes 65; corrupting influence of 23; growing awareness and sensitivity to sources of money 103; museums and 78, 96–97; performing arts and 122; worth measured by 21, 98
moneyed elite 37–38; *see also* elites
Moore, K. D. 132
moral: adjustments 79; challenges 103; compass 108; considerations 2, 11; hazard 23, 115; injury 115–116; progress 28; trade-off 69
morality 30, 38; immorality of inaction 35
"morally significant life" 126–127
morals: institutional 39
More-Than-Human World: black mule deer ruminating 76; collapse of 123; destruction of 23; extinction of 80; honouring 113–115; human separation from 55; museums and 78, 81, 136; Nature as 5; stewarding of 35, 133, 134

Museum as Muck 63
Museum as Site for Social Action (MASS Action) 105
museum community 2–7, 14, 53, 88, 115–116; Alberta 72; carbon footprint of 95; deaccessioning recognized by 96; degrowth and 94; dire realities confronting 78; Empathetic Museum 73; global 47, 55, 69–70, 100, 109; harbingers of collapse ignored by 71; neoliberal thinking among 93; neutrality and 90; repatriation issues faced by 109; resilience and 82–83
Museum of Modern Art (New York) 101
Museum of Transology 63
museums: being prepared, importance of 91–92; big picture for 127–129; branding adaptation by 58–59; as bridge between nature and culture 5; buildings 94–95; changing challenges for 2; civil society and 56–58; climate crisis unaddressed by 12; collaboration, need for 88–89; collections 95–98; current pressures on 3; deep time and xii, 55; elder culture and 107–108; ethical obligations of 59–69; erosion of funding for 2; fostering of research by 66–68; four agendas for (why, what, how, for whom) 102–103; four questions for (resilience, relinquishment, restoration, reconciliation) 81–119; fragmentation 69–74; functional stupidity in 100–102; growth myth and 93–94; historical consciousness and 23, 55, 75, 85, 89, 123, 125; hopeless but not helpless 119–120; hospicing 124–125; leadership and management of 99–100; as lifeboats 77–120; listening while saying goodbye 116–117; management 100; as "medieval" institution 37; moral injury and 115–116; museum associations 72–73; mutual aid by 89–90; myth of sustainability and 51; neutrality, questioning of 98–99; new narrative for 74–75; other ways of knowing potentially addressed by 110–115; personal agency in 104–105;

problem solving by 62–63; public advocacy by 60–62; reconciliation 108–119; relinquishment 92–102; repatriation issues faced by xii–xiii; resilience 82–92; restoration 102–108; SDG and 47; self-sufficiency in 105–107; sense of time of 87; small picture for 125–127; as social mirrors 12; social capital and 56–58; social sustainability and 54; story of humankind as presented by 10; strategic planning 54, 68, 101; trust and 90–91; uncertain future of 7; uncertainty and 117–119; urgent need for redefinition of role of 6; values or marketplace, choice between 97–98; witness, work of 4, 55, 86, 132, 137; why, importance of asking 103–104; why museums to address social collapse 55–76; wonder and diversity of 87–88; *see also* status quo
Museums Association (UK) 72
Museums for Climate Justice Campaign 72
Museum of Rapid Transition (hypothetical) 51
mutual aid 89–90

National Cultural Summit 2022, Canada 121–122
Natural History Museum (NHM) (pop-up museum) 65–66
Nature 5; ancient cultures and 23; decoupling from 13; financialization of 22; humans and 35, 76, 115; humans separate from 26; MTI mindset towards 11; protecting 21; web of 74
nature and culture 2, 4, 89, 117
neoliberal, neoliberalism 51, 116, 124, 132–133; belief in supremacy of free market 21; blind spots of 22; "bubbles" of denial created by 115; business tribalism of 98; corporatism of 89; damage of 53, 94; economic theory 11; ideology 93, 97, 98; materialism 88; self-interest 89; values 101; wisdom lacking in 144
Neolithic period 57
neutrality (museum) 98–99
NGOs *see* non-governmental organizations

NHM *see* Natural History Museum
non-governmental organizations (NGOs) 64, 90
Northwest Territories (NWT), Canada xiii, 111, 114
nuclear power 21
nuclear warfare 10, 38, 80, 134
numbing 135

organizational agency 35, 81, 132
Orinoco River (Venezuela) 27
Orlov, D. 32, 35
othering 26–27, 110
overpopulation 10, 13
overtourism 50

Pakistan 16, 135
Paleolithic emotions 37
pandemic *see* COVID-19
Paris Agreement (COP21) 18, 65
Parthenon Marbles xii
Pawnee tribe 75–76
Peabody Museum xii
performing arts 64, 122
personal agency *see* agency
philanthropy 64, 66, 103; toxic 104
placebo happiness 27
Plains Cree 111
political incompetence 18
Pollard, D. 27, 106–107, 134
pollution 20–21, 42, 45, 46, 80, 113
polycrisis 36, 48, 77, 89–94, 97; consequences inherent in 118–118; fundamental questions to pose during time of 135; global 9; grim facts of 129; institutional silence and 123; systemic nature of 127
population control 53
population growth *see* growth
Post Carbon Institute 20
post-collapse scenario 32, 84
post-growth 94
Postman, N. xii
postmodernism, dangers of 107
Potter, A. 28
Powers, R. 17
precautionary principle 31, 130
presentism 100, 108
primates, destruction of 29
privatization 11, 31, 38
progress trap 11
protesting 132
Putnam, R. D. 57

rainforest 15, 27, 29
Ramachandran, V. 53
RCMG *see* Research Center for Museums and Galleries
reciprocal regard 119
reconciliation 108–119
Red Global Scenario 29
reductionism 114–115
Rees, W. 5, 19–20, 22, 43, 53, 86
relinquishment 92–108
renewable energy 14, 25, 127, 129
renewable technologies 43–46, 77
repatriation 2, 109–110
requisite variety 20
research: climate 17, 19, 21, 26, 50, 95; humanities 66; museum 66–67, 69, 70, 91; primary 7; qualitative 7; secondary 7; social science 66–67, 68; sustainability 42
Research Center for Museums and Galleries (RCMG), University of Leicester 67–68
resilience 82–92
restoration 102–108
Rifkin, J. 91–92
risk-taking 61, 65, 90, 125
Royal Saskatchewan Museum 67

Sachs, J. 60
Sandell, R. 67
Saskatchewan, Canada 67, 85, 111
Schell, O. 64
Schenck, D. 79, 133
scholar/practitioner 2–3, 7, 48, 52, 80–81, 108, 131
Science Museum of Minnesota 61
Scott, C. 58
SDGs *see* Sustainable Development Goals (SDGs), United Nations
"second curve" thinking 100
seed banks: collections as 124; knowledge seed banks 106; memory banks and 83–85, 86, 87; museum as 87, 123; Svalbard Global Seed Vault 96
Seibert, M. K. 43
self-censorship 102
self-organization 99, 112
self-reflective work 103, 130
self-sufficiency 105–107, 129
Seneca Effect 37
Seneca, L. A. 37
sentiment: with action 94; without action 127
servitude *see* child servitude
Shinnie, P. xiii
silicon tetrachloride 43
silver bullets 3, 42, 51
Silver Global Scenario 30
Simms, A. 51
Sixth Mass Extinction 10, 22, 38, 117; *see also* mass extinction
small picture, the 125–127
Smil, V. 52–53
social: action 105; agencies 74; agency 63; capital 56–58, 59, 83, 89, 128; challenges 128; change 63; cohesion 78; collapse, threat and reality of 12, 34, 71, 79–80; consciousness 100; costs 119; disruption 46; ecology 2, 112; equality 40; evolution 10; impacts 46; injustice 45; institutions 5, 34, 55, 64, 84; justice 53, 69, 88, 117; meanings 7; media 3, 81, 90, 99, 101–102, 108; movements 107; needs 67; organizations 82; philosophers 38; pressure 94; problems 86; relationships 109; responsibility 97; sciences 66, 67, 68; sustainability 54; systems 19, 22, 36
socially constructed reality 11
socially purposeful organizations 67
societal: indifference 24, 109; issues 60, 62, 64, 98; needs 90; questions 85; resilience 1, 91, 96; triage 125; upheaval 6; well-being 5, 107
societal collapse: confronting 92; current reality of 4, 80, 81; five stages of 32–35, 82; idea of 29; managing 51; potential or possibility of 11, 41, 119; potential consequences of 1; threat of 2, 3; topic of 59; total collapse, possibility by 2050 of 16
solar energy 14, 17, 43–44, 116, 129, 133
starchitecture 94
status quo 7; moving beyond 119; museum challenge to 65; philanthropy's promise to alter 104; power of 19; redefining and transforming the museum in relationship to 69, 72, 73, 74–75, 92–93, 97, 103; Red Global Scenario 29–30; salvaging 46
stewardship 21, 55, 72, 84, 85, 115, 133–135; environmental 112–113

stupidity: collective human 137; functional 100–102, 105; role in history of 21, 38; self-reinforcing 100
sustainability: mindset of 43; myth of 21, 40–54; social 54
Sustainable Development Goals (SDGs), United Nations 46–48
Sutter, G. 67
Svalbard Global Seed Vault 96
synchronous failure 36–37
synthesizers 86–87
Szántó, A. 64

technological: benefits 31; fix 31; progress 11; solutions 22
technological-industrial: growth 47; society 115
technology: belief in human exceptionalism and 26; clean 42, 43–45, 46, 51, 52; digital 3, 50, 108; ecomodernism and 21; forgotten 85; god-like 27; green 41, 42, 54, 119; industrial 84; museums as outdated 109; new 3; Red Global Scenario and 29; renewable 14, 42, *44*, 45, 77; runaway 38; sustainable 123
techno-utopia 30–31, 54, 108, 117, 133
tiny home *128*
tipping points of global unstoppable climate change 15, 30, 36
Tisdale, R. 96
tourism 83, 128
toxic philanthropy 104
toxic money 20
toxic substances 43–44
Transition Network 88
Transition Towns 88
Trudeau, J. 19
trust: museums and 90–91
Tuck, E. 110

uncare, culture of 115
United Kingdom 63
United Nations 16, 47, 48; SDGs 46–48
United States 13; breakdown of civil society in 57; Build Back Better 19; climate action in 64; fracking by 19; greenhouse gasses produced by 43; Indian Wars 24; Indigenous Peoples 24, 109; Transition Initiatives in 88; withdrawal from Conference of the Parties 65

values: competing 57, 102; marketplace 29, 97–98; neoliberal 101; new institutional 123; non-negotiable 103; personal 30, 131; shared 56
values brand 58–59
voluntary simplicity movement 97
vulnerability 2, 7, 88, 97, 119
Vuntut Gwitchin First Nation, Old Crow, Yukon 111

Wackernagel, M. 86
wealth inequality 19–21, 31, 33, 47, 90, 110
wealth redistribution 93
wealthy countries 23, 50, 52, 94
wealthy elites 124
"We Are Still In" 65
Weintrobe, S. 115
Wengrow, D. 10
Western Development Museum, Saskatchewan 85
Western World 10, 22, 26, 52, 53, 107, 108, 114, 134, 135
wildfires 15, 91, 135
wildlife, destruction of xiv, 13, 19
Wilson, E. O. 22, 27, 37
wind turbines 43, 84, 85, 116
wisdom 12, 31, 108; conventional 62, 123; neoliberal thinking's lack of 114; received 11; seeds of 35; squandering of 107; as value 97
witness, work of 4, 55, 86, 132, 137
wonder: diversity and 87–88
wood 129, 134
Wright, R. 11, 23, 84

Yang, K. W. 110

Zarnett, B. 25

9781032382241